Books are to be returned on or before
the last date below.

18. FEB. 2002

- 5 DEC 2011

KT-489-951

042573

THE HENLEY COLLEGE LIBRARY

D

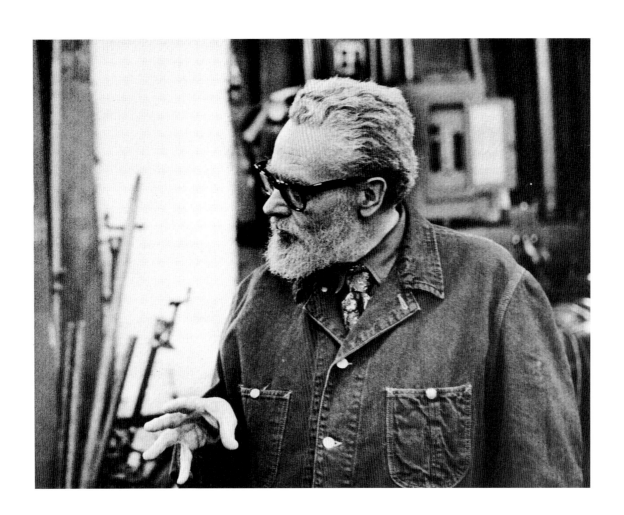

Tony Smith

ARCHITECT · PAINTER · SCULPTOR

Robert Storr

With essays by John Keenen and Joan Pachner

The Museum of Modern Art, New York

Distributed by Harry N. Abrams, Inc., New York

Published on the occasion of the exhibition
Tony Smith: Architect, Painter, Sculptor,
organized by Robert Storr, Curator in the Department of Painting and Sculpture,
The Museum of Modern Art, New York, July 2–September 22, 1998

This exhibition is made possible by Agnes Gund and Daniel Shapiro.

Produced by the Department of Publications
The Museum of Modern Art, New York

Edited by Joanne Greenspun
Designed by Emily Waters
Production by Marc Sapir
Composition by Santiago Piedrafita

Color separations by Professional Graphics, Rockford, Illinois
Printed and bound by Amilcare Pizzi S.p.A., Milan, Italy

Copyright © 1998 by The Museum of Modern Art, New York

All works by Tony Smith © 1998 Tony Smith Estate / Artists Rights Society (ARS), New York.
Certain illustrations are covered by claims to copyright cited in the Photograph Credits.
All rights reserved.

Library of Congress Catalogue Card Number: 98-65976
ISBN 0-87070-071-5 (MoMA, T& H, clothbound)
ISBN 0-87070-072-3 (MoMA, paperbound)
ISBN 0-8109-6188-1 (Abrams, clothbound)

Published by The Museum of Modern Art
11 West 53 Street, New York, New York 10019
www.moma.org

Clothbound edition distributed in the United States and Canada
by Harry N. Abrams, Inc., New York. www.abramsbooks.com

Clothbound edition distributed outside the United States and Canada
by Thames and Hudson, Ltd., London

Printed in Italy

FRONT COVER: *Free Ride.* 1962. Painted steel, 6'8"x 6'8" x 6'8" (203.2 x 203.2 x 203.2 cm).
The Museum of Modern Art, New York. Gift of Agnes Gund and Purchase

BACK COVER: Untitled. 1962, 1980. Oil and alkyd on canvas, 8' x 13'1⅛" (243.9 x 396.8 cm).
The Museum of Modern Art, New York. Gift of Agnes Gund

ENDPAPERS: Tony Smith with *Cigarette* installed in the garden of The Museum of Modern Art,
New York, 1979. Photographs by Hans Namuth

FRONTISPIECE: Tony Smith. Early 1970s. Photograph by Hans Namuth

Contents

Trustees of The Museum of Modern Art

David Rockefeller*
CHAIRMAN EMERITUS

Mrs. Henry Ives Cobb*
VICE CHAIRMAN EMERITUS

Ronald S. Lauder
CHAIRMAN OF THE BOARD

Sid R. Bass
Mrs. Frank Y. Larkin
Donald B. Marron
Richard E. Salomon
Jerry I. Speyer
VICE CHAIRMEN

Agnes Gund
PRESIDENT

John Parkinson III
TREASURER

Edward Larrabee Barnes*
Celeste G. Bartos*
H.R.H. Duke Franz of Bavaria**
Mrs. Patti Cadby Birch
Leon D. Black
Clarissa Alcock Bronfman
Hilary P. Califano
Thomas S. Carroll*
Leo Castelli**
Patricia Phelps de Cisneros
Marshall S. Cogan
Mrs. Jan Cowles**
Douglas S. Cramer
Lewis B. Cullman**
Elaine Dannheisser
Gianluigi Gabetti
Paul Gottlieb
Vartan Gregorian
Mrs. Melville Wakeman Hall*
George Heard Hamilton*
Kitty Carlisle Hart**
Barbara Jakobson
Philip Johnson*
Mrs. Henry R. Kravis
Robert B. Menschel
Dorothy C. Miller**
J. Irwin Miller*
Mrs. Akio Morita
S. I. Newhouse, Jr.
Philip S. Niarchos
James G. Niven
Richard E. Oldenburg**
Michael S. Ovitz
Peter G. Peterson
Mrs. Milton Petrie**
Gifford Phillips*
Emily Rauh Pulitzer
David Rockefeller, Jr.
Mrs. Robert F. Shapiro

Joanne M. Stern
Isabel Carter Stewart
Mrs. Donald B. Straus*
Eugene V. Thaw**
Jeanne C. Thayer*
Paul F. Walter
Thomas W. Weisel
Richard S. Zeisler*

*LIFE TRUSTEE
**HONORARY TRUSTEE

Ex Officio

Glenn D. Lowry
DIRECTOR

Rudolph W. Giuliani
MAYOR OF THE CITY OF NEW YORK

Alan G. Hevesi
COMPTROLLER OF THE CITY OF NEW YORK

Jo Carole Lauder
PRESIDENT OF THE INTERNATIONAL COUNCIL

Melville Straus
CHAIRMAN OF THE CONTEMPORARY ARTS COUNCIL

6

Preface and Acknowledgments

This is the first major museum exhibition in the United States to be devoted to Tony Smith since his death in 1980. Moreover, it is the first ever to present his protean output as a designer, builder, draftsman, painter, and sculptor in a comprehensive and fully integrated manner.

During his lifetime, Smith was primarily known for the abstract objects, monoliths, and space-framing constructions he began making in 1956 and exhibited for the first time in 1964. Within a few years, these imposing geometric sculptures earned him the cover of *Time* magazine, a very unusual badge of honor among his aesthetic peers. The accompanying article, which concentrated on his pivotal importance among a newly prominent group of artists making modernist monuments, noted in passing his previous art-world reputation as "a minor architect and Sunday painter," and "a semiprofessional Irishman." The truth of the matter was that prior to turning his hand to the sculpture that made him famous, Smith had behind him an extraordinary wealth of experience and significant accomplishments in several other mediums, as well as an idiosyncratic but profound grasp of literature and legend, of which his devotion to the Irish expatriate author James Joyce was emblematic.

With roughly twenty architectural commissions to his credit, a raft of analytic writing in the field along with speculative texts on other areas of culture, politics, and religion, and a body of drawings and paintings created over more than a quarter century, Smith arrived on center stage with a complex and all-embracing sense of artistic mission. If the sculptures he made in the twenty years following his first fully realized attempts in the early 1960s are the strange and various flowering of his large ambition, then these canvases, works on paper, theoretical meditations, and completed as well as uncompleted architectural projects are their root and branch.

As the first global but in some aspects necessarily synoptic account of Smith's manifold but always interconnected endeavors, this exhibition aims above all to whet the appetite of the general public, which has, until now, been infrequently exposed to his work and largely unaware of its formal and material variety. Thus, while this exhibition constitutes Smith's only real retrospective to date, it in no way pretends to be the final word on his achievement. Rather, it is hoped that it will be looked back on as a decisive step toward finally securing Smith's rightful place among the seminal artists of his era, thereby helping to assure that he will be the subject of continued reexamination and research befitting someone of his originality and influence.

Accurately presenting and assessing the many dimensions of Smith's achievement has required the involvement of many people. First among them is John Keenen, whose independent, in-depth study of Smith's architecture prompted the idea of inviting him to select the models, drawings, and other archival materials which compose the related component of the exhibition, as well as to contribute an essay to the catalogue. Working closely with Terence Riley, Chief Curator in the Department of Architecture and Design at The Museum of Modern Art, Mr. Keenen has, from the outset, been an essential collaborator. I thank them both. Secondly, I would like to express my appreciation for the ground-breaking work done by Joan Pachner, whose doctoral thesis on Smith is *the* indispensable reference text on this artist. Her essays for this catalogue only hint at the wealth of information she has gathered. Acting as a consultant, she has unselfishly put her expertise at the service of the exhibition from its very beginning.

In many respects, the heaviest daily load has fallen on the shoulders of Leslie Jones, Curatorial Assistant in the Department of Painting and Sculpture, who has participated in virtually all negotiations pertaining to the preparation of this retrospective, dug deep for art-historical facts, coordinated extraordinarily complex arrangements for bringing large-scale sculptures to the Museum, as well as for placing others around the city, and in all ways has kept this effort on track through its long gestation. The support offered her by Delphine Dannaud has made the difference between an almost impossible and an absolutely impossible fulfillment of the task at hand. Meanwhile, my full-time departmental assistant, Carina Evangelista, has, in excess of her official responsibilities, pitched in in emergencies and otherwise kept things in forward motion on many other fronts. Intern Michelle Yun has contributed additional support in countless ways. Amazingly, none have lost their sense of humor in the process. All have done an exceptional job.

It is unusual for museum exhibitions to include a major non-museum component, but in light of Smith's record of showing his work in public spaces, and given the sheer size of the works in question and the restrictions set by the available gallery and garden space on Fifty-Third Street, an alliance was formed with the Public Art Fund to facilitate the location of a handful of major works at sites in Manhattan. My primary partner in this campaign to place monumental Smiths around midtown has been the unusually able and engaging Director of the Public Art Fund, Tom Eccles. His goodwill and ingenuity, complemented by that of his associate, Gregor Clark, are the principal reasons we have succeeded to the extent that we have. In the realm of contemporary art, big old institutions and smaller new ones have many common interests; this collaboration has provided proof that, as a practical matter, both benefit from making common cause.

Elsewhere within the Museum credit for this exhibition is widely shared. Glenn D. Lowry, Director, has been a strong supporter all the way. For her tactful in-house monitoring and ready inter-museum outreach on behalf of a difficult exhibition at the end of an already over-eventful season, I want to note my special gratitude to Jennifer Russell, Deputy Director for Exhibitions and Collections Support. Michael Margitich, Deputy Director for Development, has gone to bat for this undertaking with his customary "can-do" attitude, and his encouraging respect for demanding art. Monika Dillon, Director of Special Gifts, has likewise been instrumental in opening up contacts with possible sponsors. I also want to thank Linda Thomas, Coordinator of Exhibitions, and Maria DeMarco, Associate Coordinator, who have devoted themselves tirelessly to the project, Rosette Bakish, Executive Secretary, Diane Farynyk, Registrar, Ramona Bronkar Bannayan, Associate Registrar, and Jana

Joyce, Assistant Registrar, who has prepared crucial logistical aspects of the exhibition. In the Conservation Department, I am indebted to James Coddington, Chief Conservator, as well as to Anny Aviram, Patricia Houlihan, Lynda Zycherman, Erika Mosier, Victoria Bunting, and Roger Griffith.

Independent conservator Steve Tatti, of S.A.T., Inc., and rigger, Joe Mariano, of Mariano Brothers, Inc., have been responsible for the restoration and transportation of the monumental sculptures in this retrospective. They deserve special thanks. Industrial Welding Company of Newark, New Jersey, and Lippincott, Inc., of North Haven, Connecticut, were the fabricators for the large-scale works exhibited. And on behalf of the Tony Smith Estate, sincere thanks is extended to Don and Alfred Lippincott. The Modern Art Foundry of Astoria, New York, cast the small-scale bronzes.

On the legal side, Stephen Clark, Acting General Counsel, and Nancy Adelson, Assistant General Counsel, have given us the benefit of their expertise. Patterson Sims, Deputy Director for Education and Research Support, and Josiana Bianchi, Assistant Educator/Public Programs Coordinator, have organized the panels and helped prepare the brochure. Elizabeth Addison, Deputy Director for Marketing and Communications, Mary Lou Strahlendorff, Director of Communications, Kim Mitchell, Press Representative, and Elisa Behnk, Marketing Manager, coordinated the publicity. Jo Pike, Director of Visitor Services, and Melanie Monios, Assistant Director, gave indispensable advice on public-access issues in relation to the exhibition. Ethel Shein, Director, Special Programming and Events, organized the opening with her customary skill and style.

Once again, the Publications Department, under Michael Maegraith, Publisher, and Harriet Bee, Managing Editor, has done its utmost to accommodate curatorial needs and curatorial schedules as the occasion demanded. Emily Waters has done an excellent job of designing under difficult time constraints, and Joanne Greenspun has matched her by editing while waiting for one or another shoe to drop. A particular debt is owed to Marc Sapir, who handled the production of this catalogue—like two others we worked on together last year—from its schematic conception to its on-press correction, and did so with unflagging attention to detail and a keen aesthetic eye. In Photographic Services and Permissions, its Director Mikki Carpenter has contributed her efforts, supported by Kate Keller, Erik Landsberg, Thomas Griesel, John Wronn, and Jeffrey Ryan. The bulk of new photography was provided by Tom Powel, who was prepared to go anywhere and work any hours to complete the job.

In the planning of the layout of the exhibition, Jerome Neuner, Director of Exhibition Design and Production, has been of invaluable service, aided by Mark Steigelman and Mari Shinagawa. Pete Omlor, Manager, Art Handling and Preparation, has coordinated the crews that installed it, aided by Chris Engel, Assistant Manager. I would like to extend special gratitude to preparators Gilbert Robinson, Arthur Simms, and John Walako. Peter Geraci served as the master electrician for the lighting, and, as is his habit, he has responded to the challenge with a true craftsman's touch. Vincent Magorrian, Director of Operations, was of indispensable assistance with the reinstallation of the garden.

In my department, I would like to acknowledge the steadfast backing of the Chief Curator of Painting and Sculpture, Kirk Varnedoe, who has given over the entire Abby Aldrich Rockefeller Sculpture Garden to the display of Smith's work as a testament to his belief in the artist. Thanks also go to Margit Rowell, Chief Curator of the Department of Drawings, and Kathleen Curry, Curatorial Assistant, for lending two important works on paper recently acquired by them. I would like to single out Kynaston McShine, Senior Curator, who championed Smith when he was a curator at the Jewish Museum in the mid-1960s, and continued to exhibit his work after moving to The Museum of Modern Art at the end of the decade. This advocacy is just one example of my colleague's foresight.

For her contribution to every aspect of the retrospective—from basic research to deft diplomatic interventions—Sarah Auld of the Tony Smith Estate merits the highest marks. His archives could not have been entrusted to a more conscientious or understanding guardian. As the gallery representative of the Tony Smith Estate, Paula Cooper has likewise been generous with her time and resources, as has Natasha Sigmund, Registrar. Without the assistance of Paula Cooper and her gallery this exhibition could not have been realized in its final scope. Matthew Marks and Jeffrey Peabody of the Matthew Marks Gallery have also kindly shared their resources related to Tony Smith's drawings.

Of course, no exhibition of this kind is possible without the generosity of the lenders themselves, both private collectors and institutions. They are listed in the back of the catalogue, but I would like to thank them all for their shared commitment to Smith's work and to this presentation of it. Lenders are, as my curatorial colleague Carolyn Lanchner once said, the real "bottom line" of exhibitions.

It is both as lenders and absolutely steadfast supporters of this Museum and of the artist that I wish to thank Agnes Gund and Daniel Shapiro. Without their sponsorship, this exhibition would not have been possible. Without their generosity over many years, we would not have the wealth of works by the artist that compose so important a part of the Museum's collection. My warmest thanks to them both.

Finally, I wish to say how honored I have been that the artist's wife, Jane Smith, and his daughters, Kiki and Seton Smith, have been willing to allow this exhibition to go forward. They have granted me and the others involved unrestricted access to the work and to private papers in their possession and have in every way made certain that we enjoyed the curatorial freedom such an enterprise necessitates. That Jane Smith has welcomed our intrusions with such charm and style has made the experience of working on the project a personal pleasure as well as an intellectual and aesthetic one. I hope the results give pleasure in return.

ROBERT STORR

OPPOSITE: Tony Smith in 1970. Photograph by Hans Namuth

A Man of Parts · ROBERT STORR

GEOMETRY HAS ITS USES. This we learn in school. In utilitarian or materialist societies such as ours, practicality is the ultimate argument for knowledge. The things we are taught are "good for us," are "good" inasmuch as they can be put to work, and so we are put to work mastering them.

That geometry also has its beauties may dawn on lucky and intuitive students as they calculate stacks of numbers, unscramble equations, or scrutinize the planes, angles, and curves of fundamental two- and three-dimensional shapes, or multifaceted polyhedra. Mathematical elegance is a function of procedural accuracy and economy. These criteria obtain both conceptually and perceptually. To puzzle-solving minds, arithmetic problems, mazes, and logical riddles of every kind are beautiful insofar as their complications hinge upon the clever application or elaboration of basic principles. Confusions and digressions dilute intellectual pleasure. In the realm of pure thought, wasted effort is ugly. To those more inclined to formal speculation, the beauty of geometry is at once abstract and visceral, a question of the manifest rightness of proportions, the relative force of space-generating or space-containing parameters, and the continuity of constructs undergoing hypothetical mutations. The mental picture or the linear diagram that transfixes the mathematician may refer to platonic absolutes, but precise manipulations of those images can enrapture the senses.

Geometry has its moods, too. This fact is implicit in the strict satisfactions it promises. In any domain where the whole of consciousness is engaged, unexpected or uncompromising phenomena jolt the psyche. The history of modern art in the twentieth century largely consists of calculated shocks administered to the artistic conventions of the past, those conventions having been predicated on the symmetry and stability of classical geometry. Cubism broke this mold at the very end of the first decade of this century. In the years that immediately followed, Constructivism, Suprematism, De Stijl, the Bauhaus, and a host of other movements and schools picked up the pieces Cubism had scattered and attempted to reconfigure them. But where Renaissance perspective and canonical measurements disciplined sensation in the name of divine or scientific order, these Cubist and post-Cubist innovations left the relative claims of rational aesthetic systems up for grabs.

The fundamental novelty and superficial eccentricities of the solutions proposed could be profoundly disturbing. Furthermore, geometric designs unadorned by recognizably figurative elements looked cold and inhuman to much of the general public—although mathematics itself is an entirely human invention—while the spatial dynamics they described struck many as arbitrary or chaotic despite the new states of balance those images frequently diagrammed. In sum, modern geometric abstraction challenged the basic assumptions people had about art and "reality," forcing them to reconsider the classic opposition between the ideal and the natural, inorganic and organic form, mind and body.

The problems posed by these dichotomies and their possible supersession have bedeviled artists and thinkers as unrelentingly as they did the layman. The emotional resonance of the logical answers they have offered testifies to the acknowledged or subliminal psychological stake people have in such "purely" intellectual or aesthetic matters. Thus a black square seen against a neutral ground may seem ominous to us, while another quite similar one instills calm because the "content" of these two versions of the same paradigmatic form is never just a matter of simple "squareness." Basic volumes may likewise be menacing or reassuring. A squat black cube in an open space can magnetize attention like a malevolent intruder; a human-sized black cube in the same space can have an anchoring presence. By themselves, gross discrepancies in scale do not explain these differences; slight adjustments might turn the small cube into a comic stumbling block and the large one into an overbearing monolith. Nor are they necessarily explained by differences in the metaphoric significance of the squares or cubes. Indeed, they may have none. Geometry's fundamental impact on the viewer touches deeper than symbolism, just as the harmonies and dissonances of language may strike a profoundly resonant chord even in those who fail to understand the words they hear, or are indifferent if not resistant to the ideas those words express.

Abstract geometric art exerts its power over the imagination in much the same fashion. Tapping into our innate pattern-making capacities, abstraction of this sort selectively rearranges the existing mental and sensory templates that characterize our way of relating the particulars we actually see to a larger entity we visually extrapolate from them, or, conversely, determine how we gradually discover the specifics in a whole we take in in an instant. On one level this synthetic process is driven by an instinctual need to organize perception so that we can reliably chart our course through the world. Experimental psychology has examined the mechanism of interpreting experience by these alternating inductive and deductive approaches. On another level, this synthesizing

impulse responds to a philosophical or spiritual conviction that the world's underlying structure will be made plain to us if only we strip away the inessentials that hide it from view.

The moodiness of modern geometric art derives from these chain-linked expectations and their incomplete or unanticipated fulfillment. A cube or a square may not represent anything other than itself but, as an increment in a larger totality, it affirms the possibility of holistic clarity. To the degree that the exact articulation of that totality remains ambiguous, the square, cube, or whatever module the artist has chosen to work with casts a shadow of doubt on the certainties for which it ostensibly stands. Ambiguity breeds ambivalence, and ambivalence, in turn, triggers anxiety. Fragments of potentially infinite armatures—like jagged shapes on the horizon—simultaneously invite and impede access to the sublime.

Tony Smith's lifelong quest was to seize upon the defining framework of such "wholeness" and represent it in concrete terms. Rather than admit a categorical separation of natural and artificial forms, he sought a generative connection between them. By itself textbook geometry seemed lifeless to him; in time, so, too, did most varieties of geometric stylization in modern art. Mathematics, nevertheless, remained the key to unlocking the mysteries of dynamic form, models for which Smith found in the formation of crystals and in the growth of elemental organic matter. On several occasions he noted his sympathy for Ananda K. Coomaraswamy's dictum, "Art imitates nature in the ways she works."[1] Smith shunned overt figuration but his regular and apparently inert solids followed this credo in their implicit anthropomorphism, while his irregular shapes seemed to be internally oriented by some vital impulse.

Like the modernist pioneers Vasily Kandinsky and Piet Mondrian, among others, Smith approached abstraction as a spiritual exercise. "Design," he wrote in his rambling meditation "The Pattern of Organic Life in America," "has the quality of freeing the particular. Of releasing it from its limitations as specific and giving a universal aspect to it."[2] He went farther than most of his predecessors in correlating his aesthetic aims with explicitly religious ones.

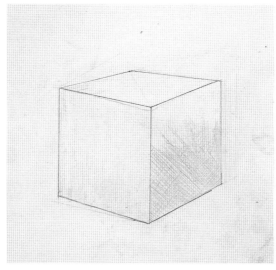

1. Untitled. c. 1961–64. Pencil on paper, 5½ x 5¾" (13.2 x 14.6 cm). Tony Smith Estate, New York

"Form follows function, function follows principle," reads one of his texts, illuminated by various emblems: a triangle or masonic pyramid, a "plus" sign or cross, a corkscrew spiral, and his own spiral cross. To this basic modernist doctrine he added, "I got the principle from God, I got the form from Christ, I got the function from the Spirit"[3] (see p. 33).

The faith expressed in this hybrid catechism is that of a man for whom unity of purpose and unity of being did not come easily. Smith's slow artistic maturation and the protean nature of his output attest to his inner struggle. They also indicate the vast scope of his ambition. "Certain ancient cultures such as China and Egypt produced a kind of intuition toward form which colored the entire society. I don't think that we in America have ever achieved that," he told art critic Phyllis Tuchman, plainly inferring that his mission was to address this failing.[4]

Smith's private vision was proud and expansive long before he had much to show for it. Until he reached his early forties, hesitations and course changes marked his unusual progress. First as a painter and architect, and only in the last phase of his life as a sculptor, Smith worked fitfully in each medium, but never abandoned his search for a common denominator linking one to the others and the ensemble of his experiments to an overarching theory that would engender the formal cohesion our culture lacked. Even after he achieved public recognition in the 1970s with monumental sculptures that ranged from arresting visual simplicity to unprecedented structural complexity, Smith continued to insist that his art was not a product of conscious calculation but was prompted instead by the enigmas and tumult of the unconscious. "All my sculpture is on the edge of dreams," he said.[5]

Smith thus echoed the preoccupations of his contemporaries and close friends, Jackson Pollock, Barnett Newman, Mark Rothko, and Clyfford Still. Among them, Smith was the late bloomer, coming into his own after Abstract Expressionism had peaked as a movement, and several of its leading lights, Pollock for one, had vanished from the scene. Alone in this group, Smith concentrated his efforts on systems-building, even as he explored various types of

spontaneous invention similar to those practiced by his "action" or "field" painter peers. By the time he had fully defined his own geometric language, he found himself surrounded by younger men—Carl Andre, Donald Judd, Sol LeWitt, Robert Morris—whose "minimal" objects superficially resembled Smith's but whose rigorous methods and closely reasoned motives could hardly have been more different from his.

Caught between two generations and two artistic camps, Smith thought like the members of the first but made art that was easily confused with that of the second. As a consequence, Smith has suffered the fate of most accomplished mavericks, which is a combination of being admired for the wrong reasons and becoming invisible against the background of "mainstream" art history. This predicament has been aggravated by the virtual impossibility of seeing his work in depth. Smith's overall production in all mediums was relatively small; compounding this is the fact that the houses he built and the monumental sculptures he was able to execute in permanent materials are geographically scattered and, for most of the latter as well as all of the former, fixed in place. For the rest, the majority of his paintings, drawings, maquettes, and models remain in his estate, in private hands, or, in the case of small editioned sculptures, have yet to be fabricated.

It is time, therefore, that attention be paid to Smith's actual distinction, and to the examples of his work which *can* be brought together and considered in all their intersecting aspects. Even then the composite image is perplexing. An improviser whose ideas came to him while doodling on scrap paper or tinkering with toylike blocks, Smith thought big but worked small. An ingenious and proficient jack-of-all-trades who sometimes built structures or had them built, he cared little for making things himself and avoided full professional status in any of the several fields in which he excelled. A soul in whom every emotional, cultural, political, and theological contradiction was deeply felt, he sought to encase his demons in immutable prisms or escape them by creative transcendence, and thereby achieve salvation. In sum, we are dealing with a *rara avis* in the already exotic bestiary of modern masters, a true polymath and a sincere, some-

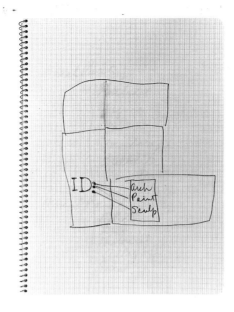

2. Page from a sketchbook (ID: Arch Paint Sculp). c. 1949. Pencil on paper, 10⅜ x 7⅞" (26.4 x 20 cm). Tony Smith Estate, New York

times profane, and decidedly American mystic. Smith did not "invent himself," as the currently popular expression goes. He was, instead, a man of many parts who, against the odds, tried to put himself together piece by idiosyncratic piece. His successes explain the exaltation of his work; the yearning and frustration that drove him account for its aggressiveness, black humor, and pathos.

. . . .

"To begin, the most important fact of my life was that I had T.B. at a very early age," reads a note for a lecture Smith prepared on his own work.[6] The lasting significance of this childhood threat was less a matter of the illness itself than the unusual circumstances of his treatment. Born into a prosperous Irish Catholic family of five younger boys and one older girl, Smith was diagnosed with consumption when he was about four. To protect the others from contagion, his father erected a small prefabricated house in the backyard of their South Orange, New Jersey, home, where the boy lived for several years. The setting and daily routine were spartan; except for the company of a full-time nurse who cared for him, Smith ate alone and played alone. The only other "presence" in the temporary cottage—which was hung with fiberglass curtains to prevent irritation to his lungs caused by ordinary drapery—was a small black stove. The year before he took sick, Smith traveled with his family to San Francisco to see the Panama-Pacific International Exposition, and on the way back they stopped at Mesa Verde National Park, where he saw the stacked dwellings of the Pueblo Indians. Among his pastimes during his long isolation was building "pueblos" out of medicine boxes and covering them with papier-mâché "adobe."

When asked about his artistic motivations, Smith returned again and again to this story, emphasizing two specific details. The first was a precocious interest in modular architecture represented by these building-block assemblages. The second was the aura of the little black stove, of which he said, "If one spends a long time in a room with only one object, that object becomes a little god."[7] One might expect this sort of observation from a prisoner explaining psychological survival in solitary confinement; it is not an insight one associates

THE HENLEY COLLEGE LIBRARY

with a solidly middle-class boy. Hearing it abruptly concentrates the idyllic picture one has of surburban life in Booth Tarkington's America around an image of potent darkness.

That was plainly Smith's intent, when, at the peak of his art-world fame, he described the stove in these terms to an interviewer. As a student of myth and archetype, of J. G. Frazer's *Golden Bough* and C. G. Jung's psychoanalytic theories, Smith appreciated the power of symbols. What other fantastic attachments he developed to comfort himself—or what other games he played—he did not say, pointing strongly to the conclusion that the significance of these two aspects of his childhood were more retrospective than predictive. (After all, Smith was only three when he went to Mesa Verde and could only have had faint recollection of what he saw.) This does little to diminish their importance, however, since the essential reality is that from the dawn of consciousness Smith lived an uncommonly self-contained imaginative life, of which the psychological referents were the distinct, animistic forms onto which he could project his emotions. The actual touchstones were objects with which he could playfully improve upon and expand his austere environment. In the penumbra that envelops Smith's mature infatuation with urban wastelands, highways, and *tabula rasa* city planning lurks the specter of a small child fixated upon a homemade model in front of a potbellied stove inside a compact frame box. Smith's far-reaching and in many ways compensatory vision as an architect and artist may not have originated in that situation, but unquestionably his work drew substance from looking back on it.

Although he was occasionally permitted to accompany the family on outings, and periodically attended the local elementary school, Smith was an adolescent before he fully emerged from this quarantine. As far as formal education was concerned, private tutoring had filled the gaps until then. For high school—1926–30—he commuted from New Jersey to New York City, where he attended the Jesuit-run St. Francis Xavier Academy. His graduation diploma was the highest degree he would ever receive.

The next six years were marked by a series of false starts. Brief stints at Fordham University in the Bronx and Georgetown University in Washington, D.C., both Catholic institutions, were followed by a retreat to South Orange, and his opening a second-hand bookstore in nearby Newark. This enterprise lasted about a year. In this context, and with the support of friends he had met in New York, such as the poet and collagist Ann Ryan, who gave him copies of *The Dial*,

Smith cultivated his taste for modernist literature. (Almost immediately he was attracted to T.S. Eliot, Ezra Pound, and especially James Joyce, whose work he could quote at length and from which he much later in life gleaned the titles of two important sculptures, *Gracehoper* [1962] and *The Keys to. Given!* [1965].) During this period Smith first grew a beard, became something of a clotheshorse, and began to demonstrate the gifts of conversation and social charm for which he would thereafter be well known.

The onset of the Depression brought this dandy-to-be up short. Although never truly wealthy, neither, in the past, had Smith ever had to worry about money. With his father suddenly facing serious financial difficulties, he was summoned home to learn the family business. Founded by the artist's grandfather, who had perfected the standard fire hydrant that bore his name, A. P. Smith Manufacturing Company specialized in toolmaking. There, for a two-year stretch (1934–36), Smith worked in the shop learning use of the lathe, the drill press, and other basic industrial skills. At night, meanwhile, he began taking courses at the Art Students League in New York, where he studied anatomy with George Bridgeman, painting with Vaclav Vytlacil, and drawing with refugee German caricaturist George Grosz.

Smith's divided schedule mirrored a fundamental imaginative duality. On the one hand, his night-school interests drew him toward the art world. Vytlacil and Grosz were cosmopolitan figures in what was still a largely provincial American scene, and as Smith gravitated to them, their breadth of visual culture was made available to him. Meanwhile, trips to The Museum of Modern Art, where Smith saw Alfred Barr's 1936 seminal exhibition *Cubism and Abstract Art*, opened up a perspective on contemporary visual art as broad as the view of literary modernism he had already developed. On the other hand, his "day job" quite literally taught Smith the nuts and bolts of useful design. A more than work-a-day interest in new technologies and changes in the environment they were giving the impetus to had been stirred by his visit to The Museum of Modern Art's paradigm-setting 1932 exhibition of modern "International Style" architecture, as well as by his awareness of the Museum's 1934 *Machine Art* exhibition. Smith's casual reading broadened his scope of possibilities in this area. An article in the January 1938 issue of *Architectural Forum* introduced him to Frank Lloyd Wright's architectural ideas, just as, in 1947, another article, this time in *National Geographic*, alerted him to the tetrahedral kites, towers, and gliders of Alexander Graham Bell that were to inspire the structural innovations of his sculptures.

Smith's father, practically minded but by no means a Philistine, adamantly opposed his son's becoming an artist, even as Smith's own inclinations also tore him between two competing courses of action. Hopeful of resolving this tension, Smith, in 1937, applied to and was accepted by the New Bauhaus, established in Chicago under the stewardship of László Moholy-Nagy and other exiled members of the original and recently disbanded German art and design academy. Prior to its suppression by the Nazis, the Weimar-Dessau-Berlin Bauhaus had represented the most advanced educational attempt at breaking down the old aesthetic hierarchies and specializations by training its students in everything from painting to weaving, furniture design to abstract photography. This ideal of the "all-purpose" artist nicely coincided with the notion of the knowledgeable generalist that had been a part of Smith's Catholic upbringing. In a taped conversation for the Archives of American Art, he recalled, "The church always encouraged the idea of the Renaissance man, you might say, the idealist who was a humanist to some extent, but who also had a lot of tools."[8] This fortuitous correlation between old-style humanist and newly minted avant-gardist ideologically removed the barrier between being the "practical" man his father intended, and the "dreamer" he himself was prone to being.

Smith's actual experience in this transplanted pedagogical Utopia was brief and, for the most part, disappointing. Overall the teaching staff was quite remarkable, including such notables as the designer György Kepes and the sculptor Alexander Archipenko, along with less-well-known figures like Hin Bredendieck, who taught a metal workshop that Smith remembered with special enthusiasm. Moreover, several of his fellow students were to become close friends and collaborators, in particular, Gerald Kamrowski, Fritz Bultman, and Theodore van Fossen, who was later to be Smith's partner in an architectural firm. But if some of the individual courses in which Smith enrolled met his needs, the program as a whole fell far short of his expectations due to Moholy-Nagy's modifications of the original Bauhaus balance between the "fine" and the "applied" arts.

Although Moholy-Nagy was a painter himself—his five *Telephone Pictures* of 1922 were the first instance on record of an artist ordering a work of art to be made to his specifications over the phone in a spirit similar to the one that would lead Smith to make a practice of this at the beginning of his sculpture career—by the time he reached Chicago the Hungarian-born artist was largely preoccupied with "scientific" design, and considered painting, drawing, sculpture, and related forms of expression something best pursued by students on their own. The rift caused by this change in emphasis soon triggered protests in which Smith played a prominent part. It was his first walk-on in art history, since the student agitation indirectly culminated in the definitive closing of the New Bauhaus less than a year after its Chicago opening.

The New Bauhaus sojourn was Smith's last attempt to prepare his future through the academy. Thrown back on his own resources, he went West, where he built a "modernist" chicken coop for a hard-hit Colorado farmer who was so taken with the result that he reportedly moved his family out of their house and into Smith's new structure. In completing this project, Joan Pachner has written, Smith was simply following Frank Lloyd Wright's call to "go into the field" and to "regard it as just as desireable to build a chicken house as to build a gothic cathedral."[9]

Although inspired by his reading of Wright's *Autobiography* to think in broad but unconventional terms, Smith had few prospects of his own and returned home to South Orange and the family toolworks in a deep funk. Despite subsequent forays into the wider world, this homing reflex was to exert an irresistible pull on him throughout his life. Later on he readily acknowledged the twin reference points that drew him back. "There's no question," he said, "but that there's a direct connection between the factory, my little house, and my approach to sculpture."[10] Sculpture, however, was the last of the three basic disciplines he "professionally" practiced. Oddly enough, the chronology of his artistic maturation is inscribed in the abbreviation of his own name. "My initials are A.P.S.," he wrote in 1966, "I used to kid about their meaning Architecture, Painting and Sculpture. But I wasn't kidding too much; it really felt that way."[11] Like the little black stove, this alphabetical correlation became a talisman for Smith. Meanwhile, architecture—symbolized by the A of Anthony—was the first creative field in which he found his footing.

. . . .

By his own account, Smith's situation after the breakup of the New Bauhaus was bleak. "I came home and I didn't really know what to do because I didn't have a job or anything. My father didn't really have any money. I wasn't going to school. All of those things seem to have exhausted the alternatives so I went into a catatonic fit or something. I just went into a black out in which I didn't talk or anything."[12]

He was rescued from this demoralized state by a photographer friend, Laurence Cuneo, who arranged for him to visit Frank Lloyd Wright's Suntop Houses project then under construction in Ardmore, Pennsylvania, near Philadelphia. For the following two years—1938–39—Smith was progressively drawn into Wright's orbit. Soon after his first trip to Ardmore, Smith was engaged as a carpenter's assistant and bricklayer, adding to the skills he had already learned from his apprenticeship at A. P. Smith Manufacturing. In short order his intellectual abilities were also called upon, and he was given the job of "clerk of the works," calculating the costs of the Usonian homes Wright had conceived in response to a commission offered him by a cooperative housing group just north of New York City. Smith's training as a mechanical draftsman at his family's factory also came in handy when he eventually made the move to Taliesen, Wright's Wisconsin enclave, where, in a virtually all-male society, he schooled his disciples in his approach to architecture.

Smith promptly came to understand that from a strictly architectural perspective Wright's theories were no contest for the more consistently developed ideas of the Bauhaus and corresponding tendencies of "International Style" modernism. The great originality of Wright's work synthesized eclectic influences—predominantly Asian and indigenous American—with spatial intuitions and a sensitivity to the natural site that were not easily codified in the manner of the European avant-gardes. What captivated Smith was Wright's person and his visionary sense of what a specifically American art form could be.

If Pound, Eliot, and Joyce had, to this point, been Smith's literary mentors, it is by way of Wright's example that his own writing seems to have turned to the Whitmanesque sweep and exhortation that runs throughout the otherwise ruminative and sometimes pedantic pages of "The Pattern of Organic Life in America," the omnibus manifesto Smith began to compose during the early 1940s. Even the hand-lettered title page of Smith's manuscript mimics the typeface chosen by Wright in the first edition of his book, most notably in the capitalized word "GENERATION," which Wright uses in its genealogical sense, but to which Smith lent a more metaphysical air. While the very notion of an "organic" architecture derives from Wright, Smith also took from him the hexagonal module that was to be the basis for several of his own buildings and, much later, the conceptual key to his fundamental reconfiguration of "cubist" sculpture.

Beyond this, Smith had, in effect, elected Wright to play the part of aesthetic father, and Wright, accustomed to the devotion of his acolytes and capable of reciprocating it on his own terms, accepted the responsibility. Smith's recollection of their brief but influential association reached an emotional pitch exceptional even for him. In answer to Paul Cummings's queries about the impression Wright had made on him, Smith responded: "Oh, I was crazy about him. I suppose I thought of him a little bit the way he thought of himself—as a sort of a god, as someone very, very superior and idealistic and you know I definitely put him on a pedestal and I definitely felt that he was really capable of creating a kind of American culture that hadn't yet existed . . . I felt a relatedness to Mr. Wright, a kind of deep emotional thing that had to do with the fact that I was American."[13]

Besides his charisma, Wright had an impact on Smith that compensated for the latter's estrangement from his own family. "I give you a sort of analogy that is the best I can do and that is people often refer to the special kind of relationship that they have to their grandparents as opposed to their parents, that they may not get along with their parents very well while they'll get along with their grandparents very well and I think it was something like that."[14]

In the Oedipal dynamic in which Wright had come to play so central a role, Smith thus transferred his filial loyalty to a man who represented for him the opposite of the businesslike pragmatism he had been raised to think of as the proper masculine attitude. "I would never think of Mr. Wright as a professional man," he said, referring indirectly to his father, who was certainly "professional," while ratifying his own non- or even anti-professional status.[15] The psychological appeal of Wright's position exceeded personal need, however, going to the crux of Smith's conflicted loyalties to "rational" modernism and American "romanticism."

It wasn't so much that I was that enthralled by his architectural ideas because . . . I was more interested in European architecture before I came in contact with Wright . . . but I did relate the prairie houses and things like that to the suburban world that I was used to . . . [The] big difference between Wright and anyone else I'd ever known . . . has to do with feelings. . . . I think he sort of suggested if nothing else that ideas like this are natural ideas; . . . It's very, very different from say the way Corbusier would talk or van der Rohe or anybody like that because they would be very dogmatic . . . I think more than anything . . . [Wright] just helped me integrate an awful lot that with Mies, or Le Corbusier, or Gropius I would have thought of as some kind of conscious and rational point of view . . . It was more like being pulled together.[16]

The split nevertheless continued to manifest itself in his fledgling architectural efforts. Teaming up with Theodore van Fossen, who invited him to Columbus, Ohio, "on spec," thereby serving as catalyst in much the way Laurence Cuneo had previously done, Smith built his first private house nearby in 1940. Like the next six houses he designed, it was patterned on Wright's prototypes. "The first seven houses that I did were very, very influenced by Wright and that wasn't due to lack of imagination; it was due to the fact that . . . I went to Jesuit Schools and in the Jesuit system, one learns to do things as they've been done . . . until you can master them."[17] Smith's 1944 design for the Lawrence L. Brotherton House is the most dramatically Wrightian of all (pp. 51–52). Based on a hexagonal grid with the kitchen as its axis, the structure branches out in two main wings with modified "prairie"-style eaves and airways.

Although Smith drew up detailed plans, his practical approach to construction foreshadowed that of his improvisatory attitude toward sculpture. In a period when codes were vague and their enforcement lax, Smith would simply round up available carpenters—often veterans of Wright's projects—and solved problems as he went along without much regard for standard procedure. Smith never identified himself as an architect and never officially qualified as one. Instead he called himself a "designer"; in the event, he was also a "builder."

Gradually Smith's reliance on Wright began to wane, and his initial allegiance to the "International Style" reasserted itself. The formal complexity of the Fred Olsen Houses, like the reductive austerity of his work for Betty Parsons, reflects this in differing but equally pronounced ways. The two major exceptions among his later works are the country residence he designed for the painter Theodoros Stamos in 1951 and the church he was to have created around the same time to contain works commissioned from his friend Jackson Pollock. The Stamos House (pp. 62, 64) is an airy rectangle on stilts with a shallow pitched roof above and symmetrically angled trusses planked beneath the main room that give the front and back of the building a hexagonal facade. In essence it was a Miesian box framed by a Wright-inspired exoskeleton.

The unhappy story of the church began in the summer of 1950, when curator James Johnson Sweeney and a group of Catholic art patrons—the painter Alfonso Ossorio acted as go-between and project gadfly—approached Pollock with the idea of his creating a cycle of paintings for a "contemporary" church. In France, Henri Matisse was then completing his decorations for a chapel in Vence that was consecrated in 1951. No more religious than Matisse,

Pollock agreed in principle to the proposal on the condition that Smith, who was observant, devise the structure.

The church (p. 66, right)—one of two Smith conceived, though neither was built—was to have consisted of a dozen nested hexagonal units raised off the ground on upright supports, with a thirteenth satellite hexagon covering the baptistry and connected to the main edifice by a walkway. Smith started with the idea of constructing an ensemble of bays to contain the paintings that Pollock initially intended to contribute, but based on experiments that were filmed by Hans Namuth in 1951, Pollock eventually came around to the notion of adding a series of gestural paintings on glass that would be installed as a band of horizontal clerestory "stained-glass" windows along the north and south facades. Smith's solution to this complicated program dramatically rearranged the interior plan of the conventional sanctuary while retaining the traditional functional areas such a sanctuary required. It was in that respect typical of all his work: advanced in conception yet essentially classical in effect. Although the plan pleased Sweeney and his core of supporters, it failed to pass muster with the wider constituency it needed in order to be realized, and the whole endeavor was dropped in the fall of 1952.

Smith's second most ambitious project during these years was the set of houses he designed for Fred Olsen and his son (pp. 67–69). Alas, these commissions also proved a travail. On this occasion Smith devised an elaborate complex of interlocking enclosures, sweeping ramps, and porches that, in the larger of the two dwellings incorporated in the plan, harmonized the "International Style" around a pentagonal variation on his basic hexagonal architectural module. However, construction problems, the orientation of the building in relation to prevailing winds, and other difficulties plagued the houses from the outset, and unwanted concessions required of Smith subsequently compounded by unwelcome alterations by the owner distorted the architect's scheme for the senior Olsen's house, though the younger Olsen's house was spared any significant changes.

From the mid-1940s on, Smith's clientele reflected his ever greater involvement in the art world. Olsen, for example, was an on-the-scene collector of Abstract Expressionist art and the original owner of Pollock's *Blue Poles, Number 11* (1952), a painting Smith claimed to have had a hand in starting during a drunken session with his friend. As early as 1945 Smith had built a studio for his New Bauhaus classmate Fritz Bultman, and in 1948 his remodeling of the

loft of the painter and close friend of his, Buffie Johnson, was featured in an article in *Harper's Bazaar*. One of his last jobs was of a similar kind, converting a Connecticut barn into a studio for the artist and writer Cleve Gray.

His most sympathetic patron, and his most frequent, was the art dealer Betty Parsons, who asked him to conceive a live-in studio for her on Long Island (1960; p. 58), then commissioned an accompanying guesthouse (1962; p. 60), and finally called upon Smith to design her Manhattan gallery at 20 West 57th Street (1963), Smith's final realized architectural project. The Parsons Studio was a single thirty-foot-square room with an L-shaped wraparound that contained a kitchen, bath, storage area, and outdoor deck. Light and exposure to the elements were controlled by exterior panels that slid on tracks to partially or wholly cover the large studio windows. The guesthouse was a similarly simple, and similarly elegant, play of basic rectangles and spatial economies. With vertical board siding, like the main house, it was framed by a veranda and roof deck, access to which was provided by a raised, graphically zigzagging, staircase of the sort that appears in several of Smith's other architectural projects.

The Parsons Gallery space—in 1959 he had designed exhibition rooms for French and Company, where he installed the career-making show of his friend Barnett Newman that same year—was perhaps the archetypical New York example of what artist/critic Brian O'Doherty once and forever tagged the "White Cube," though, in fact, the central area, unlike that in the Parsons Studio, was not a perfect cube. The main gallery, flanked on all sides by three smaller ones plus an office and storage area, actually measured twenty-two by twenty-eight feet by approximately twelve feet high. Nor did the walls meet at hard right angles; with Newman's encouragement, Smith subtly rounded the corners to soften the overall interior form. Nevertheless, with its raw concrete floors, bleach-white interior, and serene ambience, the Parsons Gallery was the purest of pure environments and the most complete expression of Smith's enduring fascination with European modernism of the first quarter of the century.

Aside from his renovations, Smith completed comparatively few projects—fewer than twenty in all—but even after he gave up building out of frustration over the paucity of jobs and the unacceptable demands of clients—the experience with Olsen had particularly discouraged him—Smith continued to address basic architectural problems in theoretical terms. Feeding these meditations were a number of sources. Having been given Jay Hambidge's book *Dynamic Symmetry* by a cousin while Smith was still in his early teens, he relied heavily on Hambidge's theory of the Golden Section and the links it established between "ideal" geometry and the patterns of organic life represented by the spiraling of natural forms described by permutations of this basic Greek paradigm. D'Arcy Wentworth Thompson's seminal text, *On Growth and Form*, further developed the connection in his mind, though its direct influence on his work probably relates more to Smith's drawings and paintings than to his architecture. (In the mid-1940s Smith gave Pollock a copy of the book as part of their artistic dialogue.) Finally, there was Le Corbusier's system of proportions based on human scale that he proposed as a universal replacement for those based on the Golden Section. His recommendations were publicized in the late 1940s and early 1950s under the rubric "Modular," and they inspired Smith's own attempts to devise such a standard based on a meter rather than on Le Corbusier's 1.3-meter unit.

As late as 1966, Smith would tell curator Samuel Wagstaff, "Corbusier is by far the greatest artist of our time."[18] Along with clearly voiced admiration, a murmur of regret is detectable in the remark, and it is understandable given that by the time he spoke, Smith had definitively cast his lot with sculpture. The full measure of Smith's ambitions as an architect must reckon not only the houses he succeeded in building but also the utopian designs and philosophical discourses found in his archives. The same man who throughout his life would diagram spiritual states and cultural syntheses in superimposed circles, trinitarian triangles, and various other configurations was the visionary planner who, working in the early 1940s with his partner Theodore van Fossen and on his own in the 1950s, imagined structurally integrated cities and communities. In correspondence with his associate Hans Noe, he drew charts and worked through complex numerical calculations to demonstrate the merits of his alternative to Le Corbusier's system. And, as Joan Pachner has shown, a "spiral cross"—Smith's fusion of Hambidge's dynamism and the static icon of Christianity—as well as other forms of symbolism were an inherent part of many of his architectural conceptions.

There was an element of vainglory in Smith's thinking, but a great, if mostly impractical, nobility, as well. "I am trying to clarify the pattern of organic life in America," he wrote. "I think that there is such a pattern here and it only needs uncovering. The poets have seen it, Thoreau, Whitman, Wright; but no one else has much idea of it."[19] An "idea man" largely left to his own devices, Smith the architect attempted to block in the functional components of a totality he had glimpsed over the shoulders of the men he cited, but had yet to fully

apprehend for himself. (Like the writers of the 1920s through the 1940s who, having surveyed the newness and variety of their homeland while simultaneously absorbing and fending off the influence of European precedents, set their sights on creating the "Great American Novel," Smith, stricken with another strain of this endemic fever, sought to define the principles of an architecture that would earn the United States parity with foreign cultures ancient and modern.) It is doubtful that he would have succeeded even if he had had the advantage of better economic and broader social and political support. Even Wright, with his genius for self-promotion, had been stymied in his attempts to "remake" America. But the stalemate of his architectural career did not humble Smith; rather, it redirected his energies to mediums more conducive to his improvisatory turn of mind.

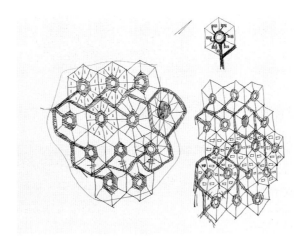

3. Untitled (Plan for Linear City). 1953–55. Ink on paper, 11 x 13 7⁄8"
 (27.9 x 35.2 cm). Private collection, New York

. . . .

To pick up the thread of Smith's artistic development in the aftermath of his retreat from architecture, it is necessary to double back to his first art-world forays. If building was his sometime vocation from 1940 until 1963, painting had been his intermittently indulged avocation from 1934 onward. Prior to this time Smith had had limited exposure to visual art of any but the most conservative kind. His family home was decorated in a manner consonant with the period tastes of their class; there were, he recalled, "a lot of Venetian paintings . . . It was one of those Victorian interiors where every inch of the wall space would be covered with paintings and we had bronzes too around the house."[20] As far as roughly contemporary art was concerned, his father was attracted to the socially conscious naturalism of John Sloan and the Ash Can school; his mother favored the more elegant "realism" of James McNeill Whistler and John Singer Sargent.

Smith's earliest drawings and paintings depart markedly from these precedents, but closely mirror those set by his teachers at the Art Students League. Of particular importance to him were Grosz, who steered him toward the city streets and taught him to simplify forms in a sharp graphic style, and Vytlacil, who showed him how to reduce shapes to their flattened contours and

orchestrate the interplay between foreground and background, or, as his mentor called it, "positive" and "negative" space. Smith's ingrained conservativism thus survived in the habit of earnest emulation that, in architecture, had paced his slow evolution away from Wright's example. Talking to Irving Sandler in the Cedar Bar as late as 1958, Smith once more cited his "Jesuit training" as the cause: "I was unlike Pollock," he said, "I always worked in someone else's style."[21]

Taken as a group, the apprentice pictures Smith made during his association with the Art Students League and for some years thereafter recapitulate the evolution of abstraction and index the prevailing tendencies of the moment when they were made. Untitled, of about 1934 (p. 96), efficiently deploys the techniques used by Pablo Picasso and Georges Braque in their Synthetic Cubist works; recognizable silhouettes—in Smith's case the detached handle of a coffeepot or a table knife traced onto the canvas and blocked in in solid pigment—and cropped geometric forms whose identity in some cases lies in the tone or textures they are given—for instance, the wood grain in the trapezoid at the lower edge of the picture—result in a quietly authoritative still life. Despite its subdued contrast of green, gray, and blue, Untitled (c. 1938; p. 98) looks to Henri Matisse in its reductive but essentially classical arrangement of forms, while Untitled (c. 1934–36; p. 97), with its wheeling biomorphs, nods in the direction of Jean Arp and Joan Miró.

In striking contrast to these more subdued but elegant essays, some of the earliest extant paintings and drawings by Smith (pp. 99, 100, top left, and 101) evidence the direct influence of the more severe Russian avant-garde artists of the teens and twenties—especially that of Kasimir Malevich, whose suprematist drawings Smith had copied in his sketchbooks—while others clearly derive from the closely allied graphic strategies of the Bauhaus. In hindsight, one can readily discern in these exercises Smith's penchant for asymmetrically balanced compositions. The notable exceptions to this are two untitled works (c. 1936 and 1933; p. 102). An Escher-like demonstration of reversible perspectives, the former anticipates the dramatic staircases in some of Smith's architec-

tural projects—those in the Parsons Guesthouse, for example—as well as similar optical effects in objects such as *The Keys to.Given!* (1965; p. 139, left) and *Equinox* (1968; p. 166). With its oval, nichelike inner framing and methodically stippled surface, the latter is a Picassoid icon to the cube.

That all of these works are derivative is the least important fact about them; with or without Smith's candor, for longer or shorter stretches of time art students nearly always "work in someone else's style." What distinguishes the paintings of this period as a whole is their reticence. None are large, many are positively diminutive. Space exists within their confines but they do not objectively occupy it. Paint is used sparingly—as it would be throughout Smith's career—and mark-making is generally subordinated to shape-making. In short, painting as a medium was barely exploited for its own sake, but rather served as a means of sorting through available stylistic options and articulating a few basic formal propositions that the artist would later return to and develop in wholly unexpected ways. Speaking to Lucy Lippard in 1971, Smith thus explained, "I think my interest in painting remains that of dealing with the interchange of figure and ground. I don't think of certain shapes. I am mainly involved with trying to make an equilibrium over the surface based on fairly close values. . . . I think that goes partly with my dislike of fragmentation, of busyness and disturbing overlays of speed and noise."[22] Despite experiments with jazzier accents or more impromptu inventions, Smith's best pictorial work was consistently in this considered, emblematic mode.

Smith's early drawings have the same general characteristics as his paintings. Until the 1950s most were physically modest and materially uncomplicated. While there are countless studies on envelopes, notepads, 8½-by-11-inch sheets of writing paper, and in standard format sketchbooks, virtually no large-scale drawings from this period survive, and it is doubtful that many were made. Through the mid-1940s variations on Cubist still lifes and figural compositions predominate, intermixed with on-the-spot descriptions of the urban American scene recorded in a manner half-Grosz, half-Stuart Davis, as well as with sundry

4. Untitled. 1953–55. Charcoal on paper, 20 sheets, 10' 7" x 16' 4" (322.6 x 498.5 cm) overall. Installed in the Smith home, South Orange, New Jersey, 1960

constructivist or surrealist-inspired abstractions.

Among these pages, however, one finds several varieties of images altogether different from those that typify his contemporaneous paintings (see pp. 78–79). The first consists of botanical or biological subjects, cross sections of the reproductive organs of flowers, for example—and, almost indistinguishable from them, those of humans—or the microscopic details of cell clusters. The second—often illustrating notes on his readings or his own philosophical ruminations—are pie charts or pictograms that schematically relate dialectical categories of thought or experience to one another within the framework of a coherent geometric whole. The third group of drawings are erotic vignettes—mostly women with hirsute bellies and gaping vaginas and, more rarely, male genitals or sexually aroused men. Occasionally these drawings turn grotesque, as Smith pursued his mystical desire to conflate opposites; in one series of sketches, a well-endowed Christ figure is rendered with full breasts while a voluptuous woman displays a large, soft phallus.

Given their vivid but often rudimentary draftsmanship, these three types of images could be treated as artistically incidental, like the alternately academic and obscene jottings of a febrile student. (A strenuous jumble of stylistic quotations, recycled symbolism, and painfully unguarded fantasy, Pollock's early sketchbooks have, by the same token, been written off as immature or hopelessly self-conscious doodles. Nevertheless, Pollock's notations and caprices—like Smith's contemporaneous, though more compartmentalized, ones—shed light not just on the artist's psyche, but on his artistic subordination and formal transformation of its essential and conflicting drives.) In truth, such diversions have as much—perhaps more—bearing on Smith's major work than the average examples of his straightforward studio work of the time, insofar as they manifest a metaphysical yearning, preoccupation with physical structure, and acute awareness of the body that would eventually come together in his sculpture. The plain scientific sketches disappeared from Smith's oeuvre early on, replaced by mathematical tables and equations, while the mandalas and pictograms grew less

frequent as Smith found ways of expressing his holistic ideas in purely abstract terms. The sexual caprices nevertheless recur with some regularity throughout his life, as if the corporeality that found its way into his mature work never fully sublimated or expressed the desire that originally infused it.

From the mid-1930s through the mid-1950s, Smith's active participation in the New York art world was an on-again, off-again affair. From 1934 to 1936, he regularly made the trip to the city from New Jersey to see friends and attend classes at the Art Students League; however, his Chicago stint and various involvements with Wright kept him away from the East Coast for much of the period between 1937 and 1940. His mother's illness brought him back to New Jersey in 1939, but he left again in 1940 for Ohio to start his architectural partnership with van Fossen only to be called home not long after by his father's sudden death. The year 1941 saw him widen his circle of acquaintances following his move to an apartment in Greenwich Village. At a gathering around this time at Fritz Bultman's studio, Smith recalls his first, fateful meetings with Jackson Pollock and Tennessee Williams, both of whom would become his close friends. Two years later in similar social circumstances, Smith met the actress and opera singer Jane Lawrence—née Brotherton—at a New Year's Eve party. Within days they were engaged, and after nine months they were married in California, where they had gone to pursue her career. Williams was their only witness at the wedding.

For the next two years the newlyweds lived in a storefront in Hollywood. Besides various money-making jobs—working for a plant nursery, assisting a Viennese furniture dealer, Paul Frankl—Smith designed a house for his father-in-law L. L. Brotherton and resumed writing "The Pattern of Organic Life in America," as well as devoting himself to other architectural speculations. Among the various people he encountered in the dispersed artistic milieu of Los Angeles, Smith formed a special bond with the avant-garde photographer Edmund Teske. Yet with all these comings and goings taken into account, Smith paid little concerted attention to his own art from 1938, when he left the New Bauhaus, until his return to New York in 1945.

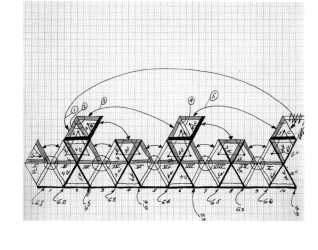

5. Untitled. c. 1960s. Ink on paper, 8½ x 11" (21.6 x 27.9 cm). Tony Smith Estate, New York

By then New York was on the verge of an aesthetic earthquake. The transformation of American art prompted by the war—which ended the Great Depression, eased the pressure to create a socially engaged art, and precipitated the temporary influx of exiled European avant-gardists—is a story that needs no retelling here. The significant fact is that Smith resettled in the city at just the moment when the pent-up energy and ideas of his own aesthetic generation were first making themselves widely known. In short order Smith found himself part of a complex artistic network. Friendships new and old rapidly intersected. In 1945 Buffie Johnson introduced him to Barnett Newman. Through Ann Ryan, with whom he had remained in touch since the early 1930s, Smith got to know Hans Hofmann, whom he saw more of in Provincetown, Massachusetts, while building a studio for Bultman there. By 1946 Smith had reacquainted himself with Pollock and, for the first time, encountered Still, Stamos, and Rothko, all of whom would become his intimates. In addition to these well-known artists, for a time Smith also saw a good deal of the Cubist sculptor Jacques Lipchitz, whom he met in the early 1940s in William Stanley Hayter's printmaking class and with whom he had in common an interest in heroic sculpture, though the Russian émigré's ballooning figurative bronzes of the postwar era could hardly have been less like the angular monuments Smith eventually created.

The basis of Smith's relation to his American counterparts was complicated and, to a degree, ambiguous, despite the strong mutual ties they established. Smith was valued for the breadth of his learning (the product of a passionate autodidacticism that had made him an expert in the mythopoetic and psychoanalytic lore that preoccupied many of the Abstract Expressionists), appreciated for his insight into and commitment to what his artist-friends were doing (although by no means well-off, Smith bought work from virtually all of them when prices were low but sales infrequent and so all the more meaningful morally and financially), and was always welcome as a boon companion (he drank as recklessly as any of the group, but drink primed his eloquence and triggered impromptu recitations from *Finnegans Wake* and other favorite texts).

After hours, an irresistibly engaging whiskey-priest of both "the new" and the primordial, Smith was, by day, part intellectual source and sounding board, and part confidant and fellow-traveler of the recently formed New York School as well as being its community architect and a collegial exhibition installer. However, Smith had no real standing as an artist in his own right, although people knew that he painted and drew. Loathe to vaunt his own talents, he was quick to defer to his peers. "I identify myself with three living artists: Barnett Newman, Mark Rothko, and Clyfford Still. I don't claim to be their equal, only to share the ideals they have in common and to attempt to emulate their nobility."[23]

Pollock's omission from this Pantheon is noteworthy. Unquestionably he loomed large in Smith's life from their shared binges—in Buffie Johnson's recollection, "There is a despair influenced by Tony Smith's when [Pollock] was drinking, but Tony's was much darker, just as he was more intellectual"[24]—to their ill-starred church collaboration. But despite his much-debated intervention in the early phase of the painting of *Blue Poles*, Smith was never tempted to emulate the oceanic flux of Pollock. Rather, he struggled to reconcile the two models represented by Newman's cleanly partitioned canvases, and Still's roughly fissured and seamed ones, with Rothko's condensed atmospheres of color occupying the middle ground. On the one hand, it was a choice between construction and gesture; on the other, between geometric consistency and organic eccentricity.

In 1950 Jane Smith left New York to take advantage of greater opportunities in Europe for her to sing opera. Three years later, Tony Smith followed, and the couple spent the best part of the next two years in Germany. This expatriate interlude took him out of the city at the height of the vogue for Abstract Expressionism but also spared him some of the stress of watching the breakup of the once cohesive enclave of artists who had brought it into being. Letters Smith received from Ad Reinhardt during his time abroad report on the tensions and temptations introduced by sudden fame and money—"a myth is as good as a pile" Reinhardt quipped—but to a certain extent Smith's reputation as a bona-fide member of his artistic generation suffered from being away at this critical juncture.[25] (Much the same thing happened to Louise Bourgeois, who was absent from the scene during this period. For Smith, as for Bourgeois, one of the side effects of having "missed the action" was the relative independence from their own generation and compensatory associations with younger artists whose reciprocal interest helped sustain them.)

On the positive side, the opportunities for travel created by Jane Smith's far-flung singing engagements afforded Tony Smith the chance to study at firsthand the great works of art and architecture, historical and modern, as well as more problematic monuments of the recent past. Thus Smith was able to tour Italy, Spain, and France as well as their temporary homeland, Germany. In the first two countries he concentrated on classical and Renaissance buildings and paintings; in France he passed through Marseilles, where Le Corbusier's "Habitation" apartment complex confirmed his faith in the architect's preeminence, and Antibes, where he saw Picasso in the flesh, "the latter being in a red shirt," Smith wrote back to a friend, "advertising, I suppose."[26]

In Germany, Smith visited Munich and rediscovered the work of Kandinsky in the spectator-dwarfing galleries of the city's Nazi-era art temple. He described the exhibition to Newman in these words: "I have often heard Hitler's Haus der Kunst called monstrous, etc. There is perhaps more than a little irony in what follows. To begin with: showing this 'degenerate art' there at all. Second it is probably the best hung show I have ever seen. . . . It is the room. It is enormous. Very long and the same height about as the width. The pictures are quite far apart and fairly high . . . The pictures have no intimate quality—but they do exist without fuss—classic, clear . . . As you may have guessed the thing as a whole was very like the church [design] I sent you."[27] What was left of Albert Speer's gargantuan stadium at Nuremberg, the city where the Smiths lived, made a similarly strong impression on him.[28] Tainted as they were by a chilling grandiosity, these remnants of empire reminded Smith of the perverse form of a novel version of the architectural sublime he had initially experienced in 1951 just outside New York City.

When I was teaching at Cooper Union in the first year or two of the fifties, someone told me how I could get on to the unfinished New Jersey Turnpike. I took three students and drove from somewhere in the Meadows to New Brunswick. It was a dark night and there were no lights or shoulder markers, lines, railings, or anything at all except the dark pavement moving through the landscape of the flats, rimmed by hills in the distance, but punctuated by stacks, towers, fumes, and colored lights. This drive was a revealing experience. The road and much of the landscape was artificial, and yet it couldn't be called a work of art. On the other hand, it did something for me that art had

never done. At first I didn't know what it was, but its effect was to liberate me from many of the views I had had about art. It seemed that there had been a reality there which had not had any expression in art.

The experience on the road was something mapped out but not socially recognized. I thought to myself, it ought to be clear that's the end of art. Most painting looks pretty pictorial after that. There is no way you can frame it, you just have to experience it. Later I discovered some abandoned airstrips in Europe—abandoned works, Surrealist landscapes, something that had nothing to do with any function, created worlds without tradition. Artificial landscape without cultural precedent began to dawn on me. This is a drill ground in Nuremberg, large enough to accommodate two million men. The entire field is enclosed with high embankments and towers. The concrete approach is three sixteen-inch steps, one above the other, stretching for a mile or so.[29]

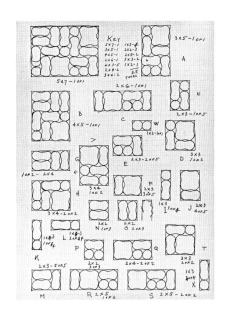

6. Untitled (study for *Louisenberg* paintings). 1953–55. Ink on paper, 11 1/4 x 8 1/4" (28.6 x 21 cm). Tony Smith Estate, New York

The impact of this encounter would have far-reaching ramifications for Smith, and for American art generally. But Smith was not yet ready to act upon what he had seen.

Lacking any chance to build while in Europe, Smith spent much of his enforced idleness planning ideal cities and designing imaginary structures, including a variation on the "glass houses" of Ludwig Mies van der Rohe and Philip Johnson that is notable for its deeply recessed windows and generally sculptural presence. The same day that Smith completed these sketches he also made four drawings of large bulbous forms, tightly packed against the framing edge of the page. The *Zabo* drawings, so-called after Zabomitte, a place just outside of Nuremberg, are the penultimate step in a protracted synthesis of surrealist biomorphism with constructivist rigor. The *Louisenberg* series—named after a geological site near Bayreuth—represents Smith's first complete resolution of that aesthetic dilemma.

All in all, the *Louisenberg* group consists of some twenty-five paintings, most of which were executed between 1953 and 1954, with the last and largest of them having been enlarged in 1968 from Smith's earlier and smaller version by two younger artists, Robert Swain and Robert Duran, who worked under his supervision. These pictures and others closely related to them (pp. 104, 105, 107–09), and the brushier oil (p. 106), as well as charcoal drawings on brown paper (see p. 82, left), are all based on a grid composed of circles, some of which are left as self-contained disks, others of which are fused together in groups of two, three, four, or more. The key variant is a peanut-shaped or, as critic Lucy Lippard saw it, a "testicular" lozenge.[30] The color schemes for these paintings are a mixture of muted primaries, pastels, and beige-browns against monochrome grounds. In some, circumscribing pencil lines are visible; in others, the forms are entirely painted in but vibrate optically as if they were finely contoured tissue-paper collages.

Matisse's late cutouts have as much to do with this effect as Jean Arp's crisply delineated amoebas, Sophie Taeuber-Arp's pattern work, and the Bauhaus aesthetic to which they both contributed. In Smith's canvases their biomorphism has been standardized and harnessed to the demands of what Clement Greenberg called "American-type" painting, in which formal mass, chromatic density, and the directionality of shapes are distributed across the surface of the picture in such a manner that, as the eye travels, the composition is constantly decentralized and realigned yet continuously in balance. Pollock had done this with arcing linear flourishes, Rothko with diffusing blocks of color, Newman with flat expanses of monochrome paint traversed by flickering "zips," and Still by lavalike crusts of pigments. Smith, however, was the first and only member of his circle to systematize the "allover" painting. Rather than think in terms of spontaneous invention, he laid out a template and worked his way around it. *Louisenberg #8* (1953–54; p. 114) thus contained all the formal permutations and pairings found in the other works in the series.

The principle operating in these paintings marked a breakthrough for Smith, but their general tone is an anomaly. One suspects that the cool, clean,

almost cheerful quality of the *Louisenberg*s might never have been conceived in New York. Smith was, in effect, ahead of himself. Designlike abstraction of this kind did not become a "mainstream" style until the early 1960s, when Smith's friend, Paul Feeley, began to make concentrically looping images that closely followed the *Louisenberg* example. The rhythmically gridded lozenges in Larry Poons's first color-field paintings offer a useful comparison with the *Louisenberg*s as well. In any event, upon returning to New York, Smith reverted to a more gestural type of painting even as he maintained the essential chain-linked outlines of the *Louisenberg* pictures. Thus, in 1956, he experimented with the first commercially available aerosol-spray paints,

7. Untitled (study for painting; detail). 1953–55. Ink on paper, overall 8¼ x 11³⁄₁₆" (21 x 28.4 cm). Tony Smith Estate, New York

and, like a precocious graffiti artist, used the soft bursts of pigment to make the basic disks and the loose motion of his hand to fuse them (p. 118, left). Around 1958 Smith did a technical about-face, turning to heavy oil impastos and dark, saturated color. The rolling earthiness of these canvases recalls Still, but their compactness and underlying orderliness are Smith's alone.

By 1960–61, Smith had abandoned the modular design characteristic of the *Louisenberg* paintings in favor of more improvisatory compositions in which dark, angular shapes break into and subdivide the flat, otherwise uninflected picture plane. Neither calligraphic in the manner of Franz Kline, nor pictographic in that of Robert Motherwell or Adolph Gottlieb, Smith's bold, black forms range from space-enfolding or space-partitioning devices to single-stroke monoliths of oil or water-based pigment. Canvases such as Untitled (c. 1961; p. 120, right) are characteristic of this mode, and have a dark, intensive presence that belies their relatively small, easel scale. It was at this point that Smith, in the words of Paul Feeley, could be said to have truly "begun in earnest to discover the austerity of his own nature."[31]

Drawing with India ink and brush, and dating the pages as a part of the image, Smith was able to push his ideas further and faster than with paint, filling whole sketchbooks in one session with a suite of rapidly phrased riffs on a few simple motifs. Among his most striking two-dimensional works, these sheets, seen in sequence, have a high-energy animation, as if we were watching a storyboard narration of pictorial metamorphosis.

The paintings Smith made after 1962 retain this stark graphic quality, but it was tempered and hardened by his contemporaneous shift to sculpture as a primary medium. The edges that quaver and slide in his ink drawings rigidify in the late canvases, and the sometimes complex nesting of shapes in the former is reduced in the latter to the stark juxtaposition of bars, blocks, and obliquely sliced rectangles or is consolidated into structural fragments resembling massive portals (pp. 122, 124–26). Thus these plain but insistent works unite Smith's architectural means of expression with his artistic ones. By this time, however, "architecture" had collapsed into monumental symbols of itself, as if living *spaces* had crystallized into markers for emotionally charged or meditative *places*. Enclosure in these paintings no longer means room to maneuver but has become instead a tectonic embrace, with the blank center of the painting held tight by a protective wall, channel, or embankment of black or red.

Stylistically, these paintings have much in common with "Hard Edge" abstraction of the early 1960s, exemplified by the work of Al Held, Myron Stout, and Ellsworth Kelly; the latter, like Smith, was a Parsons Gallery artist and one of whom Smith spoke with respect. Given their hieratic aura, however, Smith's late canvases still belong in the company of those by Newman, Rothko, and Still, although only one painting of this type—executed by assistants, like the last of the *Louisenberg*s—equals their work in reach and amplitude. With its deep cobalt-blue background and matte black framing lines and rectangles, Untitled (1962, 1980; p. 127) has the full bodily scale of the very best "Action painting" but owes that scale to its gate or doorlike armatures rather than to the movement of the hand. The close-valued combination of uniformly opaque tones seals off the depth that those tones seem at the same time to suggest.

In this painting, the grammar of visually interlocking and interchange-

able "positive" and "negative" spaces that Smith learned from Vytlacil becomes a spare poetry of fathomless crepuscular voids. Observing the huge canvas from the conventional gallery distance is like standing at the approach to, or entrance of, some mysterious precinct. But Smith keeps us at this remove. The enigmatic black "hole" in the nocturnal blue continuum does not yield to close inspection, yet neither does the sheer, brushed surface ever fully resolve itself into a purely physical entity or formal device. Instead, we are persistently mesmerized by nonobjective immanence disguised as painterly objecthood. Coming at the very end of his life, this unique work incorporates into painting all that Smith had learned about sculpture from the early 1960s onward. In the final analysis it might best be regarded as a kind of painted sculpture, for which the presence of the viewer is as necessary to the completion of the image, and his or her position as determining a factor in conscious and subconscious spatial experience, as it is to any of Smith's situational objects.

Untitled (1962, 1980) is an exception among Smith's late paintings, not only because of its size but also because of the consistent resolution of its facture. Generally speaking, the "hard edges" in Smith's work are never that hard. Neither are they soft, however. The uneven blur running along the sides of his taped or ruled forms is a slight seepage of dilute paint, which Smith did nothing to correct, since for the most part the untouched white of the primed canvas provided the pictorial ground. The "one-shot" dryness of these paintings is akin to that of some of Newman's early works or most austere later ones—neither artist placed a premium on painterliness for its own sake—but in Smith's canvases the bare-bones quality of the result reads like a denial of the materials or a deliberate unfinishedness, as if he had been holding back rather than merely saying the most he could with the least technical expenditure.

There would seem to be several reasons for this. Firstly, Smith adopted a self-effacing posture until well into his forties. Speaking of his early friendship with Pollock, Fritz Bultman remembered that "in those early years . . . [Smith's] ambition was very hidden."[32] As late as 1967, the issue of *Time* magazine that would make Smith famous describes him in his own terms as a "wallflower."[33]

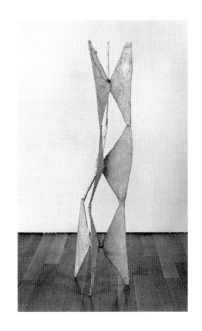

8. Untitled. n.d. Wire and canvas, 47 ½ x 12 ½ x 12" (120.7 x 31.7 x 30.5 cm). Tony Smith Estate, New York

The cover photograph, in which the artist strikes the pose of master builder at the base of his mammoth piece *Smoke*, contradicts this assessment, and Smith must have savored this triumphant role change. But he had waited a long time for it. "It is curious," art historian Sam Hunter wrote, "that although he was a valued professional colleague of the major artists, he felt inhibited and compelled to stand aside until they had finished stating their mature personalities."[34]

Secondly, Smith shunned the role of craftsman, preferring instead to think of himself as a designer, the only professional label he ever fully accepted. This was not because of any disrespect for craftsmen—far from it—nor was it an admission of any lack of skill on his part. There was, however, some basic reluctance to move from concept to realization. "It's not as if I couldn't do the stuff myself," he answered a journalist inquiring about how his sculptures got made. "After all, I once was a toolmaker's apprentice. But I'm old and I've done too damned much. I never was a physical type, and now it even hurts me to typewrite. If people didn't do these for me, they'd never get done."[35] This was said when the artist was fifty-four and progressive illness had begun to sap his strength, but the essence of this explanation—"I was never a physical type"—once again summons up the frail, solitary boy piecing together model Pueblos from medicine packets.

. . . .

Much the same practice accounts for Smith's final conversion to sculpture. While in Germany in the mid-1950s, Smith had created several small assemblages from scraps of wood, and years later he and Pollock briefly experimented together pouring and molding fine-grade cement, but until 1956 little of his energy had gone into object-making. By that time Smith was the father of three daughters—Chiara, or Kiki, was born in Germany in 1954, and the twins, Beatrice and Seton, were born in New Jersey the following year. With dwindling architectural opportunities and a family to feed, Smith, the former drop-in, dropout student and self-made intellectual, began increasingly to devote himself to the role of teacher—becoming an influential and much admired one— first at a settlement house, and later at colleges, art schools, and universities.

A classroom demonstration culminated in Smith's first surviving sculpture, *Throne* (1956–57; p. 142). His intention had been to show the structural advantages of tetrahedral as opposed to standard right-angle joints. Working at home with one-foot-square acoustical tiles, he extended the triangulated volume on its horizontal axis away from the junction of the six similar volumes that branched out from it, ending up with a still-dense, low-slung shape that reminded him of the ceremonial seat of an African king.

Black Box (1962; p. 150), the first piece to be made directly in steel, signaled a sharp turn in Smith's sculptural thinking. Its genesis simultaneously points toward the Duchampian "ready-made" and the industrial fabrication of early Constructivism. Here, in Smith's words, is how it came about.

> *The chairman of my department, Eugene Goossen, at Hunter College, was writing an article. And I was sitting in a very low chair . . . and every time I looked up, I would see this 3 x 5 filing cabinet. And for some odd reason . . . some maniac had painted his black. . . . I went home, thinking* [sic] *to go to sleep; but instead of that, all night all I could think of was that black box. Well, as the hours went by, things . . . disappeared . . . the line of the opening, the dovetailing of the joints, the hinges . . . and [it] simply became a black prism. It became a geometric object; it was no longer a filing cabinet.*[36]

Promptly the next morning he called Goossen, asked him to remeasure the filing cabinet, and with those numbers in hand Smith telephoned the Industrial Welding Company in Newark, a firm whose sign had caught his eye on trips to and from New York, and ordered the construction of a black steel box five times the size of the one that had so captivated his imagination.

Die (1962; p. 151) was made much the same way. This time, however, the scale of the piece was strictly, if enigmatically, anthropomorphic. Extrapolating from Leonardo da Vinci's rendering of Vitruvian man spread-eagle within a

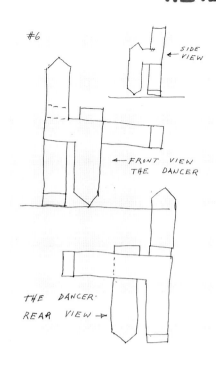

9. Untitled (The Dancer). 1953–55. Ink on paper, 11 5/8 x 8 5/8" (29.5 x 21.1 cm). Tony Smith Estate, New York

square, Smith commissioned a six-foot cube. "Why didn't you make it larger so that it would loom over the observer?" Robert Morris asked him. "I was not making a monument," was Smith's reply. "Then why didn't you make it smaller so that the observer could see over the top?" Morris persisted. "I was not making an object," the artist answered.[37] (The distinction asserted by this intermediary "thing" becomes increasingly significant as Smith's interests turned toward the monumental and still further away from conventional gallery formats.)

Free Ride (1962; p. 153) is the partial contour of a cube six feet eight inches on each side. Sculpturally speaking, the piece defines space graphically while physically occupying it and is thus simultaneously emblematic and dynamic. In Joan Pachner's words: "Smith created a work dependent not on a traditional bilateral symmetry, but on a more organic kind of rotation or balance arranged around an imaginary center point. We can see how the spiral, characteristic of Hambidge's *Dynamic Symmetry*, provided a bridge between growth in nature and human form—an abstraction of unfolding."[38]

The model for *Free Ride* had been patched together from Alka-Seltzer boxes, in accordance not only with his habits—at other times milk cartons had been his basic building block—but also with his pedagogical technique, of which he was perhaps the greatest direct beneficiary.

> *Hunter is a subway college, and it is hard to get the students to make anything large. So I would get them to make little things of cigarette packs and enlarge them. In those days Parliament and Benson and Hedges were the only cigarettes that came in stiff boxes, so we used them. I had the students make them up five times larger, and they did it, although they were furious with me. Since I had my students do it, I thought I might as well do it myself. I decided to take my own medicine . . . I really saw it as a joke on myself. Then I took it down to the fabricator, who has done all my work, and asked him if he would object to doing it. He said, "no, we're a jobbing shop and we do anything anyone wants."*[39]

All the while Smith kept this new endeavor to himself, while placing the products of his labor in and around his house in South Orange. *Black Box*, for example, sat on the spot where his prefabricated "cottage" had once stood. Word of his activity had leaked out through friends, eventually reaching Samuel Wagstaff, who, in 1964, introduced Smith to the public in an exhibition at the Wadsworth Atheneum in Hartford devoted to new art entitled *Black, White, and Grey*. Before that, Smith recalled, "I really never thought of showing them. I did them for myself, as a private thing. I've never called them sculpture, that was other people. I'm interested in structures in which all materials are in tension. . . . I did these because I was tired of having the houses I'd built as an architect changed—everything was impermanent, reduced. I wanted to make something with a kind of stability."[40]

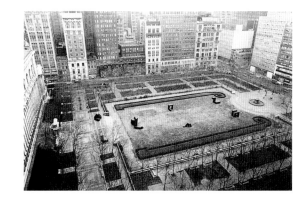

10. Installation at Bryant Park, New York, 1967

The works chosen by Wagstaff included *The Elevens Are Up* (1963; p. 156), paired wall-like constructions each eight feet square by two feet deep.[41] Two years later, Wagstaff organized a show at the Atheneum dedicated solely to Smith's work which ran concurrently with another one-person Smith exhibition at the Institute of Contemporary Art in Philadelphia.[42] That same year Kynaston McShine included Smith in *Primary Structures*, his defining survey of the new reductive art, at the Jewish Museum in New York.

A scant four years after the twenty-four-month stretch during which he conceived the group of works that thereafter set the terms for his entire sculptural production—including *Spitball*, *Cigarette*, and *Marriage* (all 1961, pp. 145–47), *Gracehoper*, *Black Box*, *Die*, *Free Ride*, *We Lost*, *Willy*, and *Playground* (all 1962; pp. 144, 150–53, 155, 157), as well as *The Elevens Are Up* (1963; p. 156)—Smith was finally launched. However, if timing is everything, critical reception of Smith's work demonstrates the problems associated with being in the "right" place at the "right" time for the "wrong" movement.

Two coincidental factors had a decisive influence on the way Smith's work was initially interpreted, even as his emergence was being seen as signaling a new era by supporters as well as opponents of change. The first of these factors was the advent of Minimalism. The second was the death of David Smith and the struggle over his aesthetic legacy. By 1965, the year David Smith was killed in an automobile accident, "minimalism"—or the art of "Primary Structures," as it had been christened by McShine, that of "Specific Objects," as it had been named by one of its practioners, Donald Judd, or "ABC Art," as it was tagged by Barbara Rose—was already a well-established tendency. Essentially a formalist challenge to prevailing formalist doctrine, it was an approach that hewed to the core tenets of "pure" abstraction in that it focused on art's intrinsic material and procedural properties to the exclusion of representation, symbolism, or narrative of any kind, yet ignored settled formalist opinion on the relation of painting to sculpture and the absolute self-sufficiency of the high modernist work of art. On one side of this divide stood Clement Greenberg and his disciples, whose logic derived from the ascendency of Abstract Expressionism, of which David Smith was widely agreed to be the avatar in three dimensions as Pollock had been in two. On the other stood the young turks: Andre, Judd, Morris, and LeWitt—and the not-so-young turk and erstwhile lone wolf, Tony Smith.

Speaking for the former camp in his landmark polemic "Art and Objecthood" of 1967, Michael Fried attacked what he, in turn, preferred to call "literalist" art. He was provoked by what he felt was the "literalists'" denial of art's complete independence from its context, by its exploitation of contingencies such as ambient light and space, by its attention to object placement and its effects upon the viewer, by its tendency to erode the boundaries separating formally distinct disciplines and, as a consequence of all of this, by its flirtation with "theater," in Fried's view the most corrupt of all aesthetic genres. Rather than take into consideration the spectator, or at least take him or her into account by inconsiderately blocking their path, sculpture should keep to itself, like a painting within a frame, asserting its formal prerogatives to the fullest extent but without "spilling" over or out of that frame. Implicit rather than explicit in Fried's argument was the exemplary oeuvre of David Smith. In the meantime, Fried did name Tony Smith, and quoted at length from his description of the night on the New Jersey Turnpike to prove beyond all doubt that what "literalists" sought was something outside of art. "If the turnpike, airstrips and drill ground are not works of art," Fried asked rhetorically, "what *are* they? What, indeed, if not

empty, or 'abandoned,' *situations?* . . . It is as though the turnpike, airstrip and drill ground reveal the theatrical character of literalist art, only without the object, that is, *without the art itself.*"[43]

Tony Smith's partisans were equally convinced that his vision held the key to something unprecedented. E. C. Goossen, Smith's former boss at Hunter College, and subsequently his curatorial advocate at The Museum of Modern Art, made the strongest case for his importance. Once more the counterexample—still unstated but identified by references to "pictorialism" and "aerial drawing"—was that of David Smith.

> *When an artist provides what other artists need and objectifies for his period both the problems and solutions, his position is not subject to mere critical judgment. Smith's position is secured on the facts. For example: With one stroke he put an end to the plague of pictorialism that has infected even the best sculpture for centuries. At the same time he returned to that art its capacity to exist in, and to affect, the out-of-doors environment. And most importantly, he reunited structure, form, scale and meaning in a wholeness unrealized before in abstract sculpture. . . . Unlike efforts by other sculptors to delineate space, either in aerial drawing or unitized space frames,* Free Ride, *because the body of it is as palpable in size as a human body, truly takes form through space. In fact, it is so successful in eliminating the pictorial that it cannot be drawn correctly (a common characteristic of Smith's work) nor even tellingly photographed.*[44]

The affinities between Smith's work and that of the "minimalists"—all of whom eschewed the term—are not to be denied. Like theirs, Smith's sculptural language was geometric and structurally "fundamentalist," his facture impersonal and largely indirect, and—as Fried had accurately observed but incorrectly analyzed—his attention to an object's situation was essential to the impact of the piece. Viewed from the perspective of Abstract Expressionism's emphasis on improvisation as a means of psychological transcription, as distinct from preor-

11. *No Stars.* c. 1965. Ink on paper, 7 15/16 x 9 15/16" (20.2 x 25.2 cm). Tony Smith Estate, New York

dained compositional constructs, Smith would, superficially, seem to have common cause with Judd, Andre, Morris, LeWitt, and their cohort.

The reality was that Smith retained all the basic attitudes of his contemporaries despite the fact that he was breaking new ground in a circumstantial alliance with his juniors. Methodical certainly, Smith was never consistently programmatic. "Morris and Judd and all those guys really thought about what they were doing. I never thought about anything that I did. I just did it," he told one interviewer.[45] To another, he said: "I use angles that are derived from different solids. When they go together, they do not follow any internal system. I assemble them, you might say, in capricious ways rather than systematic ways. You have to take each plane as it comes and find out in what way it will join the other planes."[46] Intuition combined with trial and error was his *modus operandi,* backed up, of course, by lifelong familiarity with the basic mathematical variables that comprised his conceptual and material medium. Undeniably, Smith made use of systems, but their role was to engender unanticipated choices rather than any foreseeable outcome. To Goossen he said it most simply, "I don't make sculpture, I speculate in form."[47]

Contrary to the minimalist example, the forms he preferred working with were, in many instances, intricately "composed" and impossible to grasp as an irreducible *gestalt,* as Judd, for one, had argued the case should be. Contrasting David Smith and Tony Smith, Goossen seized upon a distinction that applies generally to the work of the latter. "Those who exploit silhouette in a three-dimensional work effectually eliminate one of the three dimensions; the very purpose of sculpture as such is thus lost and the piece becomes pictorial. The silhouette of a [Tony] Smith piece is more or less an accident and because it tells little about what the piece actually in essence is, attention is necessarily directed toward mass as described by the directional force of the surfaces."[48]

With the exception of the work done by Richard Serra, who only entered into discussion in the late 1960s with his early lead rolls and Prop pieces, minimalist sculpture was, as a rule, insistently static, whereas Smith's objects— including everything from the ratcheting *Cigarette* and *The Snake Is Out,* to the

listing monoliths such as *New Piece* (1966; p. 165) or the ever-shifting *Wandering Rocks* (1967; p. 164)—were animated by "the directional force of the surfaces."[49] (Although sometimes overbearing, Smith's sculptures are essentially "nonviolent," and never threaten to collapse or topple over as Serra's fate-tempting plates and tubes frequently seem ready to do.)

Neither, finally, did Smith assume the dispassionate, "Just the facts Ma'am" manner of the minimalists; even more so than many of his coevals, Smith, in the 1960s, was still mindful of Jung and Joyce, myths and ancient monuments. Yet again Goossen assessed with greatest clarity the challenge Smith had set himself: "Smith's use of the human module, so neglected, in any rational fashion at least, by other sculptors, is a constant in his work and inseparable from any discussion of how he achieves a meaningful result without producing an anthropomorphic, subject-matter dodge to attract empathy."[50] As Fried was the first to remark, and others, using the writings of Maurice Merleau-Ponty, have elaborated, minimalist sculpture took human scale, presence, motion, and sensory apprehension very much into account. But Smith wanted what the minimalist categorically rejected, a sculpture that was symbolically charged with an unsentimental but unmistakable humanism, a sculpture in which platonic forms were imbued with life force.

Although Smith's ideas had greatly evolved by the 1960s, the lessons he had learned thirty years before from D'Arcy Thompson were, if anything, even more sharply focused now. As the Vitruvian reference in *Die* first demonstrated, an organic aspect was embedded in even the most rigidly reductive shapes. Meanwhile, Smith's more complex, multifaceted, and compositionally "active" sculptures, such as *Cigarette*, *Willy*, *The Snake is Out*, or *Amaryllis*, achieved in hard-edge geometric terms the effect of moving or twisting volumes previously found only in carved or modeled figuration; in short, a strict rectilinear version of traditional curvilinear *contrapposto*. Alert, therefore, to the "growth of forms," as well as to their inherent tropisms, Smith was also quick to recognize the latent sexual energy pent up in them. In part a Whitmanlike celebration of fecund and regenerative nature—"Urge and urge and urge/Always the procreant urge of the world" the poet had written in *Leaves of Grass*—this energy may, in line with the same literary precedent, be understood as frankly and disquietingly libidinal.[51] "There is something erotic in all my work," Smith confessed and the priapic thrust of *Duck* (1962; p. 158) or *Amaryllis* (1965; p. 163) confirms that assertion.[52]

Amaryllis bothered Smith. "I had the sense that it looked so ungainly and unbalanced. It also seemed rather classical from one view, but then taken from another, it seemed some kind of caricature of form. We're all born with a sense of rightness of form, and this seemed some kind of desecration of all that, just as the amaryllis plant seems to me a kind of orchid made out of wood or some terrible aberration of form. . . . When it was actually built, I was quite terrified by it. You know I have such a Hellenistic view of things that when I see something that strikes me as abortive, it terrifies me."[53] With an obviously phallic aspect consonant with the nakedly phallic profile of the immature flower after which it was named, *Amaryllis* is, despite Smith's disclaimer, thoroughly "Hellenistic," but Dionysian rather than Apollonian. In fact, such untamed Dionysian energies were implicit in the notion of "The Wild" that had been developed by Smith and Newman in the 1940s. Newman even titled a painting accordingly; the narrowest of his canvases, this eponymous work consists of a single eight-foot band of color running down a vertical surface only slightly wider than the vibrant and correspondingly compressed "zip" itself. Smith, meanwhile, made notes on the idea, including one in which the letters *I* and *D* are highlighted within the word "wild," apparently referring to Freud's categorization of the id as the locus of primal instinct and desire (see p. 79).

Thanatos shadowed Eros in Smith's thinking and work, just as it did in ancient myth. Until the artist placed a plywood base under it in the yard behind his house, *Black Box* initially resembled a child's tombstone, prompting one of his daughters to ask, "Who was buried there?" Proportionally as well as verbally, *Die* was a macabre sculptural pun. Answering Wagstaff's queries, Smith offered this: "Auden had written, 'Let us honor if we can the vertical man, though we value none but the horizontal one.' Six feet has a suggestion of being cooked. Six foot box. Six foot under."[54] His description of responses to the straight-and-narrow portal *Marriage* has a similarly sardonic quality. "It is like a threshold. My friends say it looks sort of soft and tender, but, to me, at the same time it also looks the least bit rough and harsh."[55] And then there are his allusions to catastrophic drinking. Two titles come from the same source. *The Snake Is Out*, Smith told Wagstaff, "was taken from John McNulty's 'Third Avenue Medicine.' The snake is an ordinary little vein, or maybe it is an artery, that runs along the left temple of a man's head. . . . Bartenders watch for [that] vein to protrude from a man's forehead. It's a warning. He's drunk too much, and bartenders say 'The snake is out.'"[56] As to *The Elevens Are Up* (1963; p. 156) it

meant "that the two cords on the back of a man's neck have begun to stick out, the way they never stuck out before his illness," that is to say, his alcoholism.[57] By identifying an otherwise abstract form with a crushed butt, even *Cigarette* (1961; p. 145) bluntly alludes to "bad" habits. (Consider how uningratiating and un-Pop Smith's treatment of this subject is in comparison to the overtly comic, albeit forlorn cigarette-stub sculptures of Claes Oldenburg.)

The disturbing side of Smith's temperament is not just a matter of gallow's humor or the names assigned to pieces made without any *a priori* theme. Smith saw something intrinsically dark or sexual in much of his own work. "I still have a very deep romantic feeling about people's physical make-up. . . . If my work has possibly more appeal than it deserves," he continued with characteristically commingled pride and self-deprecation, "I imagine it probably affects people at an animal level."[58] Describing his sculpture *en masse*, Smith gave a sinister turn to these "romantic feelings" about the body: "I see my pieces as aggressors in hostile territory. I think of them as seeds or germs that could spread growth or disease."[59] Uncontrollable metastasis is the latent danger in the formal growth factor Smith had discovered through Thompson. "They are black and probably malignant. The social organism can assimilate them only in areas which it has abandoned, its waste areas, against its unfinished backs and sides, places oriented away from the focus of its well-being, unrecognized danger spots, excavations and unguarded roots."[60]

The no-man's-land Smith evokes as the ideal site for his alien creations is yet another version of the vista offered him by the New Jersey Turnpike. It is the archetypal edge of the city explored by *film-noir* directors in the thirties and forties, postwar new realists like Federico Fellini in the fifties and sixties, earth-art pioneers like Robert Smithson in the sixties and seventies, and science-fiction writers like William Gibson in the eighties and nineties. A variation on traditional notions of "the picturesque," this marginal reality is a *chiaroscuro*, man-made wilderness and home to the modern ruin. In the domestic setting where Smith worked at his South Orange house, the artist created just such an

12. *Malignant.* 1958. Ink and pencil on cardboard (cigar box), 6⁵⁄₁₆ x 7 ½" (16 x 19.1 cm). Tony Smith Estate, New York

atmosphere. (To shut out the sun, he covered the windows with canvases.) "I think my pieces look best with very little light. In my studio I like to show them at dusk without any lights on . . . they remind me of Stonehenge. . . . I think that if light is subdued a little, it has more of the archaic or prehistoric look that I prefer."[61] Smith could, however, contradict himself, claiming on another occasion, "I'm not aware of how light and shadow falls on my pieces. I'm just aware of basic form. I'm interested in the thing, not the effects—pyramids are only geometry, not an effect."[62]

Although the last comment may have been a defense against Fried's charge of "theatricality," the discrepancy between the two statements allows one to overhear a more fundamental dialogue between the two halves of Smith's aesthetic identity. One voice is that of a dreamer enthralled by images from early modernist literature that were deeply indebted to the symbolist tradition, the other is a wide-awake empiricist anxious to physically verify his formal hunches. The first, thinking of monoliths remote in time and space, had once written, "America demands tremendous—abstract art";[63] the second simply said, "the quiet and stability of my pieces are desirable in themselves."[64] Although Smith's sculptures do take on a mysterious animism at sunrise or sunset, they hold their own under any conditions, and that is a function of the novelty and integrity of their design.

In the 1960s, when he commuted between his home in New Jersey and Bennington College in Vermont, Smith once again alluded to his enduring ambition to create a new monumental art by pointing to its absence. "In an English village there is always a Cathedral, " he noted. "There is nothing to look at between the Bennington Monument and the George Washington Bridge."[65] The former is an obelisk, the latter is a feat of engineering. Distancing himself from imitation antiquity as he did from utilitarian architecture while at the same time striving for the aura of the one and developing the technical potential of the other, Smith fundamentally altered the structural language of modern sculpture.

When initial recognition came to Smith in the mid-1960s, his squared-off sculptures such as *Black Box, Die, The Elevens Are Up,* and *Free Ride* were

the ones most often discussed. Inherently cubic, these objects are essentially symmetrical. However, it was the working premise announced in 1956–57 by *Throne* and reiterated in the early 1960s by *Cigarette*, *Spitball*, *Gracehoper*, *Amaryllis*, and *Willy* that constitutes his greatest formal invention. All of these pieces are based on compound articulations of two triangulated modules, the tetrahedron and the octahedron. Smith had been inspired by his early discovery of Alexander Graham Bell's deployment of these forms, and the slowly fulfilled consequences of this paradigm shift were far-reaching, indeed.

For as *Throne* demonstrated, it was possible, given such multifaceted units, to join these solids "face-to-face" in several off-angle orientations, and by multiplying those units arrive at securely bonded but eccentric, frequently asymmetrical, configurations. Crystals are the natural analogues to such shapes, but with the aid of mathematical distortions that do not occur naturally, Smith further elaborated them.

Smoke (p. 167), the largest sculpture Smith ever realized in full scale, is a logical extension of *Throne*. For the 1967 exhibition *Scale as Content* at the Corcoran Gallery of Art in Washington, D.C., Smith ordered the construction of a wood version of the piece, as was his custom when available funds did not permit the fabrication of a piece in steel. Against the pillars and balustrades of the Beaux-Arts-style museum building, *Smoke* rose up and swelled outward like the skeleton of a cloud. In contrast to the neoclassical details of its site, it has an almost Gothic aspect, but, in fact, the complex joinery and shifting torsion of the piece are like nothing found in Western architectural or sculptural tradition.

There are no curves, no arches, no absolutely plumb uprights. Partially modeled on the laws of physics that determine the close-packing of bubbles, *Smoke* demonstrates the cohesion of this innovative scaffolding, which was neatly summarized by John Chandler as follows: "*Smoke* reveals its hexagonal structure both horizontally and vertically since the space is three-dimensional. Each of the eight floor columns is so positioned that it stands at alternate angles of close-packed hexagons. At the top of each column there is a tetrahedral capital whose remaining three sides offer faces to which additional modules are attached. . . . Each triad of columns supports a hexagonal ring of the same; hence the whole structure reflects a basic generating function; a six-sided figure rising from a three-sided one."[66] But for the limits imposed by available space, *Smoke* could go on replicating itself *ad infinitum*. Returning after years to the hexagon he had borrowed from Wright, Smith had at last solved the problem of

how to symbolically render and, at the same time, set in motion the process of ceaseless "generation."

Thicker in its component parts and more compact overall, *Moondog* (1964; pp. 160–61) is, in effect, a single unit of *Smoke*. Walking around it one perceives the intrinsic visual dynamism of Smith's unique vocabulary. Perfectly symmetrical when viewed head-on from any angle, the huge armature seems to list to one side as one moves away from dead center, as if it were a monstrous creature pushing off the ground with its hindquarters while kneeling slightly with its forelegs. Standing beneath the piece and looking up induces a kind of mild vertigo, as the subtlest movement of the body or the eye translates into a movement of the massive twisting volumes overhead. Demonstrating the positive and strictly formal dimension of the active spectator's effect upon the work of art—which Fried could only imagine in terms of negative staginess—physical movement thus sets off a kind of sculptural kinesthesia.

The sense of flux embodied in *Moondog* and *Smoke*, as well as in the latter's truncated variants *Smog* (1969–70; p. 178)—the tensile representation of a noxious ground-hugging cloud—and *Smug* (1973; p.179), takes the principle of the interdependency of positive and negative space that Smith had learned from Vytlacil to expansive three-dimensional extremes. "The reason that it's called 'Smoke,'" Smith explained, "is that you always think you see a solid. But, a solid always dissolves into other apparent solids. There are no real solids in the voids. It just seems at first, when you're in it, that you are always going to run into a solid. You don't have to be afraid because it's really just like 'Smoke.'"[67] Inasmuch as *Free Ride* brackets a nonexistent cube, yet is a cubic volume in its own right, and *Spitball* does the same for a tetrahedron, *Smoke*, *Moondog*, *Smug*, and *Smog* also describe intricately framed emptiness while displacing parts of that empty space with massive forms.

The invisible framework of all of these pieces consists of the varied and infinitely extendable spatial matrices that order our perception. Smith's sculpture effectively requires us to think of space as physically manifest but divided up into regular units in such a manner that objects represent gaps in a taut and otherwise unbroken mesh. As Goossen remarked, Smith's work "presupposes a space-grid or space-lattice, in which the elements and their absent counterparts are like the real numbers surrounded by imaginary numbers. . . . Both exist."[68] "Thus," he continued, "his sculptures do not end up as lumps at the bottom of a sea of chaotic, unshaped ether, but are interlocked with the struc-

tured world they come from; what is absent to the senses is nevertheless present in the mind of the artist."[69] Or, in Smith's own view, his sculptures were located in "a continuous space grid. In the latter, voids are made up of the same components as the masses. In this light, they may be seen as interruptions in an otherwise unbroken flow of space. If you think of space as solid, they are voids in that space."[70]

The radicality of this idea cannot be exaggerated. Traditionally, sculpture has been regarded as a self-contained entity planted in the midst of nothingness or attached to an architectural construct that enveloped nothingness and was surrounded by it. To the extent that sculpture took ambient space into account, it contoured vacancy instead of conceptually concretizing it. Rather than dividing reality into material things and immaterial atmospheres, each governed by separate laws, Smith treated them as if they were all informed by the same forces. Moreover, Smith did not view the organizational device of the grid as necessarily monotonous or entropy-producing, in part, because he conceived of grids based on something other than the standard square or rectangle. This permitted him to build up, fracture, and reassemble forms in ways that avoided obvious reiteration of their basic "atomic" structure, as if he were zigzagging back and forth through an open maze, cutting corners here and there and realigning the coordinates as he went. *Willy* was, in this way, a by-product of several other pieces, while *Moses* (1968; p. 169) is a reworked section of *Gracehoper*, a small fragment of a larger fragment of space incarnate.

Perhaps the best illustration of the complex malleability of the continuous space-lattice is *Bat Cave* (1969; fig. 13 and p. 37), which Smith made in two versions, the first for *Expo '70* in Osaka, Japan, and the second for the *Experiments in Art and Technology* exhibition at the Los Angeles County Museum of Art in 1971. Composed of hundreds of folded-paper tetrahedra and octahedra, *Bat Cave* was a piece in which, according to Smith, "there [wasn't] any structure except the components from which the form has been made."[71] "My intention," he went on, "was to make a piece of sculpture which emphasized the negative space rather than the positive form."[72] Within a year or two,

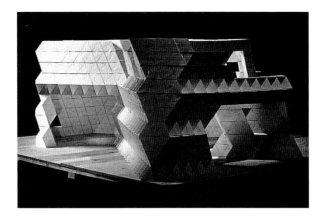

13. *Bat Cave*. c. 1969. Cardboard model, approx. 2,500 units, each 3 ½" (8.9 cm). (destroyed)

this preoccupation with homogenous surfaces, foreshadowed by the sinuous convolutions of *Smoke* and *Moondog*, led Smith toward Moebius strips, Klein Bottles, and the mind-bending hypotheses of topological math. *For Dolores (Flores para los muertos)* (1973–74; p. 177) and *Fermi* (1973; p. 176) were the product of this change in geometric perspective, and that change demanded a corresponding alteration in Smith's technique, prompting him to turn to clay and then to carved marble to produce the smooth, curvaceous shapes he imagined. Wishing to escape the architectural settings against which his previous sculptures had had to struggle while joining Christo and the late Yves Klein, among others, in conceptualizing a pneumatic monumentality, Smith looked forward to fabricating an inflated vinyl version of *Fermi* measuring fifty-six by fifty-six by eighty-four feet. Although the opportunity to pursue this avenue was never offered him, one imagines that it might have resulted in something like the three-dimensional equivalent of Smith's flat but smoothly recombinant *Louisenberg* modules.

Like the elegantly fashioned objects just described, Smith's designs for heroically scaled environmental sculptures belong to the later phase of his career. Both developments grew logically out of his long-standing concerns, and both coincided with work being done by others at the same time: Louise Bourgeois in the realm of topology; and Robert Smithson, Michael Heizer, and Walter De Maria in that of earth art. (With their twisted planes and transformations of triangular channels into square ones, Bruce Nauman's plaster and fiberglass tunnel pieces of 1979–81 also come to mind in relation to Smith's topological manipulations, as do Nauman's earlier, irregularly cubic works such as *Consummate Mask of Rock*, *Diamond Mind*, and *Forced Perspective* pieces of 1975. The emotional tension of Nauman's geometric work has much in common with that of Smith as well, and the work of both shares a pronounced spiritual dimension, although Nauman, unlike Smith, is by no means explicit about his own beliefs.)

Between 1968 and 1969 Smith responded to the challenge of site-specific sculpture with four major proposals. *Lunar Ammo Dump*, for the Chicago

Circle Campus of the University of Illinois, consisted of a group of prisms scattered across a plaza in a manner related to *Wandering Rocks*. *Mountain Cut* entailed the formally simple but dramatic "chiseling" away of a hillside in Valencia, California, that would have rendered it a kind of abstract Mount Rushmore. *Haole Crater*, a network of outdoor enclosures for the University of Hawaii that enlarged upon the ideas adumbrated in *Stinger* (1967–68; p. 168), explored his interest in sunken gardens. Flying in the face of then current attitudes toward inner-city urban renewal which aimed at enhancing social usefulness, Smith's scheme for Minneapolis—a section of whose downtown area was divided into square as opposed to the more common rectangular city blocks—involved paving a wide public space, inscribing vectors into the pavement's surface, and studding it with tank-trap-like pyramids. This idea inspired the large-scale model *Eighty-One More* (1970; p. 173) that was shown at The Museum of Modern Art in 1971, and *Hubris* (1969; p. 172), which he had planned for the University of Hawaii, where students cheerfully accepted the idea of the artist's intentionally "hostile" track of "dragon's teeth."[73] Due to practical limitations or a lack of resolve on the part of potential sponsors, none of these projects was ever carried out as Smith intended. Nevertheless, the conceptual breakthrough they represented—from sculpture back toward architecture and from buildings toward reconfiguring the land—constitutes his essential contribution to the collective enterprise of defining environmental art at that moment and to overhauling some of the basic assumptions that applied to each of the several disciplines he thus brought together in his mind.

· · · ·

By the mid-1970s, Smith's health began to deteriorate. The 1961 automobile accident that had seriously injured him and indirectly caused the temporarily invalided architect to amuse himself with sculpture, had also left him with a debilitating blood disease, polycythemia. Meanwhile, years of heavy drinking had exacerbated a diabetic condition, and cirrhosis sapped his remaining strength. Smith was awarded numerous prizes and given several important commissions during his last years, but his productivity declined steadily from the early 1970s until his death from a heart attack in 1980. Although his career as a sculptor spanned almost two decades, preceded by another two decades devoted primarily to architecture and painting, Smith's most productive years lasted only from 1962 to 1973.

In the 1966 catalogue essay that heralded his emergence as an important contemporary artist, Samuel Wagstaff wrote: "Tony Smith . . . is one of the best known unknowns in American art."[74] Now, it may be said, he has become one of the least well known of the leading figures of his era. There are several obvious reasons for this. First, one must grant that Smith's reach often exceeded his grasp. That said, however, he reached for things previously unimagined but now fundamental to any in-depth discussion of contemporary aesthetic practice. Second, as noted in the first part of this essay, there is no way around the fact that Smith's overall output was comparatively small. But so, too, was that of his close friend Barnett Newman, and so it has been of other much admired artists of his generation, such as Myron Stout. Third, a good deal of the work Smith left behind was, in a physical sense, unfinished. As often as not, his most ambitious concepts were embodied in maquettes or sketches or were presented to the public in partial scale or temporary materials. None of his environmental pieces was ever built in permanent form to his original specifications, and during his lifetime relatively few of his major sculptures were realized in steel, as he had wished. For exhibitions, he would supervise the creation of plywood mock-ups that were usually painted with heavy-duty car paints, and after they had served their immediate purpose, most were destroyed.

I have, therefore, chosen the term "leading" with care. Smith's stature within his generation does not equal that of Pollock or Rothko, as Smith himself was prepared to admit, but his sculpture does, I believe, earn him a place alongside Still and, perhaps most congruently, Newman. All things considered, though, Smith's importance resides not only in the work he managed to complete, but also in his ability to point the way beyond the situation that he and his contemporaries had collectively defined.

On one level, Smith is among those frequently ignored artists who disprove the old adage that "those who do, do, and those who can't, teach." An impatient student as a young man, he made the best of teachers in mid-life, and in so doing taught himself to take the chances his reticent creative nature long inhibited him from fully confronting. Evidence of his pedagogical legacy is everywhere that one encounters artists who took courses with him in the schools where he was an instructor or worked with him in the fabrication of his own pieces. (Some testimony on the subject appears in the documentary portrait of Smith that concludes this book.) Then there is his indirect influence to account for. If painters such as Douglas Ohlson, and sculptors such as Christopher

Wilmarth and Richard Tuttle belong in this former group, then one should also consider the sculptor Scott Burton or the conceptual artist Robert Smithson.

Burton, a critic for *Artnews* who made a name for himself with deft trans-figurations of classical sculptural motifs as well as of modernist furniture, wrote in 1966: "Tony Smith as a sculptor only seems to have sprung full-grown from the brow of Hephaestus. . . . The initial impression of his work . . . is likely to be one of great emotional power, his radical sculptural means only gradually asserting themselves."[75] Meanwhile, Smithson's interest in crystals and his fascination with neglected urban spaces closely parallel that of Smith. With this significant difference: where Smithson perceived increasingly sterile entropy in the all-encompassing grid, Smith saw vital signs and unpredictable new forms, albeit sometimes menacing ones. Smithson was enthralled by the dispersal of energy; Smith willed its concentration. Frangibility made wholeness his mantra.

Intellectually and formally, Smith's work simultaneously holds a position and indicates a direction. With their unfolding planes and leaning volumes, many of his sculptures do this quite graphically. They have places to go, and yet they stay. That is their poetry. And that too is their metaphysical *raison d'être*. Samuel Wagstaff compared Smith's work to the solidity of the Romanesque, while Smith spoke to Lucy Lippard of his admiration for "very simple, very authoritative, very enduring things."[76] The anomalous character of his aesthetic tendencies did not escape him. Like many artists with one foot in the 1950s, he found the expansion and acceleration of art-world activity in the 1960s bewildering and sometimes oppressive. The worth Smith ascribed to permanence was at odds not merely with fashion, but with the, by that time, profoundly influential ideas of John Cage, Robert Rauschenberg, Allan Kaprow, and others whose art was a celebration of the impermanent or the ephemeral.

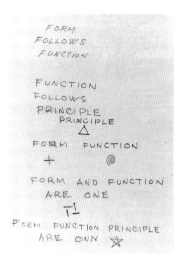

14. Untitled (Form Follows Function). c. 1940s. Pencil on paper, 11 11/16 x 9" (29.7 x 22.9 cm). Tony Smith Estate, New York

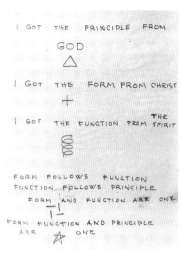

15. Untitled (I Got the Principle from God). c. 1940s. Pencil on paper, 11 11/16 x 9" (29.7 x 22.9 cm). Tony Smith Estate, New York

That such devotion—it is the only word—to "lasting values" and abiding aesthetic "presences" (Smith's term for successful sculpture) should have possessed the mind of a man so attuned to new possibilities is the fertile paradox of his art. It is all the more ironic that so much of what he imagined existed and still exists in fragile or transient versions. There is more than irony here, however. There is longing, and it forces us to pay heed to the emotional and spiritual urgency Smith's work was meant to express. "The fact is," he wrote to Fritz Bultman, "we are actually happiest in those periods which represent neither growth nor duration, but equilibrium and change. In such states, we are not only happiest, but most productive, and our work is richest, most radiant, and most satisfying."[77]

If any period of history can be said to represent this ideal balance, it was not the one into which Smith was born. For a man as delicately poised between earthy enthusiasms and mystical aspirations as he was, the twentieth century had been a particularly rough ride. It is, moreover, a century increasingly embarrassed by the religious sentiments and concerns that underlay so much of Smith's thinking. Contemporary taste in ideas—as opposed to dubious New Age and fundamentalist tendencies alive in the culture at large—clashes with unapologetic declarations of faith. Strict formalist doctrine makes no allowance for spiritual matters, while the various currents of postmodern thought that issue from formalism tend to treat them as merely symptomatic of ideological false consciousness. Consequently, in recent years, we have seen Piet Mondrian stripped of his Symbolist past and his Theosophical ideas, and similar disdain has been shown toward the mythological inspiration claimed by several of Smith's Abstract Expressionist colleagues. To an ever-increasing extent, distanced and distancing political, sociological, and aesthetic exegeses have replaced critical engagement with metaphor and belief.

The problem is not that such approaches are wholly unjustified—far from it—or that one need subscribe to an artist's creed or accept his or her intentions and conceits at face value. Not at all. The problem is that however inconvenient they might be, the convictions of an artist like Smith won't go away. They nag us as we confront the evidence supporting the work, but more important than that they are manifest in the work itself. Indeed, conviction is a basic quality of important art, an intangible alloy of matter that, once fused with the strictly aesthetic, can never be completely removed from it. Smith's work is among the prime examples of this irreversible effect, and of the dilemmas it poses. Free-thinking citizen of a democratic country, Smith seems to have simultaneously inhabited an aesthetic theocracy of his own imagining. From this double point of departure, he anticipated a new art of a grandeur proportionate to the unfulfilled greatness of America, and the equal of anything produced by the most developed civilizations of the past, virtually all of which used architecture, painting, and sculpture to celebrate their gods. The problem Smith repeatedly confronted was how to do the same in a modern, secular society, and his experiments in all mediums reflected that improbable but devout aim.

If one is to deal with Smith at all, therefore, one must tackle him as he comes, that is to say, without shying away from his unrecanted professions of faith and romantic attachment to art as a heroic enterprise, and without tidying up his diverse and often incompletely realized responses to those motivating impulses. In the final analysis, his career was as multifaceted as the objects he made, and his achievement is as unavoidable. Smith liked enduring things, and in each of its various forms his work is one of them. Awe-inspired, it is ingenious, uncompromising, imperfect, and—its full measure taken—awe-inspiring.

Notes

1. Archives, Tony Smith Estate, New York.

2. Tony Smith, "The Pattern of Organic Life in America," unpublished manuscript, 1943, Archives, Tony Smith Estate, New York.

3. Archives, Tony Smith Estate, New York.

4. Phyllis Tuchman, "Tony Smith: A Modern Master," *New Jersey Monthly* 5 (January 1981): 123.

5. [Hayden Herrera], "Master of the Monumentalists," *Time* 90 (October 13, 1967): 84.

6. Undated draft of a lecture, Archives, Tony Smith Estate, New York.

7. Tuchman, "Tony Smith: A Modern Master," 123.

8. Transcript of an interview with Tony Smith by Paul Cummings, August 22, 1978, Archives of American Art, 15.

9. Joan H. Pachner, "Tony Smith: Architecture into Sculpture," in *Tony Smith: Skulpturen und Zeichnungen/Sculptures and Drawings 1961–1969*, exh. cat., Westfälisches Landesmuseum, Münster, 1988, 50.

10. [Herrera], "Master of the Monumentalists," 85.

11. Archives, Tony Smith Estate, New York.

12. Cummings, interview, 23.

13. Ibid., 28, 29.

14. Ibid., 28.

15. Ibid., 29.

16. Ibid., 37, 35, and 32.

17. Ibid., 47–48.

18. Samuel J. Wagstaff, Jr., "Talking with Tony Smith," *Artforum* 5 (December 1966): 16.

19. Smith, "Pattern of Organic Life."

20. Cummings, interview, 6.

21. Irving Sandler, notes of an interview with Smith in 1958, kindly provided by Sandler.

22. Lucy R. Lippard, "Tony Smith: Talk about Sculpture," *Artnews* 7 (April 1971): 68.

23. This statement appears in a letter dated September 20, 1968, but it is safe to assume that these had been his sentiments all along. See Joan H. Pachner, "Tony Smith: Architect, Painter, Sculptor" (PhD. diss., New York University, Institute of Fine Arts, 1993), 169–70.

24. Jeffrey Potter, *To a Violent Grave: An Oral Biography of Jackson Pollock* (New York: G. P. Putnam's Sons, 1985), 149.

25. As one of the artists untouched by Abstract Expressionism's success, Reinhardt played the part of bohemian scold. In other respects his situation closely paralleled that of Smith, who divided his time earning a living, making art, and keeping up with the pack. Writing about himself, Reinhardt was in part describing Smith's predicament in this excerpt from a letter of 1954: "The double-triple life is the solution, otherwise some things become substitutes or consolation prizes—I teach and am pleasant to my students, I'm kind to my restless wife and happy baby and that's my social and my private life—my studio, ivory-tower, retreat, cave, magic mountain is the transcendent part of my trinity."

26. Letter from Tony Smith to Barbara and Orlando Scoppettone, December 7, 1953, Archives, Tony Smith Estate, New York.

27. Letter from Tony Smith to Barnett Newman, April 8, 1954, Archives, Tony Smith Estate, New York.

28. Anna Chave emphasizes the fascination fascist paradigms

had for Smith, Frank Stella, and Robert Morris in framing her revisionist assessment of the gendered "power politics" of Minimalist art. Chave is not wrong in pointing out this affinity or flirtation in the case of Stella and Morris, but the fact remains that, unlike fascist art and architecture, Smith's sculptures and buildings were insistently built to human rather than superhuman scale. What Smith discovered in Nuremberg and the New Jersey Turnpike was not the aesthetic solution to a problem but the statement of one: the realization that there existed an artificial as opposed to natural vastness for which no artistic correlative could be identified. His late, unfinished "earthworks" and environmental pieces may be seen as a first attempt to address that lack. See Anna C. Chave, "Minimalism and the Rhetoric of Power," Arts 64 (January 1990): 44–63.

29. Wagstaff, "Talking with Tony Smith," 19.

30. Lucy R. Lippard quoted in Sam Hunter, "The Sculpture of Tony Smith," in Tony Smith: Ten Elements and Throwback, exh. cat., The Pace Gallery, New York, 1979, 4. Although the original source for this comment has not been located, Lippard, a pioneering feminist critic of the 1970s, as well as one of the best on-the-scene writers about Minimal art in the 1960s, was in all likelihood referring not only to the actual contour of Smith's module, but also to the "ballsy" ethos of his generation of male artists. Prior to this, Jasper Johns's Painting with Two Balls (1960) wryly makes the same point about the machismo of the Abstract Expressionists. It is safe to assume, though, that however deliberate the visual double entendre in Smith's use of these bulbous forms might have been, he was not engaged in critical self-mockery.

31. Gene Baro, "Tony Smith: Toward Speculation in Pure Form," Art International 11 (summer 1967): 28.

32. Potter, To a Violent Grave, 123.

33. [Herrera], "Master of the Monumentalists," 83.

34. Hunter, "The Sculpture of Tony Smith," 3.

35. Grace Glueck, "No Place to Hide," New York Times, November 27, 1966, sec. 2, p. 19.

36. Tony Smith, transcript of a lecture given at the Whitney Museum of American Art, New York, June 21, 1976, Archives, Tony Smith Estate, New York.

37. Robert Morris, "Notes on Sculpture, Part 2," Artforum 5 (October 1966): 20

38. Pachner, "Tony Smith: Architect, Painter, Sculptor," 226.

39. Hunter, "The Sculpture of Tony Smith," 4.

40. Glueck, "No Place to Hide," 19.

41. Coincidentally, Robert Indiana exhibited a square painting in Wagstaff's Black, White and Grey show emblazoned with the word "Die."

42. Among the works included in the Wadsworth Atheneum show was Fixture, a site-specific box designed to cover up an ornate neoclassical sculpture permanently installed in the museum's atrium gallery. Smith had doubtless remembered this eyesore from the Black, White and Grey show, and his whimsical formal response to it gave him the further idea of covering public park sculpture of similarly dated aesthetic value in like manner.

43. Michael Fried, "Art and Objecthood," Artforum 5 (June 1967): 18.

44. Eugene C. Goossen, "Introduction," in 9 Sculptures by Tony Smith, exh. cat., Newark Museum, 1970, n. p.

45. Tuchman, "Tony Smith: A Modern Master," 126.

46. Grace Glueck, "Tony Smith, 68, Sculptor of Minimalist Structures," New York Times, December 27, 1980, sec. D, p. 26.

47. E. C. Goossen, "Tony Smith, 1912–1980," Art in America 69 (April 1981): 11.

48. Goossen, "Introduction," n. p.

49. The asymmetrical polyhedra of Sol LeWitt's more recent work, in particular those found in his wall drawings, show a striking affinity to tilting shapes of Smith's Wandering Rocks and related pieces.

50. Goossen, "Introduction," n. p.

51. Walt Whitman, Leaves of Grass (New York: Viking Press, 1959), 26.

52. Hunter, "The Sculpture of Tony Smith," 8.

53. Ibid., 6.

54. Samuel Wagstaff, Jr., Tony Smith: Two Exhibitions of Sculpture, exh. cat., Wadsworth Atheneum, Hartford, Connecticut, and The Institute of Contemporary Art, University of Pennsylvania, Philadelphia, 1966, n. p.

55. "Sculpture: Presences in the Park," Time (February 10, 1967): 74.

56. Wagstaff, Tony Smith: Two Exhibitions of Sculpture, n. p., and "Sculpture by Order," Time (September 14, 1970): 72.

57. Wagstaff, Tony Smith: Two Exhibitions of Sculpture, n. p.

58. Hunter, "The Sculpture of Tony Smith," 8.

59. Wagstaff, Tony Smith: Two Exhibitions of Sculpture, n. p.

60. Ibid.

61. Interview with Tony Smith conducted by Elayne H. Varian, in Schemata 7, exh. cat., Finch College Museum of Art, New York, 1967, n.p.

62. Wagstaff, "Talking with Tony Smith," 18.

63. Smith, "Pattern of Organic Life."

64. Lucy R. Lippard, "The New Work: More Points in the Lattice," in Tony Smith: Recent Sculpture, exh. cat., M. Knoedler & Co., New York, 1971, 18.

65. Wagstaff, "Talking with Tony Smith," 17.

66. John Chandler in Lucy R. Lippard, Tony Smith (New York: Harry N. Abrams, 1972), 17.

67. Smith, transcript of a lecture given at the Whitney Museum, 1976.

68. Goossen, "Introduction," n. p.

69. Ibid.

70. Wagstaff, Tony Smith: Two Exhibitions of Sculpture, n. p.

71. Jane Livingston, "Tony Smith," in A Report on the Art and Technology Program of the Los Angeles County Museum of Art 1967–1971, exhibition organized by Maurice Tuchman, 309.

72. Ibid., 310.

73. Smith himself characterized these massed tetrahedra as "hostile" (Lippard, "Tony Smith: Talk about Sculpture," 68). "Dragon's teeth" is the author's choice of words, and refers to the German name for antitank barricades during World War II.

74. Wagstaff, Tony Smith: Two Exhibitions of Sculpture, n. p.

75. Scott Burton, "Old Master at the New Frontier," Artnews 65, (December 1966): 53, 54.

76. Lippard, "Tony Smith: Talk about Sculpture," 48.

77. Letter from Tony Smith to Fritz Bultman, February 14, 1955, Archives, Tony Smith Estate, New York.

Architecture · JOHN KEENEN

I go forth to build out of the joy of my being![1]

TONY SMITH—ARCHITECT, ARTIST, TEACHER, AND POET—created a complex and diverse body of work. Although he is known primarily for the sculpture he produced during the last twenty years of his life, the origins of his ideas and process were rooted firmly in architecture, which he practiced for three decades beginning in the late 1930s. While there are moments in Smith's architectural career that offer clues of his predisposition toward sculpture, the transition from one discipline to the next occurred gradually. For Smith the two activities were clearly symbiotic, even though he considered them fundamentally distinct: his architecture frequently reflected his interest in sculptural form, and his later sculpture was to draw from earlier architectural experiments and, importantly, his periodic experiences as a builder of his own designs. The lifework produced by this intellectually restless architect/artist, when viewed in its entirety, is powerful, yet resists quick analysis. The writer Tennessee Williams, a longtime friend, wrote of the compelling nature of Smith's work: "Its inaccessibility to an easy comprehension, or perhaps to any comprehension at all, is the heart of that power."[2]

Smith was to leave behind some fifteen buildings—principally houses but also churches, and memorials among them—and even more unbuilt projects.[3] Ideas for these various projects were rendered in the form of both freehand and draftsmanlike drawings, paintings, models, and journals filled with more sketches, mathematical calculations, poetry, and theoretical writings. All showed what was to be a lifelong commitment to and passion for building. The rendering of ideas into built form was not an end in itself for Smith, but an activity through which he aspired to achieve an architectonic result: that the act of building would be a fundamentally poetic, rather than simply pragmatic, process.

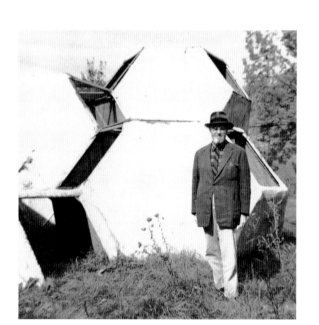

1. Tony Smith with *Bennington Structure*. 1961

Smith's architectural repertoire was expansive as he built with varying materials, at different scales, and always with structural ingenuity. He supervised the construction of his buildings and oftentimes even acted as the builder himself. These experiments remained with him as he moved, in later years, from architecture to sculpture, or as Smith himself described the transition, "speculation in pure form."[4] *Bennington Structure* (fig. 1 and p. 50), an abstract, semi-architectural work, was a pivotal piece that was more sculpture than architecture. It was created in 1961 at Bennington College in Vermont, where Smith was teaching two courses, one in painting and another in basic architectural design entitled "Space." *Bennington Structure,* made with the help of his students,[5] prefigured such works as *Smoke* (1967; p. 167) and *Bat Cave* (1969; fig. 2) and marks both an intellectual and a professional shift as Smith consciously gravitated toward sculpture and away from what he believed were the inherent constraints of the architectural profession—or, as he called it, the "business of architecture."[6]

Smith's architectural ideas sometimes appear to be overlapping and interweaving, and even contradictory. He was capable of pursuing more than one path simultaneously, as is evident in a chronological survey of his architecture projects, a progression that is anything but linear. Nonetheless, when viewed in its entirety, Smith's production can be seen as having a comprehensible series of influences, which manifest themselves both serially and in multiple form.

First and foremost, he was influenced by the divergent formal principles and the somewhat loosely defined concept of the organic that characterized Frank Lloyd Wright's "Usonian" architecture of the mid-1930s and thereafter. Later in his career, Smith was to be further impressed by the more rigorous and abstract formal principles of European modernism, particularly evident in the work of Ludwig Mies van der Rohe, Le Corbusier, and Marcel Breuer. While there are numerous instances in which Wright's work appears to be in opposition to that of the Europeans, there are cer-

tain moments when there are great affinities. These additional influences on Smith manifest themselves, alternately, as assimilation as well as disjuncture.

More than most architects, Smith found that the day-to-day realities of his many private commissions increasingly challenged his architectural aspirations. Economics, programming, and the difficulties inherent in the construction process often led to what he believed was a compromised aesthetic. Historically, the client-architect relationship has been known to be a potentially volatile one, perhaps best caricatured in the figure of the architect Howard Roark, the protagonist of Ayn Rand's 1943 novel *The Fountainhead,* who dynamites one of his own designs—a building he felt was compromised through client intervention. There was an equally defiant, if less dramatic, resistance on Smith's part to modify his designs—some of which he believed to be mystically, if not divinely, inspired—according to his clients' needs or what he perceived as their whims. Smith was particularly upset by his lack of control over the construction of Fred Olsen's Houses and his clients' constant intervention and insistence on implementing changes of their own. He was to describe to a friend how the design had come to him in a dream, "Like a Goddess, complete."[7] That the client would choose to modify such an inspired work left Smith feeling powerless and defeated, and fueled a continuing professional and moral dilemma.

This crisis is prefigured in Smith's unpublished text of 1943, "The Pattern of Organic Life in America": "To bring architecture from the level of prostitution to that of the spirit that must inform America's coming years (we) are going to work as artists not business men—*giving* not selling or trading. With every regard for those who would ask us to design buildings for them, our total responsibility to our 'client', nation, time, God forbids that our completed plan be built according to any intention other than our own."[8]

Smith had first been introduced to building during an apprenticeship with Frank Lloyd Wright starting in 1938. Like Wright, Smith had little formal

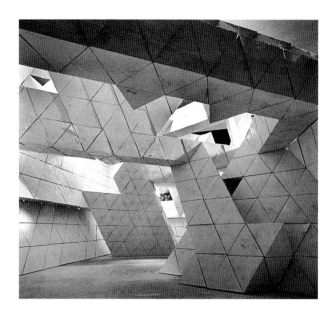

2. Model for *Bat Cave* (1969), with Tony Smith peering through the work. Photograph by Hans Namuth

education as an architect. From 1934 to 1936 he attended the Art Students League in New York City, where he studied drawing and painting following a year of liberal arts studies under the Jesuits at Georgetown University. His first exposure to design, however, was at the short-lived New Bauhaus in Chicago. Smith attended the school during its opening academic year in the fall of 1937, leaving after the school closed the following year. With a curriculum modeled on the German Bauhaus, the school was, in the words of its director László Moholy-Nagy, "a laboratory for a new education,"[9] where students could learn through experimentation while being exposed to a varied and wide-ranging curriculum that integrated the fields of art, science, and technology.

Smith had been frustrated not only by the internal politics of the New Bauhaus, but also by the lack of a specifically architectural curriculum. After leaving the school, he was granted an apprenticeship in Wright's Taliesin Fellowship, which was to occupy him for the next two years. His first assignment was as a laborer on the construction site of the Suntop Houses (Ardmore, Pennsylvania, 1938–39), which were part of Wright's larger vision of a Usonian architecture. This experience was to greatly inform his later work as an independent architect and provided him with an unstructured yet intense education in architecture, building, and culture—a more pragmatic alternative to the typically academic education being offered by architectural schools in America at that time.

Interestingly, Smith's other architectural heroes—Buckminster Fuller, Mies van der Rohe, and Le Corbusier—similarly lacked a formal architectural education. While Wright, Mies, and Le Corbusier all referred to themselves as architects, Smith chose to call himself "builder," a term which reflects the same pride, if not some of the same defensiveness, found in Fuller's self-selection of the term "inventor."

In addition to the more obvious Wrightian sources, Smith was also greatly influenced by the writings of both Jay Hambidge, which he had read as a

grade-school student, and the naturalist D'Arcy Thompson, particularly his book *On Growth and Form,* first published in 1917. For Smith, Hambidge's theory of "dynamic symmetry" was complemented by Thompson's treatise on geometric form as found in nature, which was to be a continuing inspiration throughout Smith's life. He and Theodore van Fossen, whom Smith had met at the New Bauhaus and with whom Smith was professionally associated intermittently between 1939 and 1944, were both interested in the hexagon and together had experimented with its potential design applications. They believed that it was, as Wright stated, the "universal modular," an inherently flexible basic unit of design.

In his work, Smith was to literally employ Thompson's scientific analysis of the "close-packing" of cells and their behavior and structure for years to come. This is especially evident in the 1961 *Bennington Structure,* a built study of Thompson's theory (fig. 3). Smith's Brotherton House, a series of untitled paintings dated 1953–55 (see p. 105), and his later sculpture *Bees Do It* (1970; p. 138, left) show clear affinities and speak to the formal relationship that Smith created among the three disciplines over the course of his multifaceted career.

Working in the field, Smith gained a knowledge and love of the building process, of materials and how they are put together. He also learned a great deal about the economics of building: how to estimate construction costs, control finances, and manage projects under construction. Wright was so pleased with Smith's efforts while working on the construction of the Suntop Houses that he promoted him to "clerk of the works" on the Armstrong House (Ogden Dunes, Indiana, 1939). Smith also gleaned insights into how a building, in Wrightian terms, is cultivated from the landscape, as well as the process through which drawings become edifices. He also learned of the teamwork required to successfully complete a structure and enjoyed the camaraderie of men on the construction site. All this spoke to his imagination and, ultimately, to his need to create. That he derived great satisfaction from his building experiences is evident in his writings as well, perhaps best expressed by him in a poem from "The Pattern of Organic Life in America":[10]

Relax.
Do not press.
Do not seek.
There is no stasis.
Every moment creates a new condition.
Past conditions cannot be recaptured.
Do not try.
Do not plan.
Do not design.
Build.
Wait.
Build.
Build.

In 1942, two years after leaving Wright's employ, Smith began what was to be one of his largest and most ambitious projects, a house for his father-in-law, L. L. Brotherton (Mt. Vernon, Washington, 1944; pp. 51–52, 53, bottom). The house reflects a young man's unresolved ambitions. It is idiosyncratic, overly complex, and the most Wrightian of Smith's buildings. If ambitious, it also bears the mark of earnestness and a demonstrative eagerness to build.[11]

The most notable feature of the Brotherton House is the use of a hexagonal grid as a planning device (fig. 4). This honeycomb grid, applied like wallpaper to the ground plan of the 3,500 square-foot house, was decidedly related to Smith's just-ended experience with Wright, whose interest in organic architecture in the 1930s and later was often expressed in crystalline forms and strongly geometric patterns that were molecular or otherwise drawn from nature. In a particularly clear precedent, Wright had literally adopted the molecular cell structure of a beehive to generate the plan of the Hanna House (Palo Alto, California, 1935–37).

Smith would eventually apply to his architectural designs a three-dimensional cel-

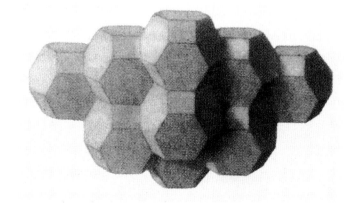

3. Diagram showing the close-packing of fourteen-sided figures, from D'Arcy Thompson's *On Growth and Form* (1917)

lular model, as demonstrated in the Stamos House of 1951. However, in the Brotherton project, it is used principally as a one-dimensional organizational pattern. This pattern, in the end, proved to be a difficult one with which to work, due primarily to the fact that the hexagon unit used by Smith—with each side measuring forty-eight inches—was almost double the unit used by Wright. Why Smith chose this larger hexagon is not entirely clear. What is clear is that the overscaled patterning fails to give the intended order and results in an architecture that is at times tentative and unresolved.

Despite this awkwardness, there is an instance in which the spatial potential of the plan is fully exploited: a shaft of space, hexagonal in plan runs vertically through the structure of the house (p. 52, right). Inserted within is a circular stair that leads from the main floor to the basement. This space fully integrates the house, connecting the living room, entrance foyer, and kitchen and incorporating the back wall of the main chimney, which serves as a literal and symbolic anchor to the spatial ensemble. The stairwell is also marked by natural light, emitted from the light monitor above. In this case, all of the essential elements of the house, from its lowest level (the basement) to its highest point (the chimney), work together as a well-articulated whole.

Smith's spatial intentions are most evident when the building is viewed in section—a two-dimensional drawing in which the vertical plane of the building is sliced through to reveal the construction, structure, and qualities of the interior spaces. (This drawing device is often incorporated into the design process itself, and was frequently used by Smith. The result is an architecture with greater volumetric or spatial richness.) In the Brotherton House, Smith's intentions are especially clear in the public living areas. There, two vaulted roofs overlap and are separated by a narrow gap—a glass reveal that brings light into the interior as it formally animates the exterior. The interior spaces created by this section are muscular and expressive, as are the exteriors (p. 52, left, and p. 53, bottom). The organic sensibility of the house is obviously inspired by Wright's work, but the

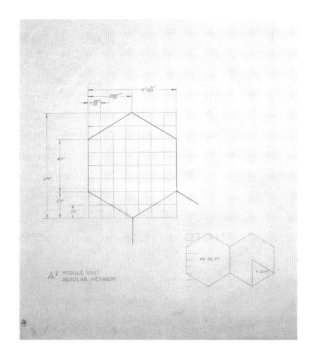

4. *Brotherton House* (A1 module unit, regular hexagon). c. 1944. Pencil on paper, 19½ x 17¾" (49.5 x 45.1 cm). Tony Smith Estate, New York

proportions of the Brotherton House are more acute, even more extreme, than those in buildings of Smith's erstwhile mentor.

In the set of construction documents for the Brotherton House, which clearly demonstrates Smith's ability as a draftsman, there is a series of three-dimensional detail drawings, including an especially revealing isometric of the primary structural masonry piers: rhomboid forms aligned in a staccato rhythm (p. 51, right). Here Smith's vision of the house is not spatial, material, or even structural, but rather sculptural. His later sculptures were often composed of numerous pieces intended to be viewed collectively, and in some cases—such as in his rigorously ordered *Lunar Ammo Dump* (1968), and the later *Ten Elements* (1975–79)—the individual pieces succumb to the whole, as they do in this drawing of ordered fragments. The same can be said of Smith's submission for the Franklin Delano Roosevelt Memorial competition (1960; p. 64, top left), a tripartite arrangement of monolithic walls, set upon a plaza for a site in Washington, D. C.

While the hexagonal planning of Wright's Hanna House may be said to have greatly influenced Smith's major, built design, Wright's real impact on the young architect can be seen in the broad range of projects that he was creating in the 1930s. At this point in his career, Wright was not producing work that had a consistent formal quality but rather that which espoused a certain sensibility. In the Ocatillo Desert Camp and Taliesin West, for example, Wright's sense of integration with nature appears to be a humble one: the forms and materials of the structures seem to blend with the surrounding landscape. Of the Ocatillo project (which served as temporary quarters, with canvas roofs and a board-and-batten palisade, for Wright and his draftsmen), Smith later wrote, "The Desert Camp . . . what will it be when it is developed as architecture!"[12] That Smith could absorb the lessons of the Hanna House and the ephemeral Ocatillo Desert Camp shows the extent to which he internalized the ethos of Wright's Usonian work, rather than the forms, spatial configurations, or material qualities of any one project.

A year after the Brotherton House was completed, Smith embarked on the design of another project, this time for his friend, the painter Fritz Bultman (p. 53, top). For Smith, the Bultman Studio (Provincetown, Massachusetts, 1945) was a cherished commission and afforded the opportunity to make sublime architecture out of what was to be one of his most modest projects. The program was elemental: a simple structure that needed to accommodate Bultman's large canvases as well as capture the available northern light. Here Smith appears to have been designing from the outside in, the final result being a building that is voluminous and seemingly sculpted from a solid mass. While the plan is a simple rectangle that is symmetrically ordered on its north-south axis, the building's spatial complexity becomes evident when viewed in section. The resulting interior spaces of the studio have an ecclesiastical quality to them, in the spirit of the chapel that Smith designed for the Bultmans, in the same year, as a wedding present (p. 54, bottom). Smith planned the studio with the knowledge that he and the painter would build it together—which they did, with the help of local fishermen—during the summer of 1945. As building materials were scarce in the immediate postwar years, the studio was primarily constructed of salvaged materials taken from two wooden barns that Bultman had purchased from a neighbor. The continuous structural system for the humble building was assembled on the ground and then raised into place.

A masonry foundation wall rises from sandy ground on the north end of the building. This brick wall serves as both a retaining wall and a support for the folded planes of the aluminum-clad roof, which is a dominant feature of the building. The highest point of the roof is found on the north face of the building. Here the roof rises sharply upward to its full height of sixteen feet, incorporating north-facing windows within the studio's steeply sloped facade. From this peak, the folded roof planes slope downward to the south, ending in a series of exposed roof beams that eventually become freestanding buttresses, not unlike Wright's drafting studio at Taliesin West. Smith had used a similar version of these buttresses in the Brotherton House. While in the case of the latter they are purely

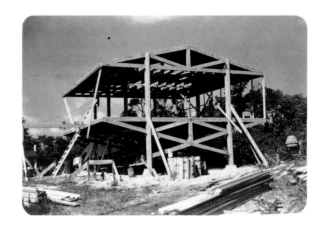

5. Stamos House under construction. 1951

formal and have no structural function, in the Bultman Studio they are structural and integral to the building. They also serve to ceremonially mark the entrance to the studio and to anchor the south facade, countering the massive volume of the barnlike roof at the opposite end.

The period during which the Bultman Studio was conceived and built was marked by the privations of postwar economics, which triggered a near halt in the construction industry in America as well as in professional architectural activity. As a result, Smith necessarily put most of his energy into teaching. As a professor, Smith was able to test new ideas and pursue interests as they related to his own work. From 1946 to 1950 he taught at New York University. One course was entitled "Visual Arts and Contemporary Culture"; another dealt with industrial design. Between 1950 and 1952, at Cooper Union, he ran an architectural design studio, as he did some years later (1957–60) at Pratt Institute in Brooklyn. Simultaneous with his teaching at Pratt, Smith was also an adjunct professor at the now defunct Delahanty Institute in New York, where he taught courses in mechanical and structural drafting.[13]

During the years Smith was teaching, he continued to produce architectural projects. His most significant work was developed during a brief period in the early 1950s. Three projects, to be discussed later, were to mark the high point of his career as an architect. The Theodoros Stamos House (East Marion, New York, 1951), an unbuilt church project (1951), and the Fred Olsen House (Guilford, Connecticut, 1951–53) distinguish Smith as an iconoclastic and visionary architect capable of transcending past experience and generating truly innovative and daring works.

In other projects completed after World War II, Smith's interest in Wright's work seems to have been tempered by his interest in the work of the generation of architects who had most influenced the course of European modernism in the 1920s and 1930s: Mies van der Rohe, Le Corbusier, and Marcel Breuer. In the immediate postwar period, the influence of these three architects would increase throughout the United States as well. Mies's design for the new campus of the Illinois Institute of Technology in Chicago (1953–56) and the

innovative program of teaching architecture there made a mark on a generation of planners and architecture students. Similarly, Le Corbusier's lead role in the 1946–47 design of the new United Nations Headquarters and Marcel Breuer's 1949 exhibition house constructed in the garden of The Museum of Modern Art, both in New York City, put a European vision of modernism high on the agenda of postwar American architecture.

In the house Smith designed in 1951 for Fred Olsen, Jr, certain references to Le Corbusier are clear (p. 63, bottom left). The self-contained, two-story building is elevated on slender columns —*piloti* in Le Corbusier's own terms—organized about an exterior court and is constructed on a six-square grid and structured with exposed steel I beams. The compositional juxtaposition of solid forms and spatial voids recalls what Colin Rowe referred to as Le Corbusier's "phenomenal transparency,"[14] which he felt derived from the architect's familiarity with the Cubist paintings of Braque and Picasso.

The Orlando and Barbara Scoppettone House (Irvington-on-Hudson, New York, 1952) demonstrates Smith's ongoing interest in Wright's Usonian architecture (p. 55). In fact, the house is located just a short distance from the town of Pleasantville, where Wright planned an entire community of individually designed, modestly priced suburban houses for the postwar middle-class family. Wright visited the Scoppettone House after its completion. The modest 1,000 square-foot, one-bedroom Scoppettone House shows a tectonic refinement lacking in the earlier Brotherton project. Here Smith was to master the building techniques learned from Wright, as is evident in the detailing, proportions, materials, and overall integration of the structural system. Like the Brotherton House, the Scoppettone House was designed primarily in section, the characteristics of which can be seen in the alternating pitch of the two primary roof planes and slight split-level changes among the three floors of the house. These variations further help to distinguish between the private and public areas. Smith chose not to repeat his experiments with a hexagonal grid and employed the more straightforward orthogonal grid, which also typified many of Wright's Usonian houses of the period.

6. Stamos House under construction, with Tony Smith (top left) and crew. 1951

The house is a hybrid of wooden post-and-beam construction, combined with supporting masonry walls. As in the Brotherton House, a band of clerestory windows is used to connect the two disjointed roofs. A series of parallel triangulated trusses forms at this intersection where the roofs are joined together by the clerestory windows (p. 55, bottom right). These trusses are articulated on the east and west elevations as triangular windows, which mimic the interior structural system. The brick foundation walls, which anchor the building, form a plinth that defines the building's footprint and supports the upper wooden volumes of the house. On the south elevation the brick walls are extended upward to frame the glass wall of the living room, creating a flat-roofed, columnless portico that, together with the steep and staggered roof planes, make for a well-balanced and studied composition.

Reference to a colorful design sketch for the project (p. 54, top), dated 1952, indicates that Smith had considered an alternate *parti*, or design scheme, which was wholly unlike that of the built scheme. Here the idea for the house was one of carving or sculpting from a platonic volume, and the play of solid-void relationships was emphasized. In the built version, the Scoppettone House was formally expressive, rather than rationally based, resulting in an entirely different (and perhaps more complex) set of spatial conditions than is evident in the design sketch. Again Smith's use of section shapes the interior and results in an exterior of well-articulated volumes, which can be simultaneously viewed as independent forms and as a universal composition. In light of Smith's later sculpture, it is tempting to read these volumes as abstract masses, devoid of their inherent function. Yet the designer was well aware of the difference between what distinguishes architecture from sculpture, and years later he remarked, "Architecture has to do with space and light, not with form; that's sculpture."[15]

Smith's work from this time forward demonstrates the fact that space and light can be rendered in endless architectural modes. As he matured as an architect, Smith seemed capable of an easy movement between architectural ideas and histories. In addition to Wright's Usonian principles, which positively inspired the Brotherton and Scoppetone houses, as well as the Bultman Studio,

Smith also absorbed the work of other architects practicing at the time.

Smith's 1954 project for a Glass House (p. 61) demonstrates his interest in the more rigorous and abstract work of the European modernists. Only two sketches were produced for this project: a charcoal perspective view and a roof plan (fig. 7) that give a clear, if scant, idea of Smith's proposal. The house is grounded in a timely Miesian aesthetic: the minimalist steel-and-glass structure which the German architect had designed for Edith Farnsworth and which was built in Plano, Illinois, in 1949. (Smith was not the only American architect influenced by Mies's design for a glass house. Philip Johnson designed and built his own version in 1949, and Frank Lloyd Wright published yet another iteration in the *Ladies' Home Journal* in 1945.) Yet Smith alters Mies's elemental box by giving it his own distinct language and ethos: he incorporates within its otherwise rigid steel framing system a prismatic faceting, thus transforming the strict formal geometries. The result is a fusion of Mies's technological and structural concerns and a crystalline profile[16] which prefigures Smith's interest in pure sculptural form.

Smith's parallel interests in his explorations into form can be seen in two of the last structures he designed, the Parsons Studio and Guesthouse (Southold, New York, 1960 and 1962, respectively), which were undertaken even as Smith was embarking on his career as a sculptor.[17] Betty Parsons, an art dealer who knew Smith from New York, proved to be a generous and trusting client. She presented Smith with the simplest of programs: to create a large space in which to paint, with tall ceilings and good light. Her budget was small, and the emphasis was on the studio space itself, while the living accommodations were to be kept modest. The site was spectacular (p. 57, top): a precipice located atop a cliff known as Horton Point, situated seventy feet above Long Island Sound with views of the water and the horizon. Parsons left for Europe in the summer of 1961, expressing confidence in Smith and requesting that the studio be completed upon her return.

The minimalism of the flat-roofed Parsons Studio and Guesthouse is

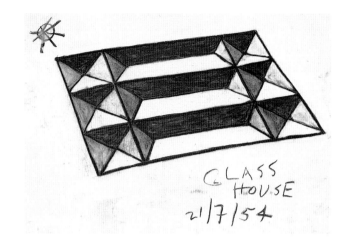

7. *Glass House* (roof plan). 1954. Charcoal on paper, 12 1/8 x 17 3/8" (30.8 x 44.1 cm). Private collection

representative of Smith's forays into Cartesian, if not Miesian, formalism. As in the Glass House project, Smith left behind the organic, naturalist form-making which characterized much of his earlier work, and arrived at a rational architecture more akin to his monolithic sculpture *Black Box* (p. 150) than it was to the *Bennington Structure*, both of which were concurrent with the Parsons project. The studio (fig. 8; pp. 56–59) is comprised of a primary volume, square in plan, which encloses the double-height studio space, and a smaller, secondary volume that contains a kitchen and bathroom below and a small bedroom above. A curving exterior stair, which springs from the base of the monumentally proportioned porch, joins the large and small volumes of the building.

There is a randomness and flatness to the structure's elevations that relate to the studio volume within and the need to capture the clear Long Island light. Taken individually, the elevations appear as seemingly unrelated compositions, consisting of various-sized punched openings, different shaped windows (some with exterior sliding shutters), oversized, barnlike doors (for moving large canvases), and a formally composed, wooden curtain wall at the porch entry.

In contrast to the studio, the guesthouse (p. 60)—located away from the bluff and set in its own clearing—is a simple rectangular volume, raised approximately four feet above the ground on concrete block piers. The plan is elemental and restrained. It adequately fulfills the programmatic requirements but, in itself, has little architectural significance. In this sense, the guesthouse is similar to the Stamos House (p. 64, bottom) in that the intent of the architect can be most clearly read on the exterior surfaces of the structure rather than in its plan. The guesthouse has an elaborate, if not mannered, series of wooden stairs and decks which attach to the south longitudinal facade. On the one hand, this somewhat overscaled appendage seems to have nothing to do with the house itself other than, perhaps, to enliven a rather rudimentary structure. On the other hand, the sequential experiences offered by the connecting stairs relate the house to the landscape in a decidedly extravagant and sculptural way. The rationalized simplicity of the Parsons House and Studio speaks not only to Smith's

oscillation between Wrightian organicism and a more rigorous and abstract sense of European modernism, but also to his own inner conflict as an architect and an artist, between rationality on one hand and expressiveness on the other.

Like many architects, Wright and Corbusier among them, Smith spent considerable effort trying to bridge the two positions. Wright's investigations into the systemization of building materials and techniques, which included his "American System-Built Houses" (1915–17) and his Textile Block System (1923), among others, were aimed at preserving the economic reality of the most romantic of American dreams: the middle-class single family home. Le Corbusier's Modular of 1946, which related architecture to the "mystical proportions of the body," attempted to infuse an increasingly technologically driven architectural culture (ironically, one that Le Corbusier was instrumental in developing) with a system of proportions that not only related architecture to the scale of the human body but also to a post-Renaissance model of humanistic culture. For Smith, the notion of a generative module had both pragmatic as well as philosophical, if not spiritual, implications. Certainly the hexagon represented more of the latter than the former. As shown in a detailed drawing of the hexagon used in the Brotherton House, Smith transcribes a circle, the center of which is the point of intersection of the three main wings of the house. Theodore van Fossen has said that Tony was "mystified by the hexagon,"[18] a reference, perhaps, to both its ability to generate expressive form and its stubborn resistance to rationalization.

While Smith was not by nature a theoretician, he used the time he spent living in Germany (1953–55) developing a modular system which he referred to as the "Metric Proportional Grid." Like Le Corbusier, Smith believed that basic geometric relationships all derived from the use of what he termed "the meter as unity."[19] Furthermore, both architects sought to uncover fundamental proportional systems that related architectural production to the human scale. The main difference lay in the architectonic implications of the two systems. Le Corbusier

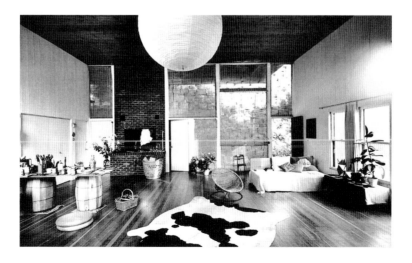

8. Interior of Parsons Studio, Southold, New York. Completed 1960

preferred the completely scaleless material of poured concrete and, thus, analyzed the meter itself to find some external system of proportions to guide his form-making. Smith's favored building materials were the more traditional brick, stone, and timber, each of which has certain dimensional relationships that relate to their production and handling. Hence, the primary unit of his "Metric Proportional Grid" was two meters combined (a rough approximation of the height of a human), rather than the more abstract single meter as analyzed by Le Corbusier. Smith's theories were thus based on the idea that the standard units of measurement in the construction industry (e.g., the dimensions of a single bed or a standard door height) were not arbitrary but related to the needs and therefore the scale of a building's occupants. Merging European notions of humanist culture and American pragmatism, the proportional grid, in Smith's words, had a "simplicity, and usefulness ideally suited for future building applications."[20]

Smith's interest in building systems extended to the construction of affordable housing. He had participated in the National Association of Home Builders Forum in 1950 and had addressed the issue of low-cost housing in his writings and sketches. One such project, "Minimum House for a Revised American Standard" (1941), was a study undertaken by Smith and van Fossen (p. 63, top). The project incorporated inexpensive and available materials assembled with standardized construction techniques. The resulting design was derived both from the stylistic influences of Mies and the building practices of Wright. The rational planning behind this hypothetical project relates it to the Parsons Studio and Guesthouse, as well as to Smith's Roosevelt Memorial competition entry (p. 64, top left).

While Smith's work can be interpreted through his serial interest in early-twentieth-century modernism, to imply that his influences were more important than his own creative skills would be a mistake. In the early 1950s, particularly, Smith embarked on a series of important and innovative projects that are remarkable, even today, for their inventiveness:

the previously mentioned Olsen houses, the Stamos House, and the church project of 1951.

The most modestly scaled of these visionary projects, the Stamos House has few earthly connections, literally or figuratively (p. 62 and p. 64, bottom). Employing a modular system of construction, the design is based not on the repetition of many cells—as was the unbuilt church project or the later *Bennington Structure*—but on the perfecting of a singular cell. This isolated cell has an extruded quality that suggests a potentially infinite module. Although unpretentious and formally forthright, the Stamos House is at the same time monumental and proud, a posture intentionally cre-

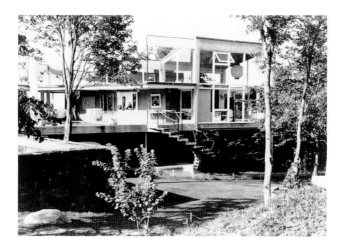

9. Exterior of Olsen Studio, Guilford, Connecticut. Completed 1953

as originally conceived. He oversaw the building process through the summer of 1951, occasionally joining the construction crew to help with the building (figs. 5, 6).[22]

That Smith approached architecture through the process of building is perhaps nowhere clearer than in this project. Beyond the larger ideas from which the design is generated—the purest expression of cellular form— were architectonic ideas about structure and construction. His personal involvement and concerns were ultimately those of a fabricator, as economies of structure, materials, and construction techniques became critical to the building of the house as designed. Smith likened the

ated by lifting the building off the ground to further reveal and emphasize its full cellular form. In this sense it prefigures *Black Box* (1962; p. 150), which floats off the ground on a recessed base. Like many of his later sculptures, *Black Box* was what Smith called a "presence," a concept which can be equally applied to the Stamos House.[21]

What is significant about this structure is not its interior—a simple, square plan—but the exterior volume: an asymmetrical hexagon that emphatically presents itself, gracefully floating above the ground (p. 62). The supporting structure consists of four equally spaced cross-braced trusses made of wood, which hold the hexagonal cell-like body of the building aloft (p. 64, top right). The structure was left fully exposed on the two lateral elevations and infilled with a skin systematically composed of doors, windows, and panels painted in bright primary colors. The tightly composed facades of these lateral elevations, when contrasted with the opaque longitudinal elevations, further emphasize the extruded formal quality of the building.

Compared to his other built work, Smith had considerably more control of the design and construction of the Stamos House, due mainly to the trust afforded by his client. Photographs and letters in Smith's archive studio indicate that he was actively and enthusiastically involved in the construction process of the house, which proved to be perhaps one of his most rewarding professional experiences. The client embraced the design and allowed Smith to construct it

project to a tetrahedral Chinese kite, which had been the subject of experiments by Alexander Graham Bell in 1901. The kite was built from standard building materials specified by the designer, used repetitively, and assembled like a kit of parts. This construction technique was similar to the prefabricated, modular assembly of Buckminster Fuller's Dymaxion House of 1944–46. Interestingly, Smith not only studied Bell's experiments, but was also in possession of working drawings and specifications for Fuller's seminal project.

There are many similarities between the Stamos House and the speculative design for a monumental Catholic church that would have been Smith's first large-scale public building (pp. 65–66). The most visionary of his career, the church project was to challenge Smith on many levels: architecturally, emotionally, and spiritually. In an unpublished essay of 1950 entitled "An Architecture," he wrote: "It is not possible that an architecture should exist without concept, or without structure . . . Architectural function has nothing to do with the banal mechanism of biological, social, or ritualistic functions. Neither has architecture to do with shelter. Nor the three-dimensional space of measure, or space expressed or expressive. It has to do with the creation of a fourth dimensional space in which the spirit might live. A space limpid, serene; a space transparent, concrete, and real."[23] In exploring the "fourth dimension," Smith was to design a powerful and enigmatic church that was to be a summation, in architectural terms, of his interest in Thompson's theories of the "close-packing" of cellular forms.

The church project was a collaboration between Smith, his friend, the painter Jackson Pollock, and the painter Alfonso Ossorio, a Catholic like Smith, who served as the catalyst for the project. The design of the church called for a series of eleven stained-glass panels, which measured approximately three feet in height by seventeen feet in length, to be installed as clerestories above the structure's two elevated hexagonal cells. These cells comprised the church's sacred interior spaces and were accessed via a ramp (p. 66, left). As in the Brotherton and Scoppettone houses, the clerestory acted as a reveal, separating the vertical planes of the walls from the cantilevered roof system. What might be called the primary bay of the decentralized church held a self-supporting glass roof (punctuated with a cross above), below which was to rest the altar.[24]

The roofs of the remaining eleven elevated hexagonal bays were opaque and were to be supported by a central structural column, an extension of the *piloti* that were to hold each cell aloft. The structural system of the roof is akin to that of an upside-down umbrella, as structural struts connect the edges of the roof back to the central column, further supporting the folded roof plates while enhancing the crystalline form of the plan.

The glass-roofed altar bay is surrounded on all six sides by adjoining hexagonal cells that collectively form a larger hexagon. Further cellular attachments, asymmetrically massed, lend a sense of randomness, if not the infinite, to the project. These bays also served to house the auxiliary ecclesiastical areas of the church: the baptistry (resting on the ground, this is the only one of the twelve bays not elevated on *piloti*), sacristy, side chapels, and confessionals. The seemingly arbitrary massing also gave the plan a non-hierarchical and less-authoritative reading, resulting in a church that has no true center. Here the more embracing organic geometry appears at odds with the history of the building type. However, the intentional lack of any hierarchical reading of the plan surely has much to do with what Smith saw as the "problems of Christianity and democracy."[25]

In an interview conducted years after the design was completed, Smith made reference to the structure of Wright's Johnson Wax Building (Racine, Wisconsin, 1936–39). The mushroom-shaped columns, which support the roof of the main work space in Wright's masterpiece, influenced Smith's elevated church design, as is evident in his sectional drawing—one of the few remaining drawings—of the project. Smith also had in his possession an essay entitled "La Maison Suspendu" (1937–38), the subject of which was an unbuilt project by

the architect Paul Nelson. This project, like Smith's church design, incorporated a structural system that elevated the principal spaces above the ground, allowing technology to express the spiritual nature of the program.

Of all his built projects, it is the house for Fred Olsen that best demonstrates Smith's aspirations and potential as an architect. Here we see all the elements of Smith's oeuvre coming together: an ingenious and highly sensitive, site-specific master plan, which is both functional and pragmatic (pp. 67–69); sectional diversity; and the incorporation of diverse structural systems and materials. All of these helped in the execution of an elaborate program. The Olsen project consisted of four buildings. Three were designed for Fred Olsen and sit atop a rocky cliff overlooking Long Island Sound. The fourth, the previously mentioned house for Fred Olsen, Jr., was built on the craggy shoreline below the others.

The notable features of the house designed for the younger Olsen have been mentioned earlier. However, the real significance of the Olsen commission is seen in the three remaining structures designed as a complex and interdependent whole, unlike any of Smith's work either before or after the completion of this project. The essence of the design was Smith's skillful master plan. Two primary elements define and organize the existing site and the buildings that sit upon it: one was the existing topology, and the other, a formally applied geometric patterning, superimposed by the designer. It was the layering of these two organizing devices that gave the site plan an overall complexity, integrity, and visionary beauty.

Smith used the highest point on the property—a natural outcropping of stone—as the center of origin for the plotting of the overlapping geometries from which the buildings are generated. Radiating outward from this point are a series of concentric circles whose edges touch the rim of the cliff that mark the limit of the site. Within the circumference of the outermost ring (which has a radius of fifty-one feet), Smith inscribed a five-pointed star oriented due north. Connecting the points of this star, he then outlined a pentagram, which marked the dimensions and site location of the three building components: a studio which housed the clients' art collection; the main living quarters; and the guesthouse.

The main house and guesthouse, both trapezoidal in plan, were defined by the eastern and southern edges of the pentagram. In contrast, the studio (to the west) was formed by the larger pattern of the concentric circles. The structural bays of the studio were plotted along radiating lines originating at the center point of the circle, and were further articulated by use of an exposed system

of lateral crossbeams and pipe columns. While the two lateral facades radiated from the center point of the master plan, the two longitudinal facades stepped in a faceted fashion along points on the superimposed concentric circles. The roof of the studio is faceted as well, rising up in both directions from the low point in the center. Of the three buildings, this is the most sculpturally expressive and mysterious. As it was to house artwork, perhaps it can also be seen as an indication of Smith's relationship to art itself (fig. 9).

The concentric planning was further exploited by setting the three structures at different elevations, suggesting an upward spiral. The studio is on the lowest part of the site, the main house takes up the middle ground, and the guesthouse is elevated on rough-hewn timber *piloti*. The three are then connected by a series of paths and covered ramps (p. 69), and are further joined on the northern edge by an amorphic, if slightly awkward, pool that wraps itself around the central rock outcropping. Each of these buildings could stand alone on its own merit. As elsewhere, traces of Smith's various architectural influences can be noted, yet they are enriched and transformed by the relationship Smith created between the buildings and their sites, and thus become representative of Smith's particular vision.

As a grouping of buildings, the Olsen project is pure Smith: formally complex, spatially heroic, fearless. The monumentality of the realized compound—confidently securing its position on the rocky precipice like a modern-day Acropolis—represents the strength and conviction with which Smith could build his visions. Yet this project was fraught with disappointment for Smith and was, in fact, the catalyst prompting his retreat from the practice of architecture. Ultimately, his appetite for a greater expression and invention was too resolute to be satisfied by the architecture process alone. Yet the years he spent as an architect—struggling, conceiving, drawing, dreaming, and building—became the backdrop from which he was to emerge as an artist.

With great foresight in his earlier years, Smith articulated what was to become a directive for his life and work: "I can create a life that is filled with variety and richness, simplicity and complexity, naïveté and sophistication, invention and meaning and poetry and love."[26] His life was a constant probing of the physical world, always mediating between conceptualization and the affirming act of building. To fully comprehend Smith's oeuvre, it is essential to see his architecture as a precursor to his artwork, and to frame his later sculpture within the context of the earlier architecture: rightfully, to see the artist as a builder.

Notes

I wish to thank the Graham Foundation for Advanced Studies in the Fine Arts for a 1993 grant, which facilitated my research for this project. I would also like to thank Jane Smith for her initial and continuing encouragement and trust; Sarah Auld of the Tony Smith Estate for her constant assistance and patience; Terence Riley for his thoughtful criticism and guidance; Andrew Bush for his insightful photographs and advice; Shana Jackson for her comments; and Robert Gober for directing me to the Parsons Studio.

1. Tony Smith, "The Pattern of Organic Life in America," unpublished manuscript, 1943, Archives, Tony Smith Estate, New York.

2. From a eulogy for Tony Smith by Tennessee Williams, Archives, Tony Smith Estate, New York.

3. For a comprehensive listing of Smith's built and unbuilt projects, see Joan H. Pachner, "Tony Smith: Architect, Painter, Sculptor" (Ph. D. diss., New York University, Institute of Fine Arts, 1993), 448–52.

4. Samuel J. Wagstaff, Jr., "Talking with Tony Smith," *Artforum* 5 (December 1966): 15; see also Gene Baro, "Tony Smith: Toward Speculation in Pure Form," *Art International* 11 (summer 1967): 27–30.

5. Along with some students from his architectural design course, Smith enlisted the help of students from the music department at Bennington, believing that as they were aspiring musicians, they had an intuitive understanding of math, which was essential to calculating the design and ultimate execution of *Bennington Structure*.

6. Smith, "Pattern of Organic Life."

7. Interview with Hans Noe, a friend and colleague of Smith's, conducted by the author, April 13, 1993.

8. Smith, "Pattern of Organic Life."

9. Adam J. Boxer, ed., *The New Bauhaus, School of Design in Chicago: Photographs, 1937–1944,* exh. cat., Banning + Associates, New York, 1993, 13.

10. Smith, "Pattern of Organic Life."

11. Although the Brotherton House is primarily the work of Smith, he was assisted by Theodore van Fossen, with whom he was associated in an architectural practice at that time.

12. Smith, "Pattern of Organic Life."

13. From a résumé written by Smith entitled "Anthony P. Smith—Education and Employment Data," c. 1950, Archives, Tony Smith Estate, New York.

14. For a further discussion on phenomenal transparency, see Colin Rowe, *The Mathematics of the Ideal Villa, and Other Essays* (Cambridge, Mass.: MIT Press, 1976).

15. Wagstaff, "Talking with Tony Smith," 16.

16. For a further discussion of Smith's use of crystalline form, see Joseph Masheck, "Crystalline Form, Worringer, and the Minimalism of Tony Smith," in *Building Art: Modern Architecture Under Cultural Construction* (New York: Cambridge University Press, 1993): 142–61.

17. In 1991, upon the suggestion of a friend, I visited the Parsons Studio at Horton Point on the North Fork of Long Island, which was my introduction to Smith and his work. The house caught my eye and imagination, and as a practicing architect, I was led to a study of his architecture.

18. Interview with Theodore van Fossen conducted by the author, March 7, 1995.

19. For an account of Smith's two years in Germany, from 1953 to 1955, see Pachner, "Tony Smith: Architecture, Painter, Sculptor," 178–88.

20. Letter from Tony Smith to Hans Noe, from Nuremberg, November 15, 1954, Archives, Tony Smith Estate, New York.

21. Friedrich Meschede, "Tony Smith—The Presence of Form," in *Tony Smith: Skulpturen und Zeichnungen/Sculptures and Drawings 1961–1969*, exh. cat., Westfälisches Landesmuseum, Münster, 1988, 27.

22. Interview with Jane Smith conducted by the author at the Tony Smith Estate, New York, May 27, 1993.

23. From an essay by Tony Smith entitled "An Architecture," September 20, 1950, Archives, Tony Smith Estate, New York.

24. It is believed that the design of the church underwent some revisions. As I have been unable to locate the revised design, I have chosen to use the design as represented in the original model for the church. For a further discussion of the church, see E. A. Carmean, Jr., "The Church Project: Pollock's Passion Themes," *Art in America* 70 (summer 1982): 110–22.

25. Letter from Tony Smith to Hans Noe, November 15, 1954, Archives, Tony Smith Estate, New York.

26. Smith, "Pattern of Organic Life."

Architecture

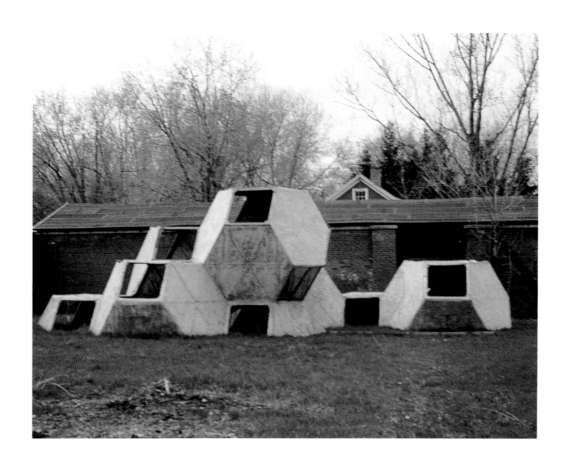

Bennington Structure. 1961. Plywood, metal, lathe, and Portland cement, 40' (1219 cm) long overall; diameter of each unit approximately 9' (274.3 cm). (destroyed)

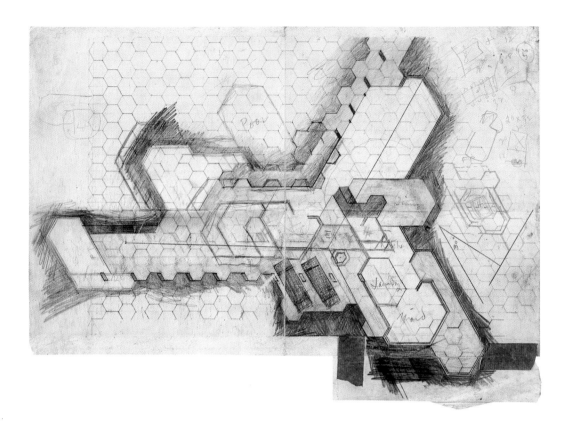

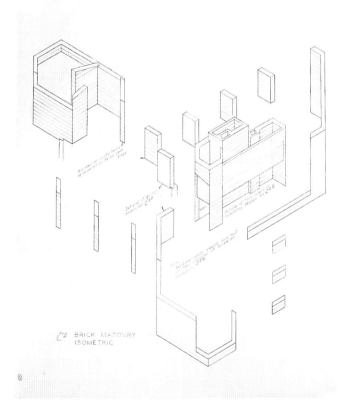

ABOVE: *Brotherton House* (plan). c. 1944. Pencil and colored pencil on paper, 11¹⁵/₁₆ x 19¹/₁₆" (30.3 x 48.4 cm). Tony Smith Estate, New York

RIGHT: *Brotherton House* (isometric). 1944. Pencil on paper, 21⁷/₈ x 17¹/₂" (55.6 x 44.4 cm). Tony Smith Estate, New York

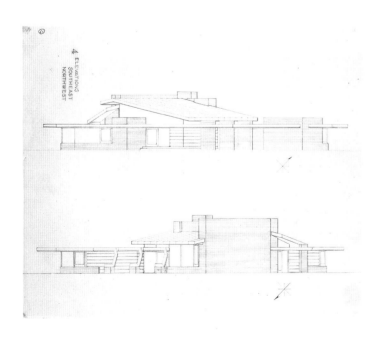

LEFT: *Brotherton House* (elevations). 1944. Pencil on paper, 17¾ x 21⅞" (45.1 x 55.6 cm). Tony Smith Estate, New York

ABOVE: Interior view of Brotherton House, Mt. Vernon, Washington. Completed 1944

THE HENLEY COLLEGE LIBRARY

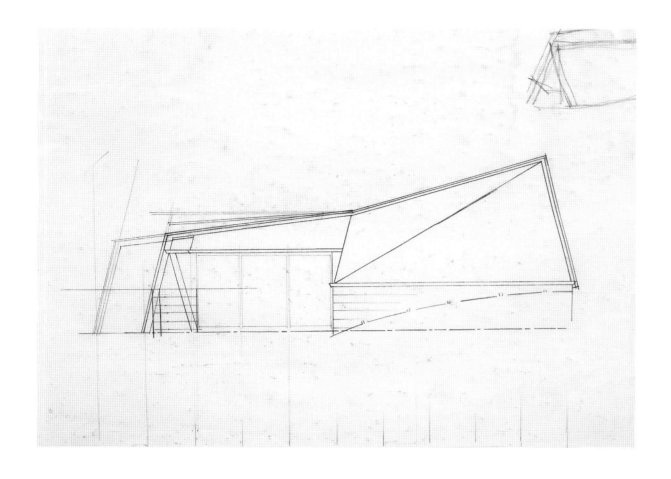

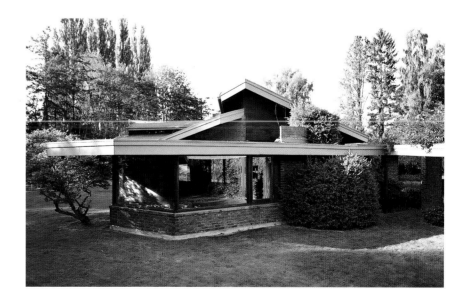

ABOVE: *Bultman Studio.* 1945. Pencil on paper, 16 11/16 x 22 3/8" (42.4 x 56.8 cm) (irreg.). Tony Smith Estate, New York

RIGHT: Exterior view of Brotherton House with glass corner

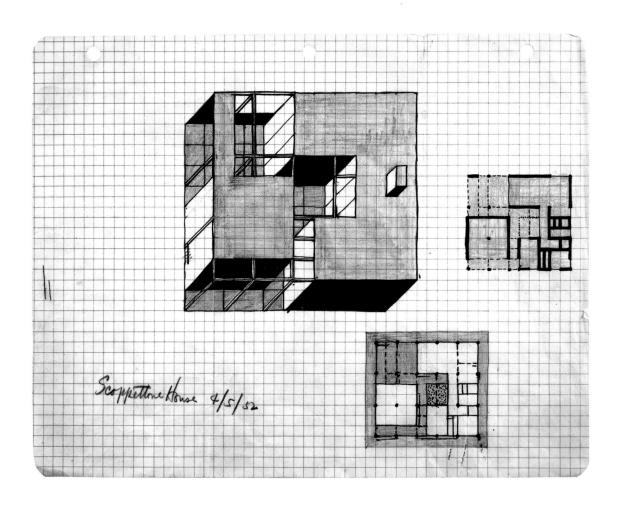

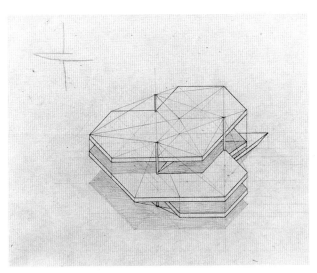

LEFT: *Bultman Chapel* (axonometric). 1945. Pencil on paper, 8½ x 11" (21.6 x 27.9 cm). Collection Jeanne Bultman

ABOVE: *Scoppettone House* (axonometric and plan). 1952. Ink and colored pencil on paper, 8⁷⁄₁₆ x 10¹⁵⁄₁₆" (21.4 x 27.8 cm). Tony Smith Estate, New York

LEFT: *Scoppettone House* (section). c. 1952. Pencil on vellum, 10 11/16 x 13 1/2" (27.1 x 34.3 cm). Tony Smith Estate, New York

BELOW LEFT: Exterior view of Scoppettone House, Irvington-on-Hudson, New York. Completed 1952

BELOW RIGHT: Interior view of Scoppettone House with trusses

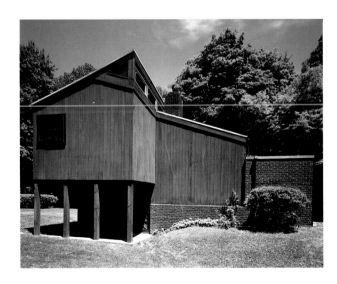

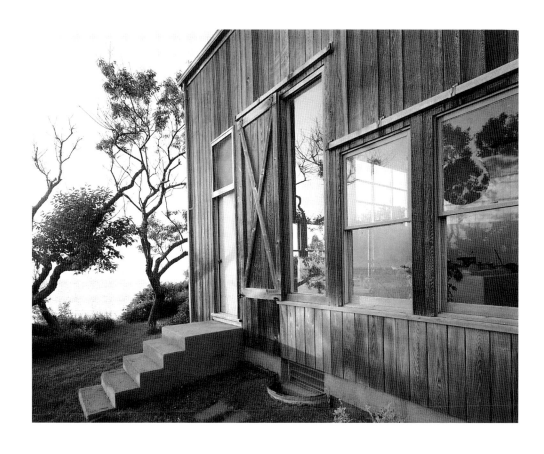

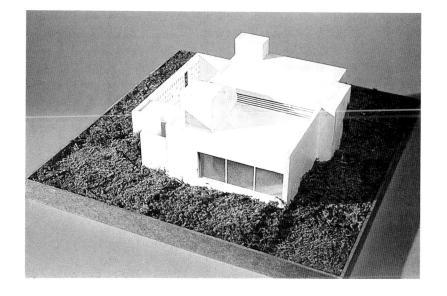

OPPOSITE: *Parsons Studio* (entry portico). c. 1960. Thumbnail sketch in pencil on paper, approx. 4 x 3" (10.2 x 7.6 cm). Tony Smith Estate, New York

ABOVE: Exterior view of Parsons Studio, Southold, New York, with sound view. Completed 1960

RIGHT: Parsons Studio. c. 1959. Model. Painted wood with masonite base, 6 x 18⅝ x 18⅝" (15.2 x 47.3 x 47.3 cm). Tony Smith Estate, New York

BELOW: *Parsons Studio* (perspective). 1960. Pencil on paper, 13⅜ x 24" (34 x 61 cm). Tony Smith Estate, New York

RIGHT: Exterior view of Parsons Studio with walkway. Completed 1960

FAR RIGHT: Interior view of Parsons Studio looking toward entry portico

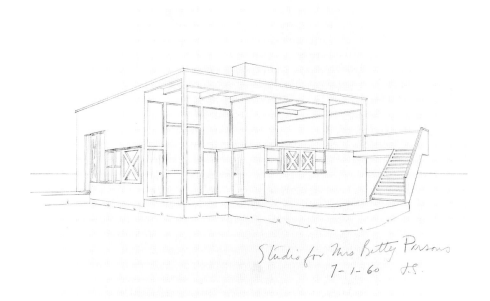

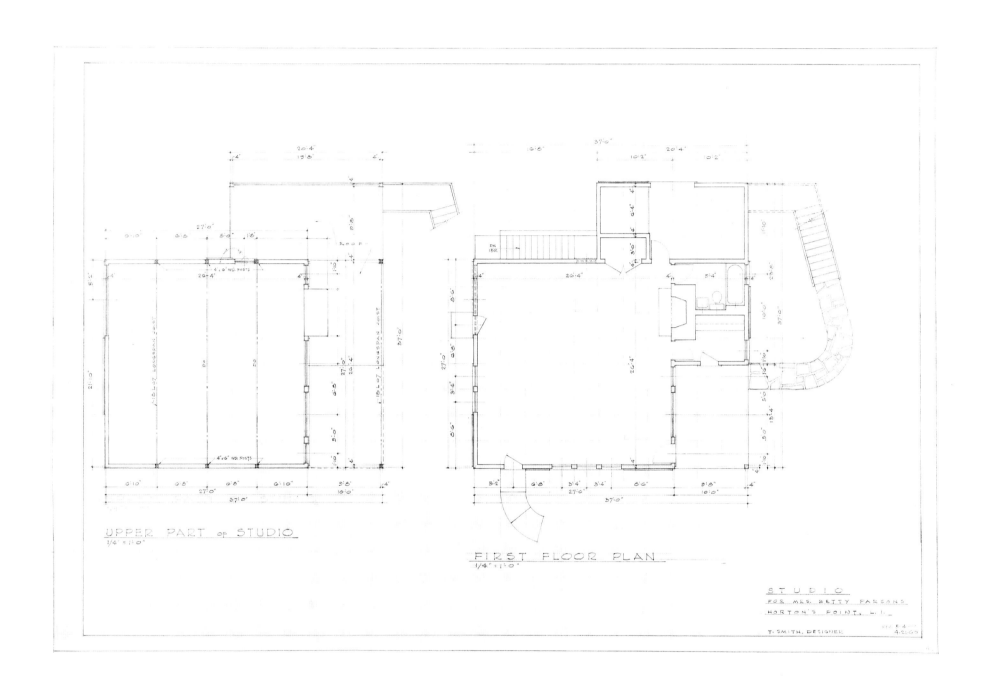

UPPER PART of STUDIO
1/4" = 1'-0"

FIRST FLOOR PLAN
1/4" = 1'-0"

STUDIO
FOR MRS. BETTY PARSONS
HORTON'S POINT, L.I.

T. SMITH, DESIGNER

Parsons Studio (plans). 1960. Pencil on paper, 19⅝ x 30¼" (49.8 x 76.8 cm). Tony Smith Estate, New York

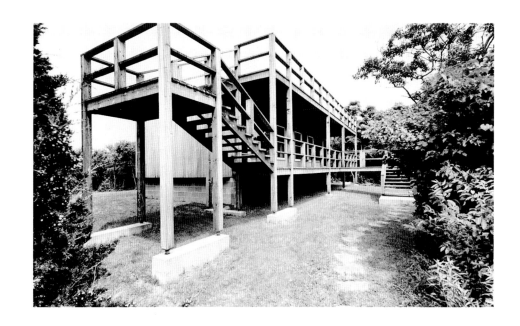

LEFT: Exterior view of stairs of Parsons Guesthouse, Southold, New York. Completed 1962

BELOW: Exterior view of Parsons Guesthouse

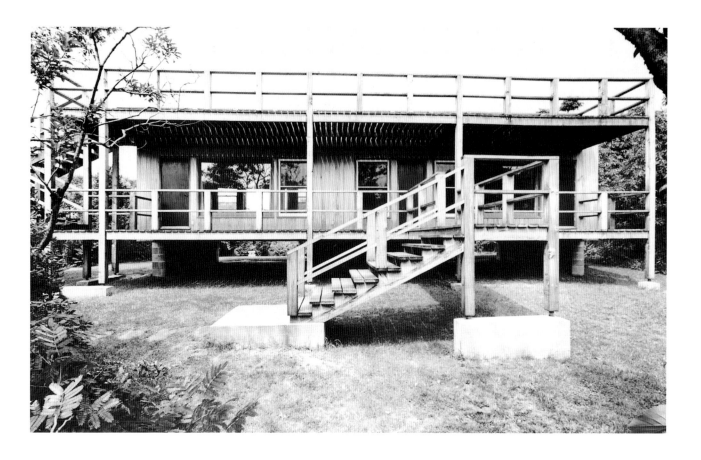

GLASS HOUSE

21/7/54

Glass House (perspective). 1954. Charcoal on paper, 12⅛ x 17⅜" (30.8 x 44.1 cm). Private collection

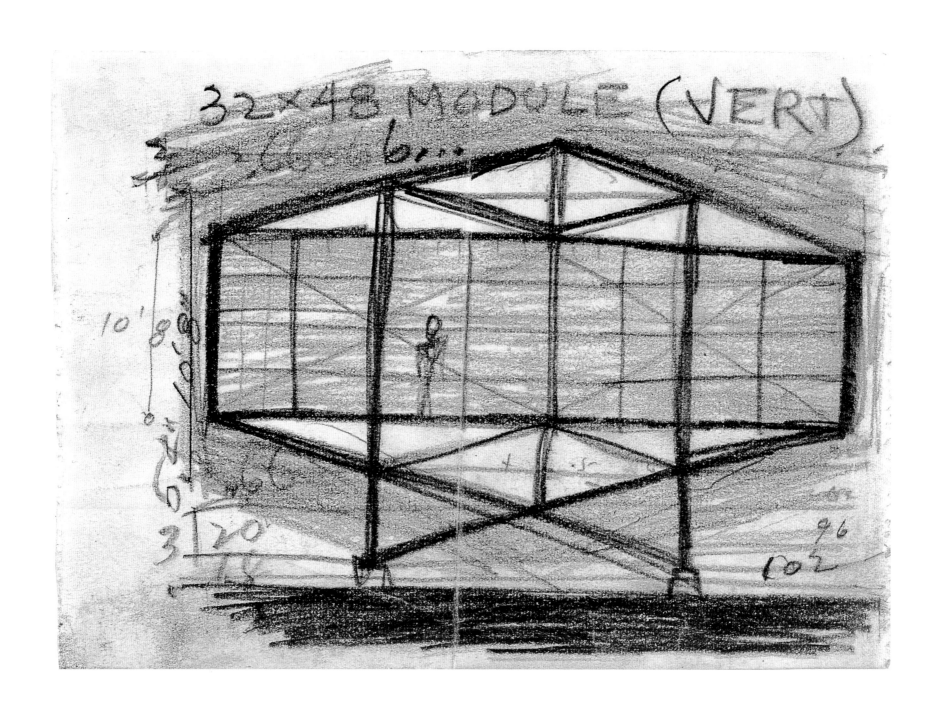

Stamos House (elevation). c. 1951. Pencil on paper, 3⁷⁄₁₆ x 4¹³⁄₁₆" (8.7 x 12.2 cm). Tony Smith Estate, New York

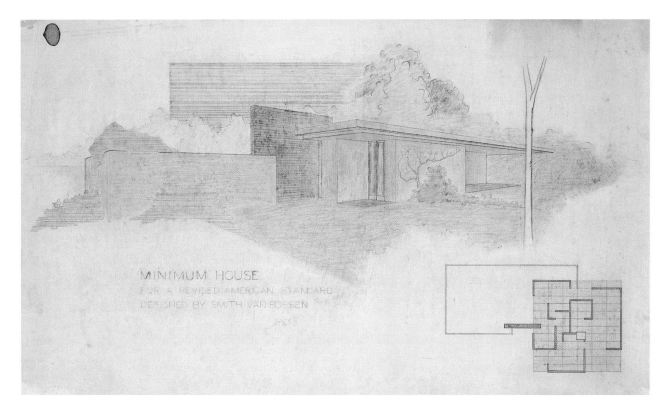

MINIMUM HOUSE
FOR A REVISED AMERICAN STANDARD
DESIGNED BY SMITH VAN ROSSEN

LEFT: *Minimum House for a Revised American Standard.* 1941. Pencil and colored pencil on paper, 18¾ x 32⅛" (47.6 x 81.6 cm). Tony Smith Estate, New York

BELOW LEFT: *Olsen Jr. House* (perspective). c. 1951. Pencil on paper, 18 x 24" (45.7 x 61 cm). Tony Smith Estate, New York

BELOW RIGHT: Proposal for Johnson Wax Museum. 1962. Model. Painted wood, 8¼ x 14¼ x 31" (21 x 36.2 x 78.7 cm). Tony Smith Estate, New York

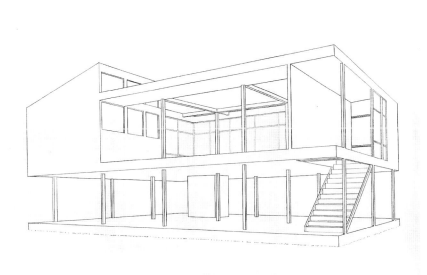

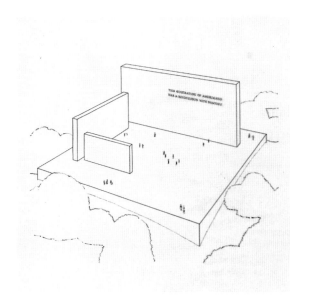

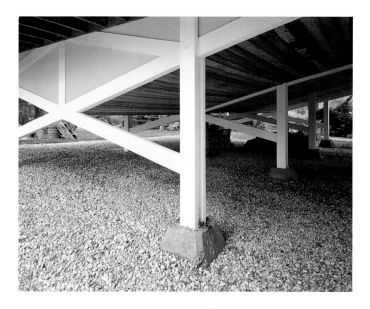

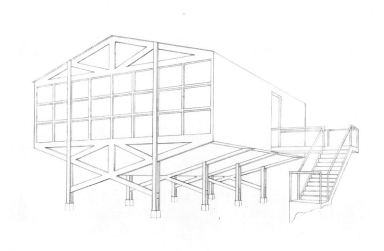

CLOCKWISE FROM UPPER LEFT:

Franklin D. Roosevelt Memorial (perspective). 1960. Ink on paper, 30 ¼ x 43" (76.8 x 109.2 cm). Tony Smith Estate, New York

Detail of exterior trusses of Stamos House, East Marion, New York. Completed 1951

Stamos House (perspective). 1951. Pencil on paper, 17 ¹³/₁₆ x 29" (45.2 x 73.7 cm). Tony Smith Estate, New York

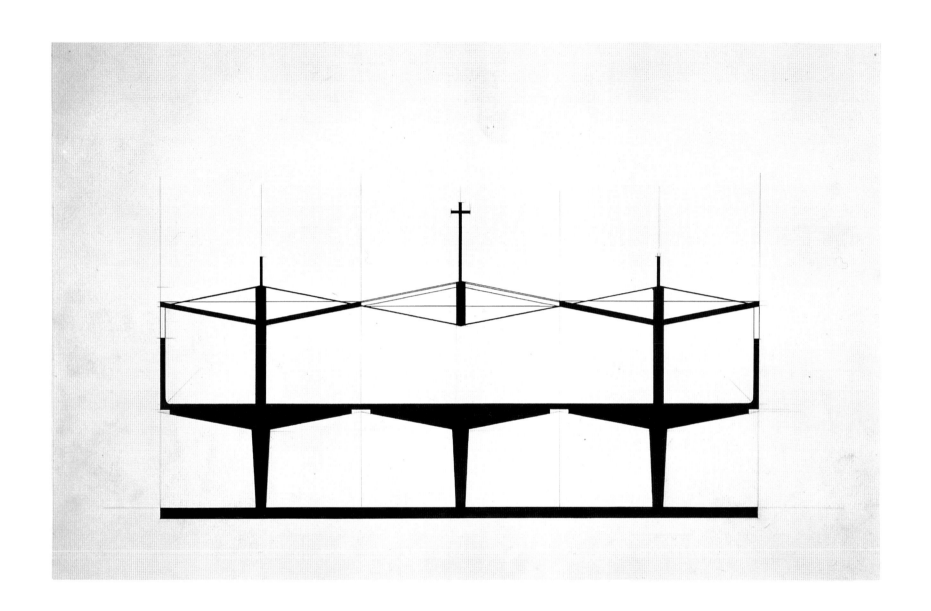

Church. 1951. Ink on paper, 13 13/16 x 21 7/8" (34.8 x 55.6 cm). Tony Smith Estate, New York

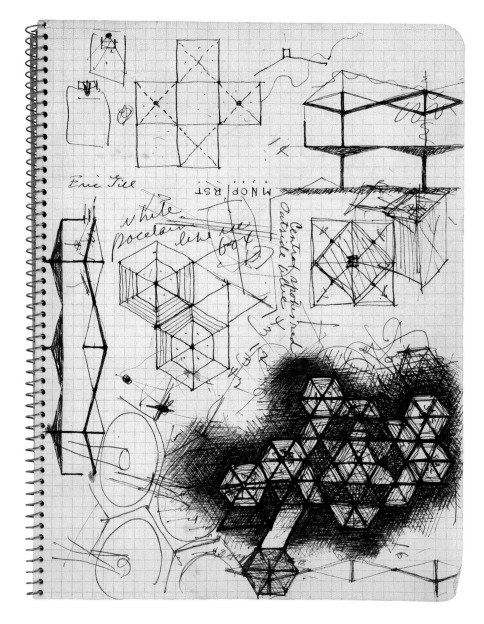

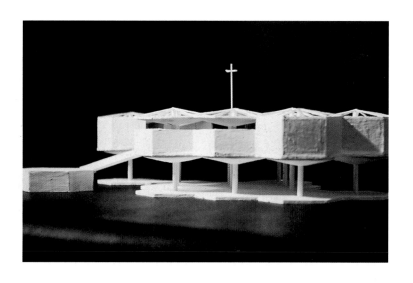

LEFT: Church. 1951. Model. Wood and cardboard with paint and plaster, 6¾ x 18½ x 29" (17.2 x 47 x 73.7 cm). Tony Smith Estate, New York

ABOVE: Page from a sketchbook. c. 1951. Ink on paper, 10⅜ x 7⅞" (26.3 x 20 cm). Tony Smith Estate, New York

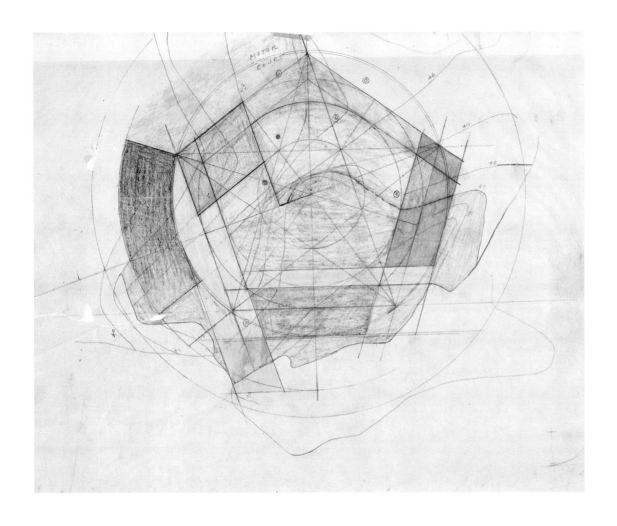

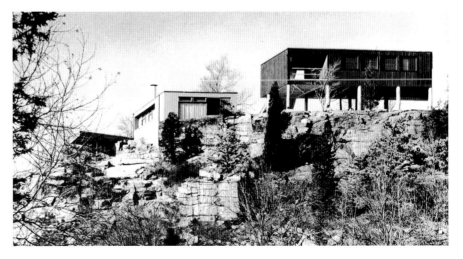

ABOVE: *Olsen House* (site plan). c. 1951. Colored pencil on paper, 18¾ x 23⅞"
(47.6 x 60.6 cm). Tony Smith Estate, New York

RIGHT: Exterior view of Olsen House, Guilford, Connecticut. Completed 1953

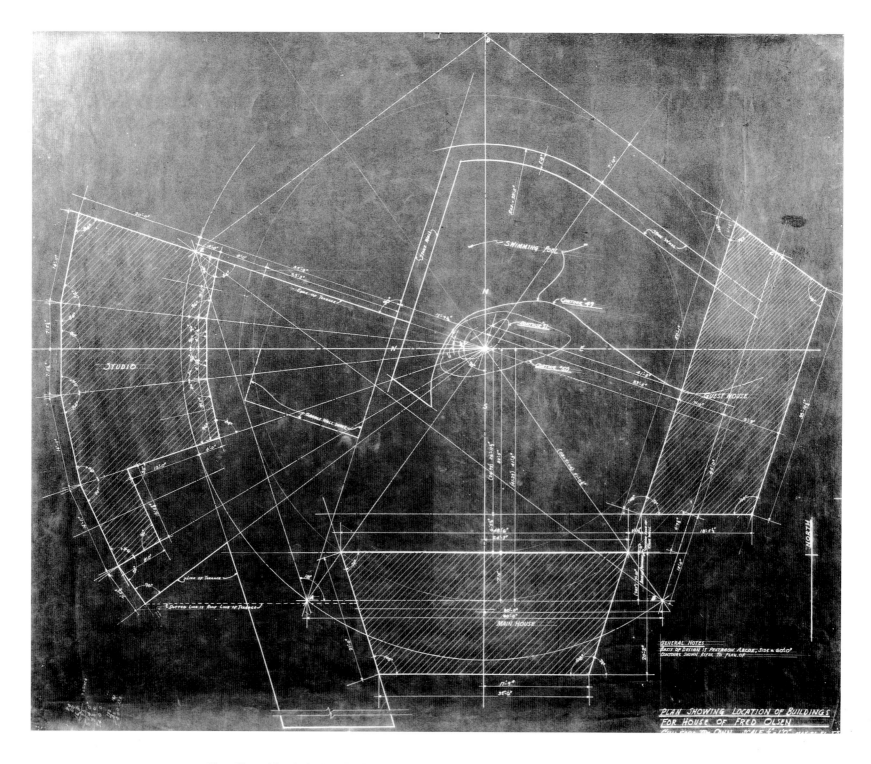

Olsen House (site plan). 1951. Blackprint, 14¼ x 16⅞" (36.2 x 42.9 cm). Tony Smith Estate, New York

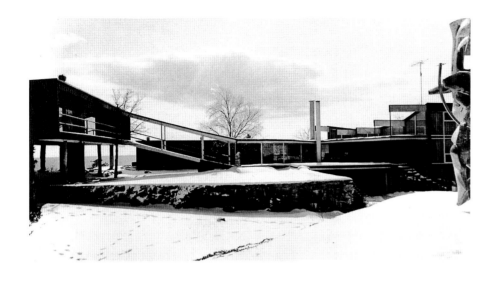

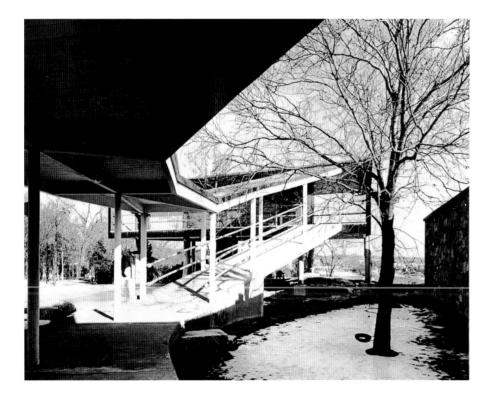

The plan

CLOCKWISE FROM TOP LEFT:

Exterior view of Olsen House. Completed 1953

Page from a sketchbook. c. 1945. Ink on paper, 9 11/16 x 7 1/2" (24.6 x 19.1 cm).
Tony Smith Estate, New York

Exterior view of Olsen House with ramp to guesthouse

Paintings and Drawings · JOAN PACHNER

TONY SMITH'S ORIGINAL AMBITION WAS TO BE A PAINTER. Around 1932, when he was twenty years old, he began attending sketch classes at the Art Students League in New York; he continued there at night for two years, from 1934 through 1936, studying drawing, painting, and anatomy. His most intense periods of painting were in the 1930s, the mid-1950s, and the early 1960s. Painting is an integral aspect of his oeuvre.

Untitled (p. 102, right), of 1933, is among his earliest oils. Referred to by Smith as the "Fiametta cube," this small painting of a cube set in the corner of a room is obscured by a veil of neo-impressionist-style dots in an oval on the surface of the canvas. The prescient image seems to announce his trajectory as an artist.

Among Smith's teachers at the Art Students League was the Czech modernist Vaclav Vytlacil. He also studied with George Grosz and George Bridgeman. Smith deeply admired Grosz, but rejected his model of urban realism. Ultimately, the lessons about modernism that Smith learned from Vytlacil were more important to his artistic development than was any of the other instruction he received.

Under Vytlacil's tutelage, the young artist explored a range of styles through the vehicle of still-life tableaux (pp. 96–98, 102, left). Groups of paintings reveal his ready absorption of early modernist models, including Georges Braque and Juan Gris—artists he was drawn to for their rationalized compositions. Untitled (c. 1934; p. 96) is the most abstract picture of a group of six still-life paintings that includes some of the same elements: a coffeepot and the negative image of a knife. This work is dominated by geometric polygons hovering in an indeterminate shallow space. One senses that the pictorial elements have been flung by centrifugal force toward the edges of the painting, while the center of the composition is notably empty and dark. The four elegantly

1. Untitled. 1934–36. Oil and pencil on canvasboard, 11 7/8 x 16" (30.2 x 40.6 cm). Tony Smith Estate, New York

spare apples in Untitled (c. 1938; p. 98) derive ultimately from Smith's extensive study of Braque's still lifes. In this case, the work suggests a filter of Purism and the lessons of Amédée Ozenfant, whose work Smith admired.

Vytlacil introduced Smith to the then-radical idea that negative and positive shapes could be treated as neutral abstract forms of equal weight. The inherent spatial ambiguity of such a system was explored in Untitled (c. 1936; p. 102, left), a scheme of light and dark gray Escher-like steps to nowhere. Anchored visually to the ground by irregular square shapes on either side of the central image, the steps can be viewed as either going up at the right or coming down from the top left. In another untitled work of the period (c. 1934–36; p. 97), a group of free-floating, organic, abstract forms punctuates the blue color field, creating visual tension between solid and void. The integration of positive and negative space laid the groundwork for Smith's later development of the space-lattice as the physical and philosophical basis for his mature artwork.

The small black, white, and gray paintings Smith began in 1936 were inspired by the Russian Constructivist Kasimir Malevich and the De Stijl artist Georges Vantongerloo. In some instances, such as Untitled (1934–36; fig. 1), the squares and rectangles appear as flat, thin forms hovering in a shallow, indeterminate space. In other works, the black rectangular units project the image of more massive forms. For example, the oddly top-heavy composition of Untitled (c. 1933; p. 99) suggests an object much larger than the size of the work itself, perhaps presaging the sculptures Smith would make many decades later. The unusual positioning of dominant black rectangular bars along the right side and bottom of Untitled (c. 1933; p. 101, center) gives prominence and palpability to the negative white rectangle; Smith used this same scheme in his 1960s paintings. The rectangles in Untitled (c. 1934–36; p. 100, top left) hover around an empty center. This picture recalls an earlier untitled work (c. 1934; p. 96), while at the same time it looks forward to Smith's image of The Spiral

Cross (fig. 2) developed in 1943, as well as to his boldly graphic later paintings.

If crisply painted cubic forms were on one end of the spectrum, pulsing, organic, surrealist-inspired lines, such as those seen in an untitled drawing (c. 1949–50; p. 80), were on the other. This drawing reveals aspects of Smith's art in the later 1940s that are indebted to the innovations of the Abstract Expressionists, especially to the allover style of Jackson Pollock. Smith frequently used automatic drawing techniques as a starting point. In this particular image, he seems to have added elements around the edges of the composition to contain and define an instinctive shape.

An untitled painting, which probably dates from about 1950 (p. 103), is an important transitional composition. A veil of small, evenly spaced, colorful rectangular marks creates a rhythmic frontal plane, obscuring a layer of larger irregular geometric forms painted in light tones underneath. The multidirectional movement of the brushstroke would be tempered by 1953–54, when Smith's urge to regularize and order forms became a central aspect of his work.

From 1953 to 1955, Smith lived in Germany, and these years, during which he devoted much of his time to drawing and painting, were among the most productive of his career. He made a number of different groups of works, which he often created simultaneously. Particularly important are the *Louisenberg* paintings, in which every composition, from the tiniest sketch to the largest oil, was laid out on a grid; each square circumscribed a circle.

In his first year abroad, Smith began to explore a new kind of allover composition based on a system of regular circular modules linked together like beads in a chain into a series of irregular shapes, evenly dispersed across the composition and never touching or overlapping. Formed on an abstract grid, these shapes nonetheless conjure up the teeming world visible under a microscope. Two "linked-bead" paintings done around this time share a family likeness, but to very different effect. The first, done in black and white (1953;

2. *The Spiral Cross,* from "The Pattern of Organic Life in America." 1943. Pencil on paper, 7½ x 9⅝" (19.1 x 24.5 cm). Tony Smith Estate, New York

p. 104), turned the familiar negative white space into a pulsing positive form; the second (1953–54; p. 105) is a vibrating composition of red "linked beads" on a blue ground. While the black-and-white image of the first work resembles nothing so much as a microbe colony of amoebas beginning to take form, the overall disposition and vibrating colors of the second suggest the more ordered, decorative pattern of a textile design.

A group of black-and-white charcoal drawings from the summer of 1954 shows the earlier cell-like beads metamorphosed into a stack of irregularly shaped rounded forms, shaded by charcoal into massive elements that suggest either dismembered body parts or boulders (see p. 81). The varied round shapes in one of the drawings (p. 81, right) are defined by heavily drawn and redrawn dark charcoal contours; forms appear to press against each other and against the edges of the paper. Smith reworked this composition, eliminating the curved, triangular, negative spaces between the boulders and creating new irregularly shaped forms. It is as if the flat negative spaces have been pushed to assume a life of their own and have literally overtaken the volumetric masses. The images become flatter as volumes have been pulled, pushed, and pressed like silly putty into a shallow space.

At the same time as Smith was creating the quivering "linked-bead" paintings, he was also moving in a different direction while using the same basic elements—circles in a grid. In a group of untitled paintings, both the squares of the grid and the circles are larger than the elements in the linked-bead works (1953–54; pp. 107–09). The tangential disks are often united into an amorphous or peanut form using a color overlay. The "peanut" shapes emerge like cells that can be viewed as elements coming together, undergoing meiosis, or separating, as in mitosis. The carefully outlined shapes are crisply painted. The amoebic imagery, particularly prevalent in these paintings (probably mid-1953), presages the *Louisenberg* group (1953–54). The shapes are generally more irregular than they are in the final group of *Louisenberg* paintings.

In these works the tangential disks were united into one peanutlike form by an overlay of color. These paintings represent Smith's first maturity—an assimilation of the modular principles he knew from the New Bauhaus and from his years of architectural work, combined with his interest in urban planning and his desire to reconcile the Apollonian and Dionysian forces he saw in himself and in the world.

This group of paintings (pp. 110–14) represents a leap to a more regularized system that opened up a completely new set of aesthetic possibilities. Consisting of perhaps twenty-five compositions of various sizes and colors arranged within a grid, they were intended to be hung throughout a single building (see p. 22). The division of a whole wall into multiple component parts was a radical way to conceive of a composition. Smith's willfully fragmented arrangement on the wall also suggests an archaeological reconstruction.

Louisenberg #8 (p. 114) is the touchstone, the composition on which all the other paintings in the series were based; it is the image Smith chose to enlarge in 1968 (p. 115). The red ground was added after the composition was completed. This color was a symbolic choice, rekindling the memory of an attic room in his family's house that Smith had painted red in the 1930s; it was also a reference to the crucifixion of Christ.

While Smith repeated and isolated certain compositional elements in this group of paintings, he changed the color scheme from one image to the next and altered the density of the image itself. For example, *Louisenberg #4* (fig. 3) is compositionally identical to *Louisenberg #8,* although the scale has been enlarged. It is the overall range of the color, more than the size or the scale of the image, that causes it to differ in mood and affect from *Louisenberg #8.* The former, on a white ground, appears lighter; the forms seem to float in relation to one another. The latter image, in comparison, appears tighter, more intensely concentrated. The red ground, which outlines the shapes, contributes greatly to the effect.

3. *Louisenberg #4.* 1953–54. Oil on canvas, 39½ x 55¼" (100.3 x 140.3 cm). Private collection

Some compositions within the group are close-up images of the circular format. *Louisenberg #2* (p. 113) and *Louisenberg #5* (p. 112) are variations on the modular sections. The relatively enlarged units of these works, such as *Louisenberg #5,* contrast with the more distanced view of the components, which is evident in *Louisenberg #4.* They all contain the same elements in subtly different combinations, some more painterly than others. *Louisenberg #2,* for example, is painted with thin veils of color, reminiscent of Mark Rothko's mature work, while in others, such as *Louisenberg #4,* the shades are dense and the work looks much flatter. Despite the disparity in scale from near to far within the paintings, the group reads cohesively part by part and part to whole. The working method, which involved a symphonic reuse of like elements to create distinctly different, yet related, compositions, was essentially the same approach that would characterize the sculpture that Smith began to make a few years later.

These modular-based compositions exemplify Smith's continued engagement with the philosophical and aesthetic concept of "generation" he had defined ten years earlier. Smith used the word as a symbol to encompass the biophysical and spiritual implications of generation and regeneration. The concept "generation" had no single given form, but rather was understood as a principle of repetition, like modules or biological cells.

The grid as an organizing structure was essential to these paintings. In Smith's work the grid symbolized the imposed structure of rational societal order, civilization in general, and America in particular. The integral relationship between geometric and organic abstraction that is evident in these paintings had been a central concern of Smith's since the early 1940s. The regular structure that underlies the *Louisenberg* compositions stems from both an architectural tradition and a painterly one.

Smith looked to many sources for an alternative to traditional bilateral symmetry and sought an organizing structure that could incorporate the development of organic form within its confines. Moreover, he believed that the rep-

etition of modular elements—in the form of overall patterns or prefabricated units—was a characteristic of American art and culture. Thus, Smith viewed the allover aspect of contemporary painting and the repeated units in architectural plans as formats particular to American culture.

The hard-edge, geometrically inspired *Louisenberg* pictures exist within a creative milieu that included Smith's friends Barnett Newman and Ad Reinhardt. All three artists had attempted to create compositions based in part on geometric systems that were associated with an overarching philosophical imperative. This is not a goal unique in the history of modern art. Smith was striving to evolve a personal style that fit within the great tradition of modernist painting.

After Smith's return from Europe in 1955, an added level of emotive content, even an urgent sense of distress, is reflected in his work. The many drawings and paintings he created were loosely based on the modular system that he had devised in Germany. These new paintings had as their basis an underlying grid of tangential circles loosely drawn in black on the canvas. The grid itself disappeared, pulling the finished works closer to the more expressionist style of the earlier "linked-bead" paintings. The more casually organized arrangement of tangential circular forms was joined by black spray paint into interlocking groups (p. 118, left). These soft-edge, "dreamy" pictures, with a hint of underdrawing, feel like out-of-focus blowups of the earlier paintings. The amorphous quality of the spray was somewhat more muted in the smaller works when it was overlaid with more conventional, expressionistic brushwork (p. 118, right). These rhythmic, allover compositions were painted in 1956, the year Smith's close friend Jackson Pollock died. These qualities, combined with the way Smith integrated the actual spray of the paint into the compositions, are unimaginable without Pollock's example.

Another group of related paintings from the later 1950s was painted in dark color combinations instead of the clear colors Smith had used when he was in Germany. The paintings now projected a darker, more tormented mood (pp. 116–17). This despairing feeling is underscored by a small sketch dated

4. Untitled. 1961. Ink on paper, 11 x 13⅞" (27.9 x 35.2 cm). Collection Hans Frei

July 4, 1958, that is captioned "malignant" (p. 29).

In 1959 a number of Smith's compositions became more aggressively confrontational in feeling, with forms becoming more attenuated and colors more intense. Yet, at the same time, Smith also created images with large, crisply delineated planes of color, presaging the direction of his paintings in the next decade (c. 1961; p. 120, right). The irregularly shaped, allover configurations, interlocked and free-floating, were common to his compositions in the late 1950s and in 1960.

In the late winter of 1961 Smith was in a serious automobile accident. During his convalescence, he created numerous drawings of organic and geometric forms, all of which were based on an interlocking system of positive and negative shapes. The series reveals his intuitive working method, as one image immediately generated another (see pp. 84–85). The bold, graphic ink drawings indicate Smith's natural tendency toward architectonic imagery. On the whole, these are crisp but not hard-edge pictures. The wavy, hand-drawn profiles (for example, fig. 4) give them a sense of lively animation.

Beginning in 1962 Smith mined the possibilities of the cubic form in two- and three-dimensions. Many of the paintings he made that year are based on combinations of graphic rectangular units that seem to be grounded in both the De Stijl tradition of Theo van Doesburg and Piet Mondrian and in the reductive geometries of American art in the 1960s. While Smith himself asserted that there was almost no correlation between his paintings and his sculptures, the work suggests otherwise. His paintings seem like enlarged details of floor plans—compositions created to be seen from an aerial perspective. Since Smith acknowledged that the problems of architecture, painting, and sculpture are identical, it is not surprising that the aesthetic problems addressed in his two-dimensional compositions mirror those found in his building designs.

When hung on the wall, some of his compositions recall architectonic elements like doors and windows, the same basic shapes he created in his sculptures. The interplay among a number of these paintings (see pp. 124–26) shows Smith working through a variety of relationships between positive and

negative forms and exploring the ambiguity between the architecturally suggestive shapes of the canvas and planar images. In a drawing titled *The Piazza* (1964; p. 88, right), Smith transposed a unitary cube into a two-part spatial puzzle: the front section must be rotated in one's mind in order to fit the contours of the back section. He then re-imagined the separate pieces of the projected eight-foot cubic form as hugely scaled apartment buildings sited at opposite ends of a rectangular plaza. The overall scheme derived from his monstrously scaled architectural designs of the 1950s. These conceptions clearly played an important role in Smith's transition from architect to sculptor.

Many of Smith's ideas on paper from the early 1960s were never realized in three-dimensional form. One example is a drawing captioned "Monster" and dated March 20–21, 1962 (p. 87, left). In addition to the overly complex cubic form, Smith's own notation, "practically a hydrant," suggests that the image may be too literal in its allusions—too close in form to the fire hydrants on New York City streets that had been designed and manufactured earlier in this century by his family's business.

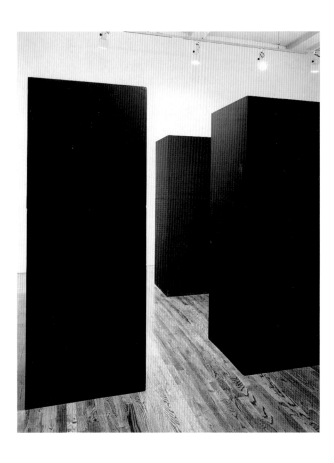

5. *Maze.* 1967. Plywood mock-up; 2 units: 6'8" x 10' x 30" (203.2 x 304.8 x 76.2 cm) and 2 units: 6'8" x 5' x 30" (203.2 x 152.4 x 76.2 cm). Installed at the Paula Cooper Gallery, New York, 1987 (subsequently destroyed)

tures, for example, *Marriage* (1961; p. 146), *Free Ride* (p. 153), *We Lost* (p. 155), and *Playground* (p. 152) (all 1962), and *The Elevens Are Up* (1963; p. 156). Some of these paintings were rendered starkly in black and white, while others were given saturated hues, often reds, yellow ochers, and royal blues, as well as black.

Smith frequently worked with colored shapes pulled to three edges of a painting, with a bar at the right usually ending a certain distance before the bottom; the white negative space created is palpable, yet elusive in form: Is it a door or perhaps a window? Is it open or closed? Curiously, it is the squat configuration of *Playground,* with its cubic central mass and a horizontal, ground-hugging "arm," that is often restated in the paintings. For instance, while the arrangement of graphic elements in Untitled (1962; p. 122) dispersed around a central core is reminiscent of Smith's small constructivist-inspired paintings from the mid-1930s, the shape of the central white space is not only empty but has a square shape with an "arm" projecting to the right along the bottom edge that is reminiscent of the general schemes of both *Playground* and *Marriage.*

Other drawings were made after he had finished a sculpture as a means of clearly elucidating a work's overall plan in a way that he could not have done when the work was in process. He did this with both *Smoke* and *Maze* (fig. 5). The drawing of *Maze* (1967; p. 92, top) places the lithic elements in the context of a triangulated space-lattice. One can see at a glance the fabric in which the wall-like elements existed in his mind. They are related not just to the room in which they were situated, but to the macrocosmic space-lattice, a concept that underlies all his mature work.

A cluster of Smith's architectonic paintings with rectangular units from 1962 and 1963 (pp. 122, 124–26) are comparable to his lineal and planar sculp-

There is also a connection between the triangulated sculptures *Beardwig* (p. 130) and *Duck* (p. 158) (both 1962) and at least one painting (p. 121) that was most likely made in the year after the sculptures were completed. The two-dimensional work depicts in graphic form the joining of rectilinear and tetrahedral systems. The knifelike shape common to these compositions is the sign for a sliced end of a tetrahedral form. The angled element also creates a spatial tension between the implied recession of the angle and the larger area of the mainly frontal image. In two dimensions Smith varied the relative proportion of the design elements, played with positive and negative forms, and even rotated the design, but the basic configuration, including a cubic base and a projecting

"arm," remains constant. The intensely colored bands, however, almost obscure any obvious connection to the sculpture.

A separate group of painting compositions is further removed from sculptures Smith created at the time, presenting ideas that would be explored later. For example, an untitled work (1962; p. 123, right) and *Exit* (1962–63; p. 126)—one of the few paintings that Smith titled—unite the rectilinear and orthogonal systems. His decision to obliquely slice the end of the red bar at the right in *Exit* changes the profile of the negative space. The title suggests many possible interpretations, including *No Exit,* the existentialist play by Jean-Paul Sartre, as well as the red of an exit sign, but Smith himself left no specific reading of the name. The configuration of Untitled (1962–63; p. 125, top left) includes a small opening into a large central area; this could well be the conceptual beginning of *Stinger* (1967–68; p. 168).

The last painting Smith executed, in 1980, was an eight-by-thirteen-foot blue-and-black canvas (p. 127). The original composition had been painted in 1962; it measured two-by-three feet. In 1979 Smith decided to return to this picture and asked his assistant Jim Shepperd to execute a much larger full-scale version. The size of each canvas is related to number progressions in the Fibonacci series which, as they increase, approach the proportions of the Golden Section. The dimensions of the full-scale painting were based on a higher set of numbers in the Fibonacci series than the original, creating a rectangular shape of different proportions that was closer to the size of the ideal golden rectangle than was the smaller canvas. First in oil, and then in alkyd, Shepperd painstakingly applied ten coats of the translucent cobalt blue paint, using between three hundred and four hundred tubes of paint to cover the surface.

For Smith, painting began as an end in itself, but as his career progressed, it became a critical aspect of his multifaceted oeuvre. Characteristic formal traits can be identified in the earliest paintings, but it is the modular system devised between 1953 and 1955 that was the true harbinger of his later sculptural method.

Drawings

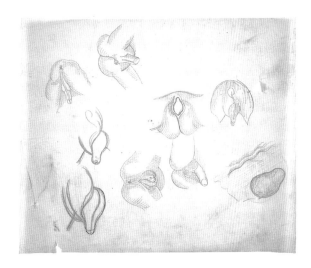
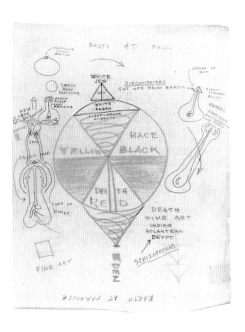

CLOCKWISE FROM TOP LEFT:

Page from a sketchbook. 1934–36. Ink on paper, 10 3/16 x 7 3/4" (10.2 x 19.7 cm). Tony Smith Estate, New York

Page from a sketchbook. 1937–38. Ink on paper, 7 3/4 x 4 7/8" (19.7 x 12.4 cm). Tony Smith Estate, New York

Page from a sketchbook. Late 1930s. Pencil on paper, 7 x 5" (17.8 x 12.7 cm). Tony Smith Estate, New York

Untitled c. 1943. Pencil and colored pencil on paper, 11 3/8 x 9" (28.9 x 22.9 cm). Tony Smith Estate, New York

Untitled. c. 1940. Pencil on paper, 13 5/8 x 16 11/16" (34.6 x 42.4 cm). Tony Smith Estate, New York

THE HENLEY COLLEGE LIBRARY

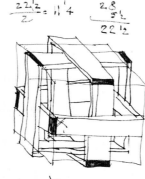

What is the meaning of id?
In relation to Wild?

WILD

Stanley Kowalski might have
been a pig - but he was ten-
der - and got the coloured
lights going.

Spiral-stair scene.

What about relation of
 Orient to id?
Primitive to id? Clyff Still
Rousseau to id? Rothko
Nietzsche to id? Pollock
Dionysus to id. Hofmann

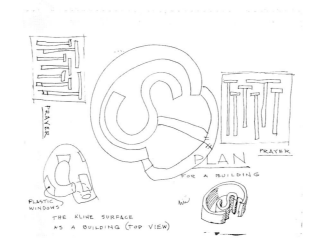

Will Jackson Pollock affect
our cars?

CLOCKWISE FROM TOP LEFT:

Page from a sketchbook. c. 1949–50. Ink on paper, 9 11/16 x 7 1/4" (24.6 x 18.4 cm). Tony Smith Estate, New York

Untitled. c. 1963. Ink on paper, 5 x 3" (12.7 x 7.6 cm). Tony Smith Estate, New York

Untitled. c. 1960s. Ink on paper, 4 drawings, each 4 3/4 x 3" (12 x 7.6 cm). Tony Smith Estate, New York

Page from a sketchbook. c. 1949. Pencil on paper, 10 3/8 x 7 7/8" (26.4 x 20 cm). Tony Smith Estate, New York

Untitled. c. 1970s. Ink on paper, 11 x 13 7/8" (27.9 x 35.2 cm). Tony Smith Estate, New York

Untitled. 1963. Ink on paper, 7 7/8 x 9 7/8" (20 x 25.1 cm). Tony Smith Estate, New York

Drawings

Untitled. c. 1949–50. Ink on paperboard, 8⁵/₁₆ x 24⁷/₈" (21.1 x 63.2 cm). Tony Smith Estate, New York

LEFT: Untitled. 1954. Charcoal on paper, 17³⁄₈ x 12¹⁄₈" (44.1 x 30.8 cm). Private collection

RIGHT: Untitled. 1954. Charcoal on paper, 17³⁄₈ x 12¹⁄₈" (44.1 x 30.8 cm). Tony Smith Estate, New York

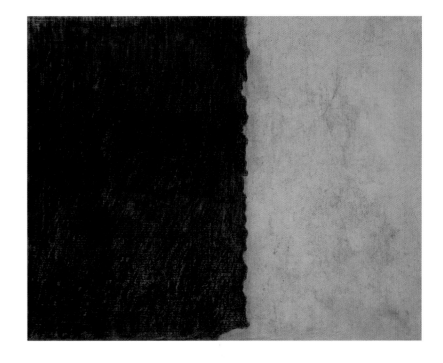

ABOVE: Untitled. 1953–55. Charcoal on paper, 31 ½ x 39 ⅛" (80 x 99.4 cm). The Museum of Modern Art, New York. Purchased with funds given by Agnes Gund

RIGHT: Untitled. 1953–55. Charcoal on paper, 31 ½ x 39 ⅛" (80 x 99.4 cm). The Museum of Modern Art, New York. Purchased with funds given by Sarah-Ann and Werner H. Kramarsky

CLOCKWISE FROM TOP LEFT:

Untitled. 1961. Ink on paper, 11 3/4 x 17 11/16" (29.9 x 44.9 cm). Tony Smith Estate, New York

Untitled. 1961. Ink on paper, 11 3/4 x 17 11/16" (29.9 x 44.9 cm). Private collection

Untitled. 1961. Ink on paper, 11 3/4 x 17 11/16" (29.9 x 44.9 cm). Private collection, New York

Untitled. 1961. Ink on paper, 8 3/8 x 10 7/8" (21.3 x 27.6 cm). Whitney Museum of American Art, New York

Untitled. 1961. Ink on paper, 11 3/4 x 17 11/16" (29.9 x 44.9 cm). Tony Smith Estate, New York

THIS PAGE AND OPPOSITE:

Untitled. 1961. Ink on paper, 9 sheets, each 8⅜ x 10⅞" (21.3 x 27.6 cm). Collection Sarah-Ann and Werner H. Kramarsky

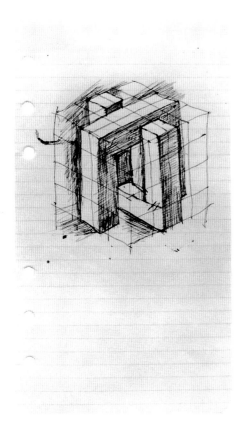
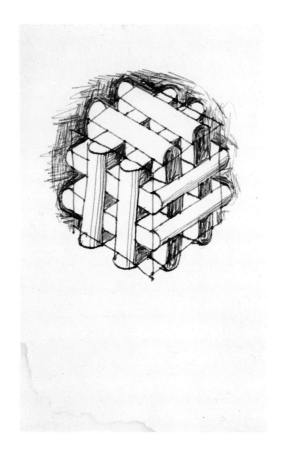
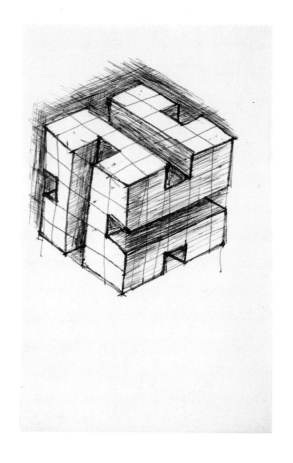

LEFT: Untitled. c. 1962. Ink on paper, 6¾ x 3¾" (17.2 x 9.5 cm). Courtesy of Robert Gober

CENTER: Untitled. c. 1962. Ink on paper, 4¾ x 3" (12.1 x 7.6 cm). Tony Smith Estate, New York

RIGHT: Untitled. c. 1962. Ink on paper, 4¾ x 3" (12.1 x 7.6 cm). Tony Smith Estate, New York

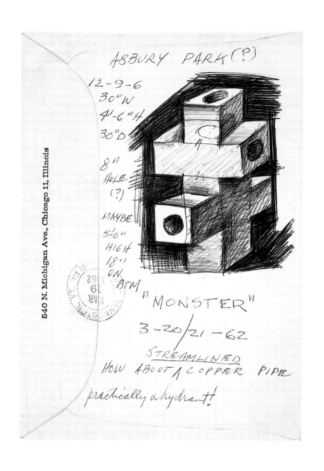

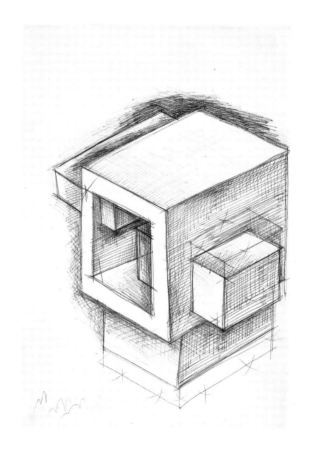

LEFT: *Monster*. 1962. Ink on paper envelope, 7¾ x 5½" (19.7 x 14 cm). Collection Tony and Gail Ganz

RIGHT: Untitled. 1962. Ink on paper, 9³⁄₁₆ x 6¼" (23.3 x 15.9 cm). Collection Tony and Gail Ganz

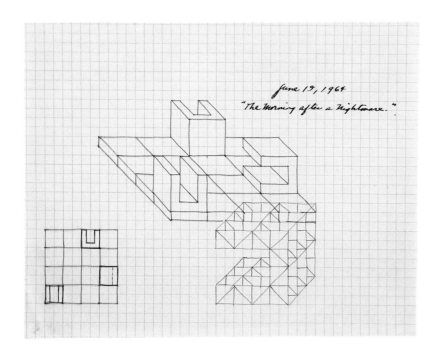

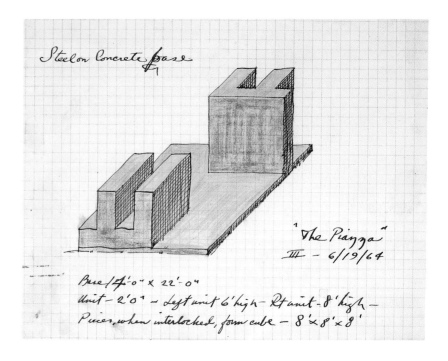

ABOVE: *The Morning After a Nightmare.* 1964. Ink on paper, 8½ x 11" (21.6 x 27.9 cm). Tony Smith Estate, New York

RIGHT: *The Piazza.* 1964. Ink, pencil, and colored pencil on paper, 8½ x 11" (21.6 x 27.9 cm). Collection Tony and Gail Ganz

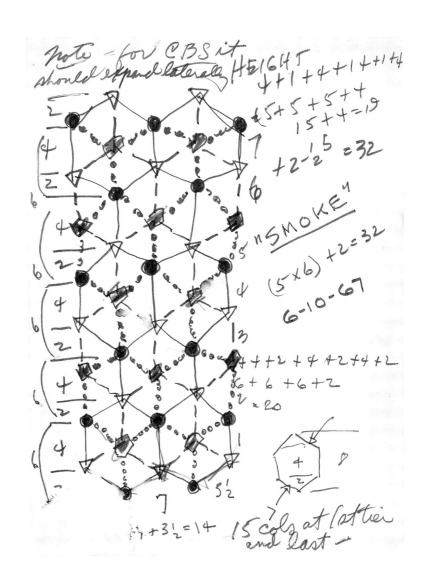

Smoke. 1967. Ink on paper, 12 x 9" (30.5 x 22.9 cm). Private collection, New York

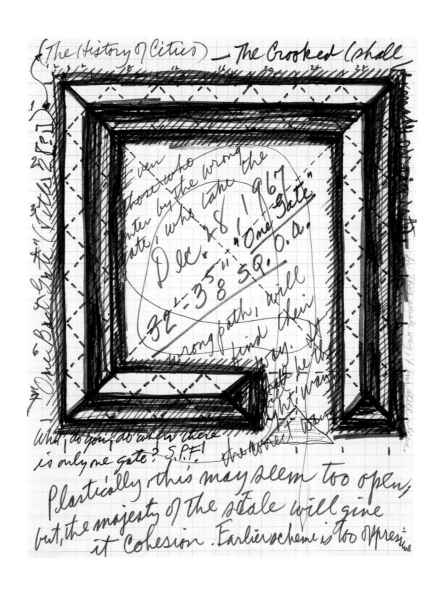

One Gate (drawing for *Stinger*). 1967. Ink on paper, 10⅞ x 8⅜" (27.6 x 21.3 cm). Tony Smith Estate, New York

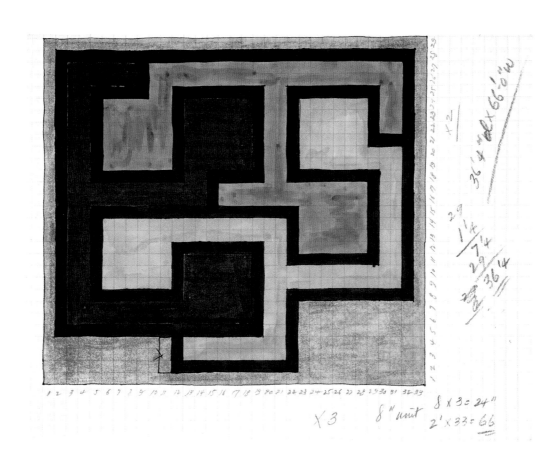

Untitled. c. 1965. Ink on paper, 8 ½ x 10 ¹⁵/₁₆" (21.6 x 27.8 cm). Tony Smith Estate, New York

ABOVE: Untitled (drawing of *Maze*). 1967. Collage on paper, 8 ½ x 11" (21.6 x 27.9 cm). Tony Smith Estate, New York

RIGHT: Untitled (drawing of *Maze*). 1967. Ink on paper, 8 ½ x 11" (21.6 x 27.9 cm). Tony Smith Estate, New York

CLOCKWISE FROM TOP LEFT:

Untitled. 1964. Ink and pencil on paper, 7 1/4 x 7 1/4" (18.4 x 18.4 cm). Tony Smith Estate, New York

Untitled. 1964. Ink, pencil, and collage on paper, 7 1/4 x 7 1/4" (18.4 x 18.4 cm). Tony Smith Estate, New York

Untitled. 1964. Ink, pencil, and collage on paper, 7 1/4 x 7 1/4" (18.4 x 18.4 cm). Collection Tony and Gail Ganz

Untitled. c. 1962. Collage on paper, 11 x 10½" (27.9 x 26.7 cm) (slightly irreg.). Private collection

Paintings

Untitled. c. 1934. Oil on canvas, 18 x 14" (45.7 x 35.6 cm). Collection Jane Smith, New York

Untitled. c. 1934–36. Oil on cardboard, 11¾ x 16⅞" (29.8 x 42.9 cm). Tony Smith Estate, New York

Untitled. c. 1938. Oil on canvas, 9 x 12" (22.9 x 30.5 cm). Collection Jane Smith, New York

Untitled. c. 1933. Oil on canvasboard, 10 x 8" (25.4 x 20.3 cm). Collection Jane Smith, New York

CLOCKWISE FROM TOP LEFT:

Untitled. c. 1934–36. Oil and pencil on canvasboard, 10 x 8" (25.4 x 20.3 cm). Tony Smith Estate, New York

Untitled. c. 1934–36. Oil and pencil on canvasboard, 10 x 8" (25.4 x 20.3 cm). Private collection

Untitled. c. 1933. Oil on canvasboard, 8 x 10" (20.3 x 25.4 cm). Collection Robert M. Cochran

CLOCKWISE FROM LEFT:

Untitled. c. 1937. Oil on canvasboard, 9 x 7" (22.9 x 17.8 cm). Private collection

Untitled. c. 1933. Oil on canvasboard, 9 x 7" (22.9 x 17.8 cm). Private collection

Untitled. c. 1934–36. Oil on canvasboard, 10 x 8" (25.4 x 20.3 cm). Private collection

LEFT: Untitled. c. 1936. Oil on canvasboard, 8 x 10" (20.3 x 25.4 cm). Tony Smith Estate, New York

ABOVE: Untitled. 1933. Oil on canvasboard, 8⅞ x 6⅞" (22.5 x 17.5 cm). Collection Daniela Frua De Angeli Rivetti

Untitled. c. 1950. Oil on canvas, 20 x 13" (50.8 x 33 cm). Tony Smith Estate, New York

Untitled. 1953. Oil on canvas, 35 ½ x 39 ½" (90.2 x 100.3 cm). Private collection, New York

Untitled. 1953–54. Oil on canvas, 31 ¼ x 39" (79.4 x 99.1 cm). Private collection, New York

Untitled. 1954. Oil on canvas, 19¾ x 19¾" (50.2 x 50.2 cm). Private collection

LEFT: Untitled. 1953. Oil on board, 15 5/8 x 19 1/2" (39.7 x 49.5 cm). Private collection, New York

RIGHT: Untitled. 1953. Oil on board, 15 3/4 x 19 1/2" (40 x 49.5 cm). Private collection, New York

LEFT: Untitled. 1953. Oil on board, 15¾ x 19½" (40 x 49.5 cm). Tony Smith Estate, New York

RIGHT: Untitled. 1953. Oil on board, 15¾ x 19½" (40 x 49.5 cm). Tony Smith Estate, New York

LEFT: Untitled. 1953–54. Oil on board, 19½ x 23⅜" (49.5 x 59.4 cm). Collection Agnes Gund, New York

RIGHT: Untitled. 1953–54. Oil on canvas, 31½ x 39¼" (80 x 99.7 cm). Tony Smith Estate, New York

LEFT: *Louisenberg #7.* 1953–54. Oil on canvas, 15¾ x 15¾" (40 x 40 cm). Private collection

RIGHT: *Louisenberg #9.* 1953–54. Oil on canvas, 15⅞ x 23¾" (40.3 x 60.3 cm). Private collection, New York

Louisenberg #3. 1953–54. Oil on canvas, 39 1/4 x 31 1/2" (99.7 x 80 cm). Collection Donald Windham, New York

Louisenberg #5. 1953–54. Oil on canvas, 19 1/2 x 39 1/4" (49.5 x 99.7 cm). Private collection, New York

Louisenberg #2. 1953–54. Oil on canvas, 39¼ x 39¼" (99.7 x 99.7 cm). Private collection, New York

Louisenberg #8. 1953–54. Oil on canvas, 20 x 27¾" (50.8 x 70.5 cm). Private collection

Louisenberg. 1953–54 / 68. Acrylic on canvas, 8'3¾" x 11'7¾" (253.4 x 355 cm). Tony Smith Estate, New York

OPPOSITE, CLOCKWISE FROM TOP LEFT:

Untitled. 1959–60. Oil on canvas, 16 x 20" (40.6 x 50.8 cm). Private collection, New York

Untitled. 1959–60. Oil on canvas, 16 x 20" (40.6 x 50.8 cm). Private collection, New York

Untitled. 1959–60. Oil on canvas, 16 x 20" (40.6 x 50.8 cm). Private collection

THIS PAGE, ABOVE: Untitled. 1958. Oil on canvas, 24 x 30" (61 x 76.2 cm). Tony Smith Estate, New York

LEFT: Untitled. 1956. Oil on canvas, 36 x 24" (91.4 x 61 cm). Private collection, New York

RIGHT: Untitled. 1956. Oil on canvas, 30 x 24" (76.2 x 61 cm). Private collection, New York

Untitled. 1956. Oil on canvas, 5'10" x 17' (177.8 x 518.2 cm). Tony Smith Estate, New York

LEFT: Untitled. c. 1961. Oil on canvas, 24 x 30" (61 x 76.2 cm). Tony Smith Estate, New York

ABOVE: Untitled. c. 1961. Oil on canvas, 30 x 24" (76.2 x 61 cm). Tony Smith Estate, New York

Untitled. 1962–63. Oil on canvas, 42 x 48" (106.7 x 121.9 cm). Private collection

Untitled. 1962. Oil on canvas, 5'4" x 7'10½" (162.6 x 240 cm). Tony Smith Estate, New York

ABOVE: *Winter Solstice*. 1962–63. Oil on canvas, 24 x 30" (61 x 76.2 cm). Collection Richard Tuttle

RIGHT: Untitled. 1962. Oil on canvas, 44 x 42 ½" (111.8 x 107.9 cm). Private collection, New York

CLOCKWISE FROM TOP LEFT:

Untitled. 1962–63. Oil on canvas, 24 x 36" (61 x 91.4 cm). Tony Smith Estate, New York

Untitled. 1962–63. Oil on canvas, 24 x 36" (61 x 91.4 cm). Private collection, New York

Untitled. 1962–63. Oil on canvas, 24 x 36" (61 x 91.4 cm). Tony Smith Estate, New York

CLOCKWISE FROM TOP LEFT:

Untitled. 1962–63. Oil on canvas, 24 x 36" (61 x 91.4 cm). Private collection, New York

Untitled. 1962. Oil on canvas, 24 x 36" (61 x 91.4 cm). Collection Jean Taylor Federico

Untitled. 1962–63. Oil on canvas, 24 x 36" (61 x 91.4 cm). Private collection

Exit. 1962–63. Oil on canvas, 40 x 50" (101.6 x 127 cm). Private collection, New York

Untitled. 1962, 1980. Oil and alkyd on canvas, 8' x 13' 1/8" (243.9 x 396.8 cm). The Museum of Modern Art, New York. Gift of Agnes Gund

Sculpture · JOAN PACHNER

TONY SMITH BEGAN MAKING SCULPTURE only in the last twenty years of his life, yet these works represent the culmination of a lifetime of thought and artistic creation. His large, black modular sculptures of the 1960s and 1970s are his best known works, but already in the late 1950s he had begun to make three-dimensional cardboard maquettes using the tetrahedron as the basic element.

Throne, of 1956–57 (p. 142), the first sculpture that Smith titled, evolved from an assignment he gave to his students to determine the simplest possible three-dimensional joint. Smith enhanced the geometrical solution of four triangular prisms joined together by adding another joint, creating a form with seven triangular prisms enclosing two tetrahedra. The symmetrically massed abstract form reminded him of the dense volume of an African beaded throne. In 1957 the original model of *Throne* was made of twelve-inch-square acoustical tiles, which he found in the basement of his house; a wood model was made after the original fell apart. *Throne* was fabricated in steel in 1963.

Cigarette and *Spitball* (both 1961) were among Smith's earliest multipart tetrahedral-based works of the 1960s (pp. 145, 147). They were made by taping together small, handmade paper tetrahedral modules. When Smith liked a particular form, as he did in the instance of these two works, he painted the small model black so that he could view the piece as a sculptural whole. *Spitball* is symmetrical when it is rotated; its outer faces define the exterior planes of a tetrahedron. The surfaces are at such an angle to each other that the outer faces tend to reflect the light, rather than to absorb it, while the central portion has the appearance of a black hole. To Smith, the dense form of the small model resembled a spitball.

Cigarette is arguably Smith's first environmental sculpture. It is a twisting, linear, openwork composition that invites the viewer to walk through and around the space that the gatelike piece creates. The sculpture is a natural descendant of the "linked-bead" imagery he had created in Germany. Its title was suggested to Smith by the original white plaster model, which looked like a cigarette from which one puff had been taken before being snuffed out.

Also in 1961 Smith made a unique, hand-modeled, plaster form which he titled *Tetrahedron* (p. 149). While Smith had hoped to have this and *Wingbone* (1962; p. 148) cast in bronze, he felt that the plasters could also have the timeless quality he was striving for.

In addition to tetrahedral-based works, between 1961 and 1964 Smith explored the formal potential of the cube—the most elemental and bilaterally symmetrical of forms—in drawings, paintings, and finished sculptures. He dissected the cube into its axial components, explored its edges, disassembled its planes, and punctured its volume. The cube was not simply an abstract form; it was seen as a nourishing shape that one could return to again and again. The cube enabled Smith to take his designs beyond pure utility.

We Lost (1962; p. 155) is part of Smith's intensive investigation of the permutations of the cube. The small scale of the original reminded Smith of the scaffold of a coffeetable, but when it was realized four years later as a full-size object over ten feet square, the work was transformed from a design into a sculptural presence. A drawing of the same form is captioned *Erehwon*

"EREHWON"

1. *Erehwon.* 1962–65. Ink and crayon on paper, 8 ½ x 11" (21.6 x 27.9 cm). Tony Smith Estate, New York

(1962–65; fig. 1), after Samuel Butler's 1872 novel of that name; the word is "nowhere" spelled backwards. The sculpture's title gives the otherwise formal scheme a poignancy.

In this same year, Smith ordered the fabrication of his first steel piece, *Black Box* (p. 150). This sculpture developed from a mundane object—a three-by-five-inch file-card box. Smith decided to enlarge the proportions of the box five times, emulating an assignment he had given to his students at the time. He expanded the image itself and stripped away the recognizable details. The finished work was set on thin two-by-four-inch plywood boards. *Black Box* seemed an appropriate title, based as it was on an actual object, but there was also an aura of mystery connoted by the title and by the physi-

cal hollowness of the form. He recalled that when he asked his young daughters what they thought was in the box, they just giggled and ran away.

Shortly after completing *Black Box,* Smith created *Free Ride* (1962; p. 153), a black steel sculpture that drew on Smith's architectural experience. Smith described it as a living cube that one lives in. Its size, six feet eight inches in all directions, is based on the height of a typical door opening in a modern building. The asymmetrical "arms" define the three axes of a cube. *Free Ride* evolved from a casual demonstration in Smith's home on how to most efficiently pack three gyroscopes (one for each axis of navigation). The work's title was inspired by the fact that the design was created on the same day that Scott Carpenter became the first astronaut to orbit the earth.

Smith's contemplation of *Free Ride* led to the creation of *Die* (1962; p. 151), which is both a continuation of *Free Ride* and a complement to it. *Die,* a fabricated hollow, six-foot steel cube, was Smith's second and last closed square volume. The size and form of the piece were inspired by a reproduction of Leonardo da Vinci's *Vitruvian Man.* Its scale is in a kind of gray area between object and monument. Smith wanted to make a work that, by sharing our space, would command our attention; *Die* is the geometric, abstract equivalent of man. While it looks like a perfect architectural form, *Die,* according to Smith, represents an actual person more than a space in which to live. The one-word title is a multilayered pun encompassing the ideas of death and chance; it also makes reference to industrial fabrication.

Other variations on the cube were explored in works such as *Beardwig* (1962; fig. 2). The rectangular base of this work has a truncated, narrow parallelogram extending out from the top planar edge of the base. *Beardwig,* in turn, metamorphosed into the related, but more complex, triangulated structure of *Duck* (1962; p. 158). This work was made by forming each tetrahedral and octahedral module separately and carefully placing them together. Three-dimensional triangulated forms like *Duck* are extremely difficult, if not impossible, to render in two dimensions.

When he finished *Duck,* Smith was smitten with the idea of trying to put some of the same clusters together at random. *The Snake Is Out,* of 1962 (p. 154), was the result. It consists of tetrahedral and octahedral forms that were stuck onto other module clusters that Smith had assembled while making *Duck.* The arbitrary nature of the composition was tempered by a need to create an object that respects gravity and is stable. He titled the new piece *The Snake Is*

Out because the shape reminded him of both a dead garden snake and a vein on a man's temple that pops out when he has had too much to drink.

Smith also used "spare parts," modular groupings left over from some of the small paper models of earlier works, to create new sculptures, such as *Willy* (1962; p. 157), his most intuitively designed work. He recalled that it incorporated parts from *The Snake Is Out* and, perhaps, from *Cigarette.* Ground-hugging elements that stabilize the piece were added last. In this sense, the piece exemplifies Smith's contradictory urge to create images based on rational modules that are balanced but, at the same time, generated by impulsive forces. The title *Willy* was inspired by a character in Samuel Beckett's play *Happy Days* (1961) who crawls around the stage making only occasional noises. The image of a pathetic, barely human creature corresponded to Smith's feeling about his recently completed work.

On the day that the plywood mock-up of *Willy* was made, Smith took apart its model and by the same process of addition made *Gracehoper* (p. 144). Like all of Smith's sculptures, it was based on his vision of an invisible space-lattice of alternating tetrahedrons and octahedrons. Designed in 1962, *Gracehoper* was fabricated in steel in 1971 for the Detroit Institute of Arts; twenty-two feet high and forty-six feet long, it is the size of a modest two-story house. The funnel-like "body" reminded Smith of hoppers—old-fashioned coal fillers used in the heating of houses, and grain hoppers on trains. Smith named the work after a mythical creature in James Joyce's *Finnegans Wake* that represents dynamism, change, and progress.

Playground, also of 1962 (p. 152), is a cubic central mass with a ground-hugging plane—a basic shape for Smith. Its short planar elements were perhaps reminiscent of the ancient Pueblo mud-brick buildings that Smith had seen in his youth. These elements may also have reminded him of images of black horizontal sections of buildings found in archaeological handbooks, thus connecting the ambiguity and mystery of ancient architectural forms with the present moment of the sculpture.

A drawing captioned "For" and dated June 1, 1964 (fig. 3), derives from the 1962 design of *Playground.* The proposed title "For" may have been a pun inspired by the four-inch measure in each of the specified dimensions. This is one of a series of drawings that Smith envisioned to modify the proportions of the piece, making it more square and reminiscent of a step, a staircase, or a building and less ambiguous than the final form of the sculpture. This drawing

captures Smith's thoughts in action as he considered various proportional solutions. It becomes apparent that the work's deceptively simple final form represents the culmination of a series of complex decisions.

The concept of negative space interested Smith, and it is an integral part of *The Elevens Are Up* (1963; p. 156). The severe configuration consists of two four-by-eight-foot rectangular solids set parallel to each other, separated by a four-foot distance. As a whole, the sculptural elements form an eight-foot cube. The title refers not only to the parallel dimensional planes of the work that form the number "11" but also to a physiological sign of alcoholism—two "cords" becoming visible on the back of a man's neck interpreted as a sign of impending death.

2. *Beardwig.* 1962. Cardboard model, 12 x 10½ x 10½" (30.5 x 26.7 x 26.7 cm). Tony Smith Estate, New York

Moondog was the starting point for *Generation* (1965; p. 159), which was begun as a series of six small models. The final monolithic, pentagonal form is a distant relative of the openwork, slanted *Moondog*. The shape resulted from Smith's urge to create a monumental image for an urban setting that he considered "dignified" and "stable." The seventeen-foot-high model was only half the size of the piece that Smith planned. The angled profile of *Generation* was inspired, in part, by Smith's memory of the angled ceilings and windows in a small attic room he lived in in his family's house.

Also in 1965 Smith began a work which he originally intended to be a cave, but the process became too laborious for him to complete. The sculpture that eventually

Marriage (p. 146), conceived in 1961, was made in a full-size mock-up in 1965, using the same boxes Smith had used to make *The Elevens Are Up*. The opening in the mock-up looked too claustrophobic to Smith, so it was enlarged. In this work, Smith experimented with variations on the basic rectangular gate. The interaction of the volume of the sculpture with the space around it took precedence over the plan as it was initially conceived.

Smith's ongoing interest in the octahedron led to *Moondog* (1964; pp. 160–61), which is the first instance in which Smith stretched a regular octahedron into an elongated form. When attached to similar elements, this procedure enabled him to open up sculptural form, leading eventually to *Smoke* (1967), *Smog* (1969–70), and *Smug* (1973). Smith initially viewed the form as a human pelvis; it then developed into a more generalized holder, a Korean garden lantern. The leaning openwork form was inspired by a reproduction of a small jade Mexican house Smith had seen on the cover of a magazine. The title was sparked by Smith's memory of Joan Miró's painting *Dog Barking at the Moon* (1926) and by seeing the street musician and poet nicknamed "Moondog" on the day that he first made the piece. "Moondog" wore a kind of Viking helmet that Smith thought resembled the form of the sculpture.

emerged, *Amaryllis* (p. 163), was created by fortuitous accident. It was ultimately composed of module clusters, one set on top of another, like clumps of geometric forms instead of clay. According to Smith it looked a little bit like a work by Constantin Brancusi, and he was so stunned by this realization that he stopped working on it. When he made the small model that preceded the full-scale work, he thought of it as a toy, but when it was actually built, it quite terrified him. He named the piece *Amaryllis* because it reminded him of the amaryllis flower that Smith considered ugly; the title was appropriate for an image that he regarded as "some terrible aberration of form."

The formal innovations of *Moondog* led, in 1967, to the creation of *Smoke* (p. 167), a twenty-four-foot open lattice all-encompassing structure. This radical openwork sculpture depends on the interaction between solid and void and breaks with the tradition of the sculptural monolith. The columns of *Smoke* are octahedra, stretched beyond recognition. Smith liked the idea that he could render the known form of a platonic solid all but unrecognizable by a topological extension of its form.

Smith was able to realize his environmentally scaled vision for the first time with *Smoke*. The two-tiered sculpture merged Smith's interest in both the

plan of a honeycomb structure—first used in his 1951 project for a Roman Catholic Church (p. 66, right)—and the tetrahedral space-lattice. From an aerial vantage point, clearly evident in a bronze and in drawings like *Smoke* (p. 89), made after the fact, one can see that the plan is based on an array of close-packed hexagons. The geometry of the work can be explained, but the clarity of its parts dissolves when visitors are actually inside the piece. The allover design has no single focal point or axis; it looks like a complicated jungle gym. Interior views are dominated by the linear scaffold and the implied infinite expanse of the design. The self-supporting structure suggests both organic and man-made forms, from trees to building scaffolding and arches. The title *Smoke* seemed appropriate to Smith because of the complex spaces created by the piece, in which its logic disappeared, like smoke.

The honeycomb, a natural configuration of close-packed hexagons, was a critical formal and metaphoric framework within the context of Smith's development. The allover plan of *Smog* (1969–70; p. 178) is made from the same components as *Smoke*, but it was built as only one layer; each unit sits on a triangular prism designed to lift the work off the ground. But whereas *Smoke* seemed to have the potential to burst out of its interior space, *Smog* is a more squat, contained form. *Smog* was envisioned as a work to be seen from outside, instead of inside like *Smoke*. Yet Smith also thought that the physical presence of viewers would soften the piece.

In 1973 Smith made *Smug* (p. 179), the third and last of the series that had begun in 1967 with *Smoke*. The prisms on the top of *Smog* metamorphosed into octahedra in *Smug*. The thicker, squatter members change the interior volume, making the whole look more massive and, from some vantage points, menacing. While few of Smith's sculptures look like traditional mazes on a structural level, he used the metaphor of confusion and formal complexity to describe some of his own works; he considered *Smug* and *Smog* to be "maze-like."

Smith continued to make individual works at the same time as he

3. *For.* 1964. Ink and crayon on paper, 11 x 8 ½" (27.9 x 21.6 cm). Collection Tony and Gail Ganz

developed environmental schemes. In 1967 he dismantled the *Gracehoper* model (1962), and *Source* (1967; p. 139, right) and *Moses* (1968; p. 169) were the result. According to Smith, the inspiration for the title of *Source,* a more than two-foot-high black, flowing, horizontal work, was Gustave Courbet's painting *The Source of the Loue* (1864; fig. 4). Like many of Smith's other work, *Moses* was a freely developed combination of already formalized elements. The title *Moses* was inspired by Smith's own iconographical reading of his work that links this modern creation to Michelangelo and Rembrandt. The vertical "arms" sparked his memory of both the horns on the head of Michelangelo's sculpture and the raised arms of Moses, shown about to break the tablets in one of Rembrandt's painting (1659; fig. 5). The angled front plane of the black sculpture also reminded him of Moses' tunic in the same painting. Yet the monumentally scaled architectonic, eccentric form is somewhat at odds with the artist's humanistic interpretation of the imagery it aroused.

Stinger (p. 168) resulted from an opportunity to design an environmental work. Conceived in late 1967, the overall design of *Stinger* was based on a thirty-two-foot square with part of one side removed. The plastic form looks like a continuous diamond-shaped line; it is a run of cross sections of tetrahedra and octahedra. The impact of the elevation contrasts with the simplicity of the plan. The work, which is set directly on the pavement, rests on a single point of the diamond, not on a flat surface. The piece itself created a space, but was conceived independently of the ground plane. *Stinger* undercuts the viewer's expectation of the square space because the orthogonal system is turned on end. The sculpture's "walls" are not planar; the central point of the six-foot-high shape impresses itself physically into the viewer's space while the other planes recede. This gives the work a sense of organic animation, a mixture of threatening protrusion and buoyancy that might be unexpected in a work of such bulk. The title itself adds to one's apprehension as it suggests the whipped, attacking mechanism of a scorpion that could be used against an approaching invader.

Smith saw the entrance that provided access from outside to inside the "empty" interior of the square *Stinger* as a metaphor for both spiritual passage and physical transition— a gate. He annotated a preliminary drawing of the work (1967; p. 90) with these words: "Even those who enter by the wrong gate, who take the wrong path, will find their way. It shall be the right way, the correct way."

The summer of 1969 was a particularly fertile period for Smith. In a few months he designed *Bat Cave* (pp. 31, 37) and proposed other monumentally scaled designs, including *Hubris;* he also created a group of nine more modestly scaled marbles and bronzes, such as *For D.C.* (p. 171). The 2,500 unit module *Bat Cave* was formed out of small corrugated-card-

4. Gustave Courbet. *The Source of the Loue.* 1864. Oil on canvas, 39 1/2 x 52" (100.3 x 132.1 cm). Albright-Knox Art Gallery, Buffalo, New York. George B. and Jenny R. Mathews Fund, 1959

was about plastic volumes. Although *Bat Cave* retained its identity as sculpture, the interaction of visitors with the object tilted the final effect closer to architecture than Smith had intended.

Another monumental work, *Hubris* (1969; p. 172), has the appearance of a relatively straightforward composition—one half is a flat, scored grid with nine elements on each side, while in the other half a pyramidal form rises from each square. Smith said that the pointed shapes reminded him of the sharp crests of the Hawaiian mountains. The scheme was also inspired by a cheese board which, on one end, was rectangular and flat for cutting, while on the other there were points on which to set the cubes of cheese. The rectangles were changed to squares, which he felt were

board modules of tetrahedra and octahedra taped together. The triangulated forms begin to protrude from the angled interior wall only above one's head, at around seven feet above the ground, and continue irregularly for six feet, reaching the thirteen-foot height of the interior space. The construct is oriented toward the space within, not to the exterior surroundings. The outside walls do not match the irregular interior but rather contrast with it; all the elements penetrate to the inside. The overall form recalls the stepped forms of Mayan architecture that Smith admired.

This semiarchitectural, environmental sculpture was ultimately inspired by an actual bat cave Smith had seen in 1969 in Aruba. He also felt that the texture and color of the cardboard material that his *Cave* was made of suggested the feel of a wasp's nest and that the corrugated board recalled eroded parts of the Arizona desert. The thirteen-foot-high piece was originally planned with wind currents, damp atmosphere, and sound effects, including tapes of bat cries that one might hear in a cave.

Since 1963 Smith had been trying to create a "cave of light." Both *Amaryllis* and *Gracehoper* were related to these efforts. In the *Bat Cave* of 1969 Smith wanted form to be made of space and light, not material. Architecture, for Smith, was about creating space out of immaterial qualities, whereas sculpture

more appropriate to the monumental scale of the project. But it took seven schemes before he resolved the final design (not finished until 1970).

The design of *Eighty-One More* (1970; p. 173) derives from *Hubris,* but in this case the pyramids rise from every other triangular element, creating flowing spaces between the pointed forms that ultimately invite human interaction. The work was inspired, in part, by the pyramids of the Sun and Moon at Teotihuacán. Smith had *Eighty-One More* painted deep red because it reminded him of José Orozco's murals at Dartmouth College in New Hampshire and at the New School in New York, as well as of the red of Barnett Newman's paintings. The work was envisioned as a twenty-foot-high sculpture set at an airport and apprehendable only from the sky.

Smith often created colorful "skins" for the works destined to be placed in cities. To him, the graphic forms of the urban landscape threatened to reinforce the design element of the composition and undercut the plasticity. *Light Up!* (1971; p. 174), intended to be set between two modern office buildings in Pittsburgh, is yellow, and *She Who Must Be Obeyed* (1971–72; p. 175), sited outside the General Services Administration Building in Washington, D.C., is blue. Those colors were chosen because Smith wanted to ensure that the sculptural forms would not get lost in the grit of the urban environment. *Light Up!*

was one of the only works that Smith felt had the visual strength to hold its own against the gridded buildings around it.

Increasingly, the fluid forms of biology found a prominent place in Smith's work. *Fermi* (1973; p. 176) and *For Dolores* (1973–74; p. 177), based on topological Klein surfaces, reflect his ongoing search for mathematical and scientific patterns which could serve as models for artistic form. The marble versions of the *Fermi* pieces were intended as indoor, domesticated sculptures that could be transported through doors and not overload floors. At last, Smith had found a way to make sculptures whose relatively voluptuous curved surfaces are contained within a gridded construct that integrates the two-dimensional work with his three-dimensional work.

In his last years, Smith created both figuratively suggestive and grandly abstract work. *One-Two-Three* (1976; p. 137, bottom) shows Smith exploring the evolution of forms that are subject to mathematical progression, as each new form was generated by the previous one, moving from the single element to the double, and, finally to the triple. *Throwback* (1976–77; p. 180) and Untitled (Atlanta) (1980; p. 181) are among his most figural works. In *Throwback,* Smith joined his standard geometric modules to create a horizontal, undulating form that is suggestive of a reclining figure. The hovering, animated *Atlanta* is one of Smith's last creations. The twisted snakelike shape appears as a figure suspended in midair. Also envisioned as a horizontal work, it was given the alternate title *Lowbridge.* When the work is vertical, the faceting catches light in such a way as

5. Rembrandt. *Moses Showing the Tablets of the Law to the People.* 1659. Oil on canvas, 65 3/4 x 53 1/4" (167 x 135.3 cm). Staatliche Museen zu Berlin, Gemäldegalerie

to change the color from black to a symphony of grays and blacks—the same effect as Smith's sculptures from the early 1960s, such as *Spitball.*

The untitled sculpture known as Five Cs (1980; p. 182) is among the last that Smith conceived. The ambiguous, chunky block form, which can be read as either the letter *C* or the letter *U* turned on its side, recalls an identical shape that recurs frequently between 1962 and 1964 in Smith's drawings; it is the modular unit shown in *The Morning After a Nightmare,* of 1964 (p. 88, top). This form may be a pun referring both to the conscious and the unconscious mind, a subject which profoundly affected Smith throughout his career and seems an appropriate one for the twilight of his own life.

Smith's works confound the boundaries between architecture and sculpture, between monuments and objects. The structures do not function as shelters, yet they often depend for their form and effect on his subversion of known forms and spaces like caves, gates, and mazes. The boundaries between inside and outside, the natural and the man-made, sculpture and architecture, are constantly called into question in Smith's created spaces. The effect of his sculpture depends on the tension he understood between the rational clarity of his modules and the impulsive manner in which he tended to put the elements together, undercutting the assumptions of fixed logical systems. Smith encouraged others to see associations between his sculptures and great historic monuments, the symbols of collective societies, conflating the present day with the deep past.

Sculpture

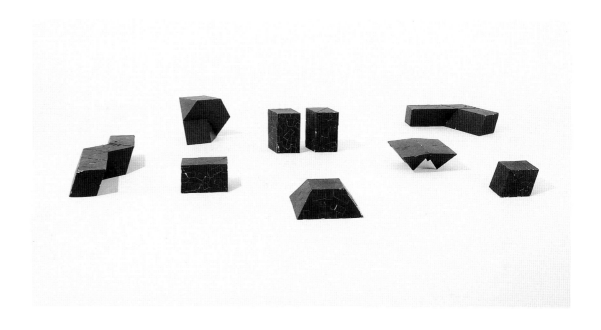

ABOVE: *She Who Must Be Obeyed*. 1971–72. Cardboard model, 9 x 14 x 6½" (22.9 x 35.6 x 16.5 cm); *Yellowbird*. 1971. Cardboard model, 6 x 9 x 3½" (15.2 x 22.9 x 8.9 cm); *Tau*. 1965. Cardboard model, 7 x 10 x 6" (17.8 x 25.4 x 15.2 cm). Tony Smith Estate, New York

RIGHT: *For* series. 1969. Painted cardboard models, 3 to 6¾" (7.6 to 17.1 cm) high. Tony Smith Estate, New York

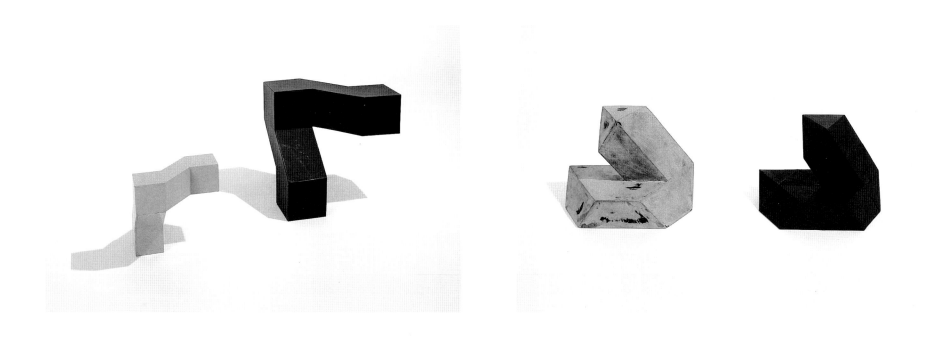

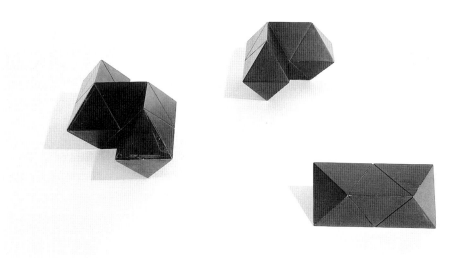

CLOCKWISE FROM TOP LEFT:

Mistake. 1963. Wood model, 12 x 12 x 8" (30.5 x 30.5 x 20.3 cm); *Mistake*. 1963. Painted cardboard model, 18 x 18 x 12" (45.7 x 45.7 x 30.5 cm). Tony Smith Estate, New York

Duck. 1963. Plaster model, 10¾ x 13 x 8¾" (27.3 x 33 x 22.2 cm); *Duck*. 1963. Painted cardboard model, 10 x 12 x 8¼" (25.4 x 30.5 x 21 cm). Tony Smith Estate, New York

One-Two-Three. 1976. Painted fiberboard model, 5¾ x 13¾ x 8" (14.6 x 34.9 x 20.3 cm); 9¾ x 13⅞ x 13⅞" (24.8 x 35.2 x 35.2 cm); 9¾ x 20½ x 14" (24.8 x 52.1 x 35.6 cm). Tony Smith Estate, New York

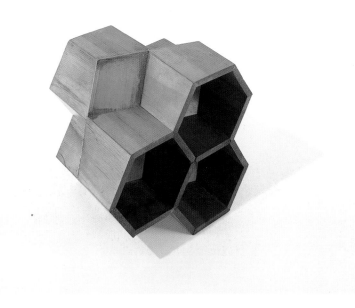

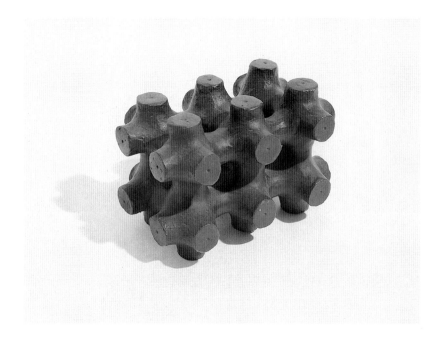

LEFT: *Bees Do It.* 1970. Wood model, 13 1/2 x 15 1/4 x 11" (34.3 x 38.7 x 27.9 cm). Tony Smith Estate, New York

RIGHT: *Fermi.* 1973. Cast bronze, 6 1/4 x 9 x 6" (15.9 x 22.9 x 15.2 cm). Private collection, New York

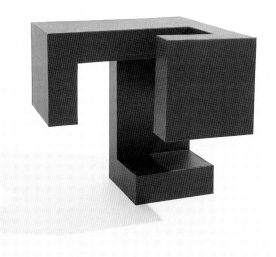
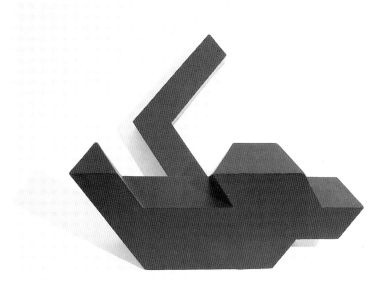

LEFT: *The Keys to. Given!*. 1965. Painted cardboard model, 16 x 16 x 16" (40.6 x 40.6 x 40.6 cm). Tony Smith Estate, New York

RIGHT: *Source.* 1967. Painted cardboard model, 11 ½ x 30 x 32" (29.2 x 76.2 x 81.3 cm). Tony Smith Estate, New York

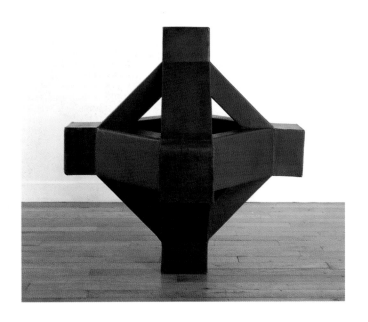

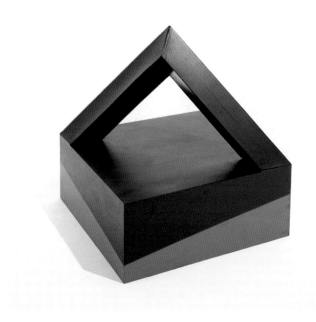

LEFT: *Cross*. 1960–62. Painted cardboard model, 32 x 32 x 32" (81.3 x 81.3 x 81.3 cm). Tony Smith Estate, New York

RIGHT: *Arch*. 1968. Painted wood model, 26 x 23 x 23" (66 x 58.4 x 58.4 cm). Tony Smith Estate, New York

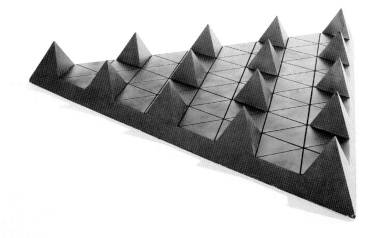 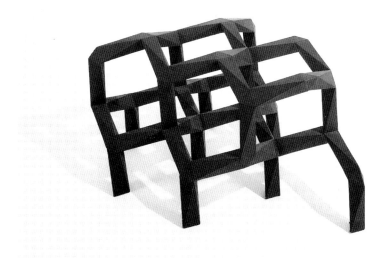

LEFT: *Eighty-One More*. 1970. Painted plywood model, 7 x 55 x 49" (17.8 x 139.7 x 124.5 cm). Tony Smith Estate, New York

RIGHT: *Smoke*. 1967. Painted fiberboard model, 18 1/4 x 35 1/2 x 25 1/2" (46.4 x 90.2 x 64.8 cm). Tony Smith Estate, New York

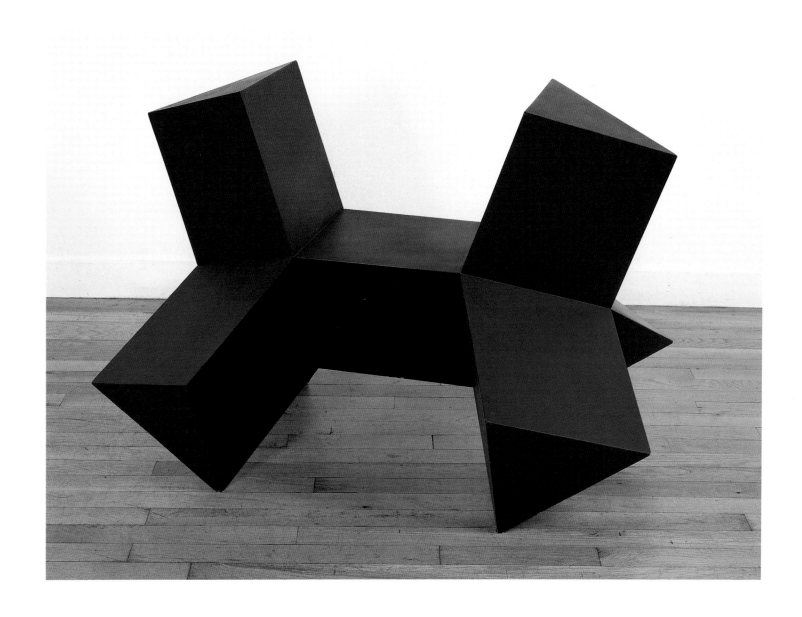

Throne. 1956–57. Painted wood model, 27 x 39 x 32" (68.6 x 99.1 x 81.3 cm). Tony Smith Estate, New York

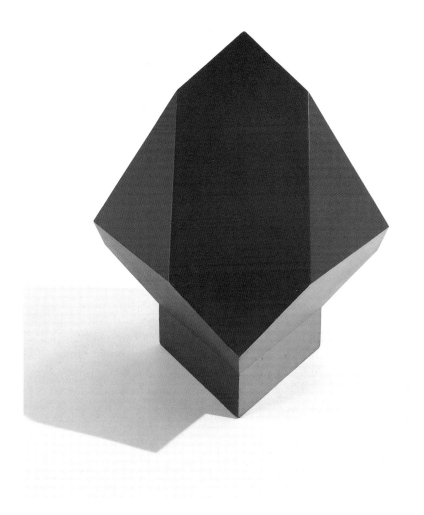

Memphis. 1962–63. Painted wood model, 30½ x 27 x 27" (77.5 x 68.6 x 68.6 cm). Tony Smith Estate, New York

Sculpture

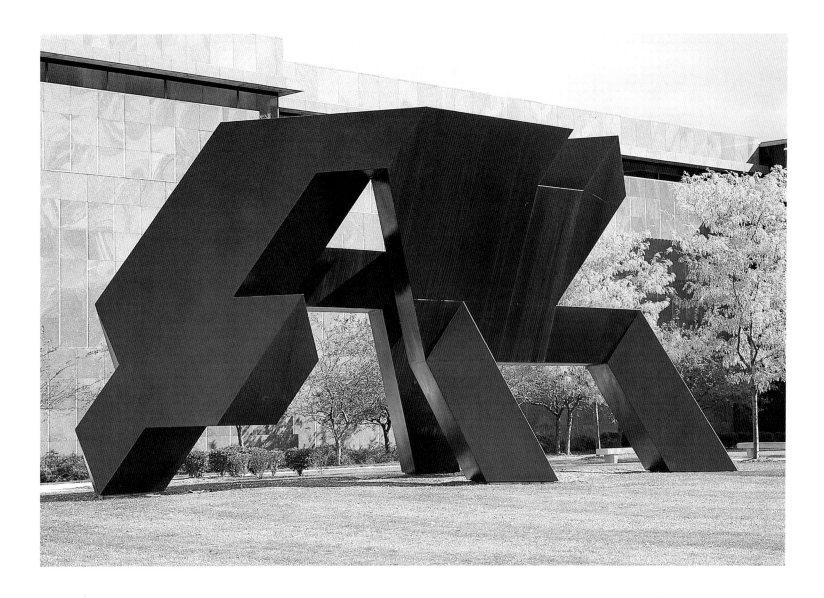

THIS PAGE AND OPPOSITE:

Gracehoper. 1962. Painted steel, 22'8" x 24' x 46" (690.9 x 731.5 x 1402.1 cm). The Detroit Institute of Arts. Founders Society Purchase

Cigarette. 1961. Painted steel, 15'1" x 25'6" x 18'7" (459.2 x 777.2 x 566.3 cm). The Museum of Modern Art, New York. Mrs. Simon Guggenheim Fund

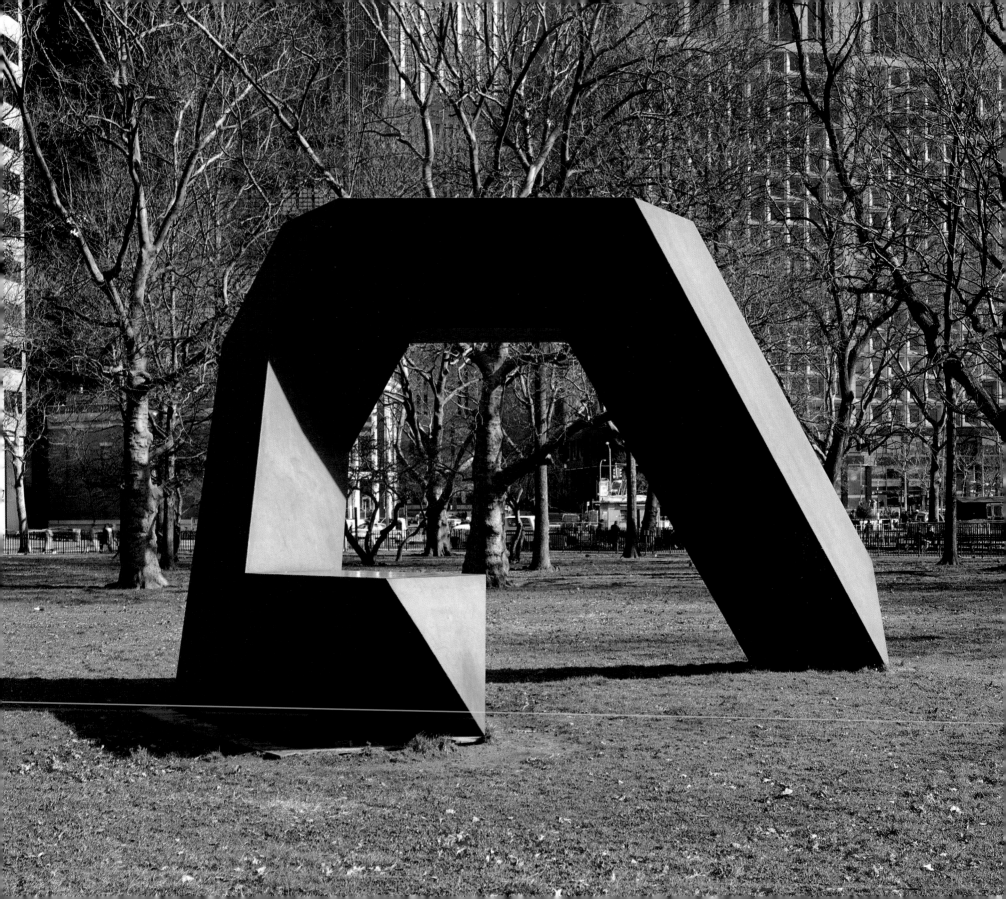

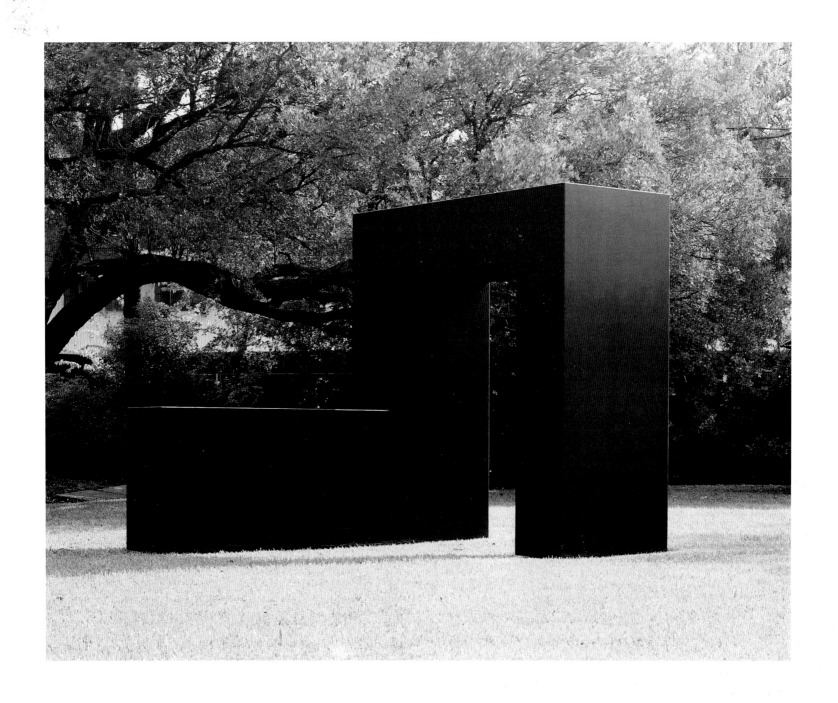

Marriage. 1961. Painted steel, 10 x 10 x 12' (304.8 x 304.8 x 365.8 cm). The Menil Collection, Houston. Gift of the Menil Collection to the city of Oslo, Norway

Spitball. 1961. Painted steel, 11'5" x 14 x 13'4 1/2" (348 x 426.7 x 407.7 cm). The Baltimore Museum of Art. Purchased as the gift of Ryda and Robert H. Levi, Lutherville, Maryland

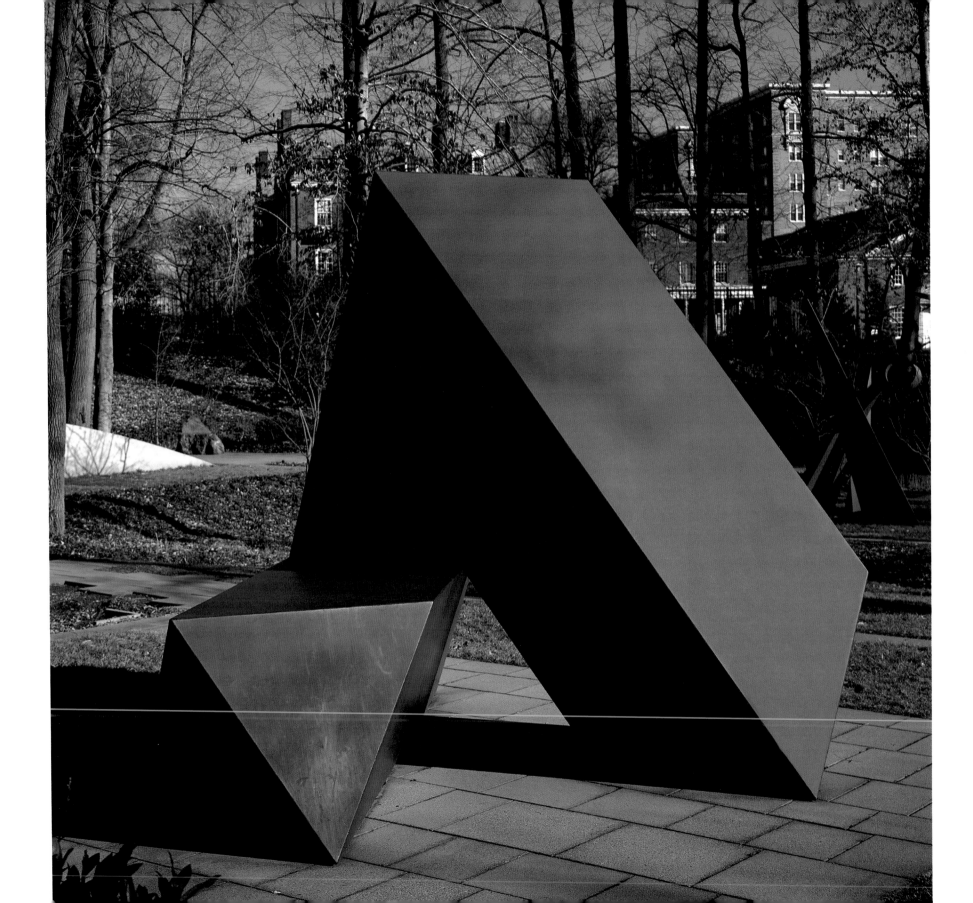

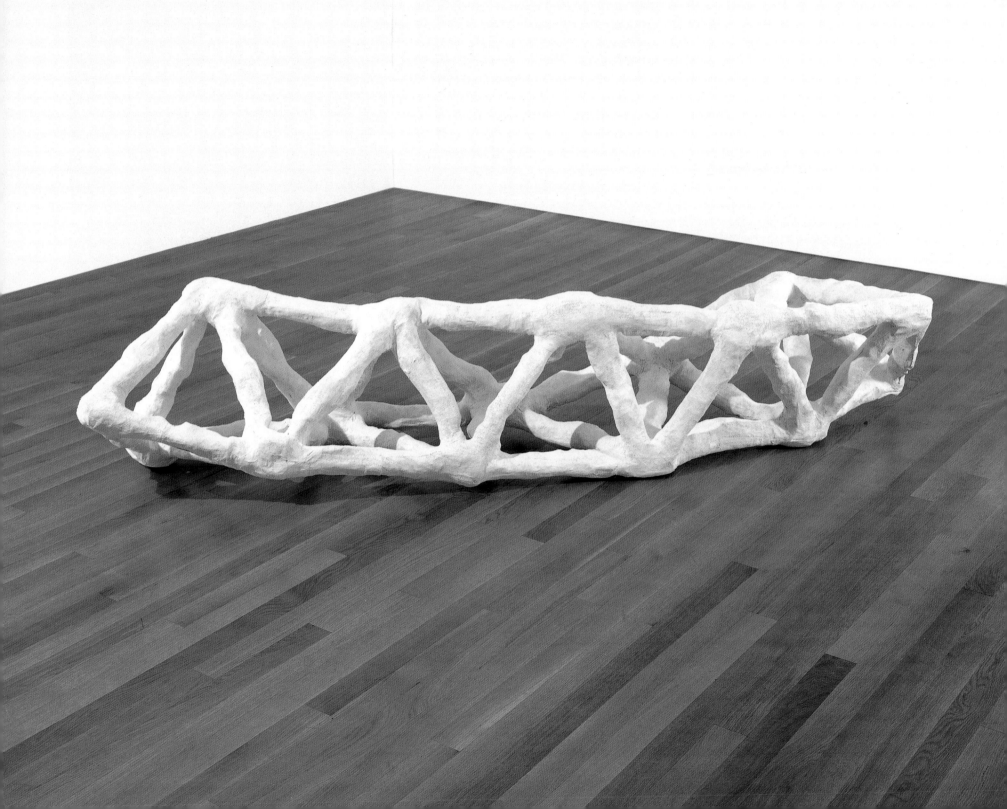

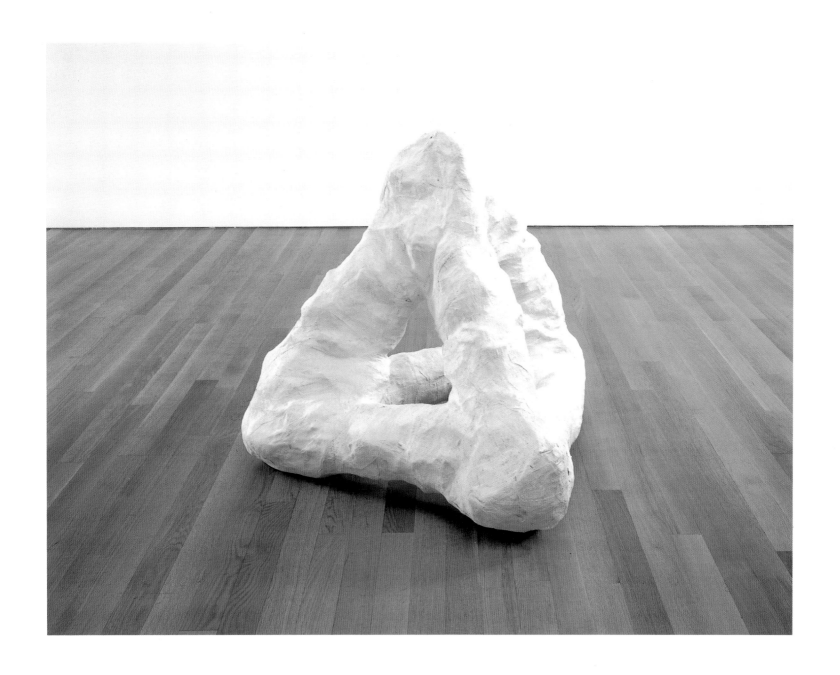

Wingbone. 1962. Plaster, 26" x 25" x 9'10" (66 x 63.5 x 294.6 cm). Collection Chiara Smith, New York

Tetrahedron. 1961. Plaster, 38 x 48 x 43" (96.5 x 121.9 x 109.2 cm). Tony Smith Estate, New York

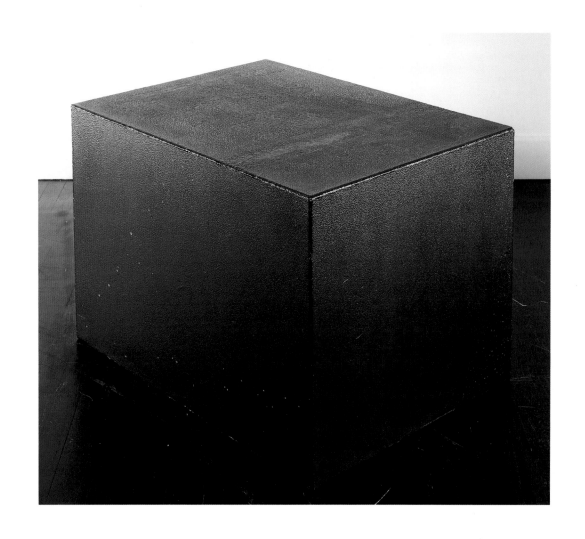

THIS PAGE AND OPPOSITE:

Black Box. 1962. Painted steel, 22 ½ x 33 x 25" (57.2 x 83.8 x 63.5 cm). Collection Ellen Phelan and Joel Shapiro

Die. 1962. Painted steel, 6 x 6 x 6' (182.9 x 182.9 x 182.9 cm). Private collection, New York

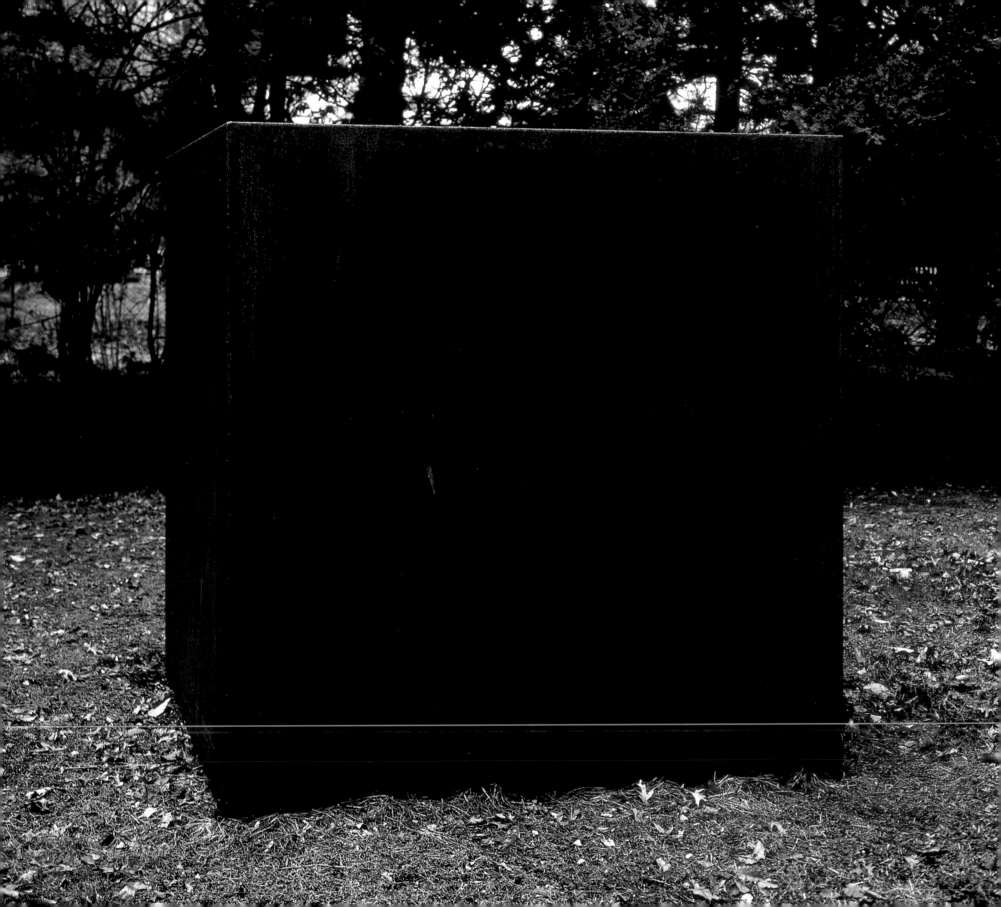

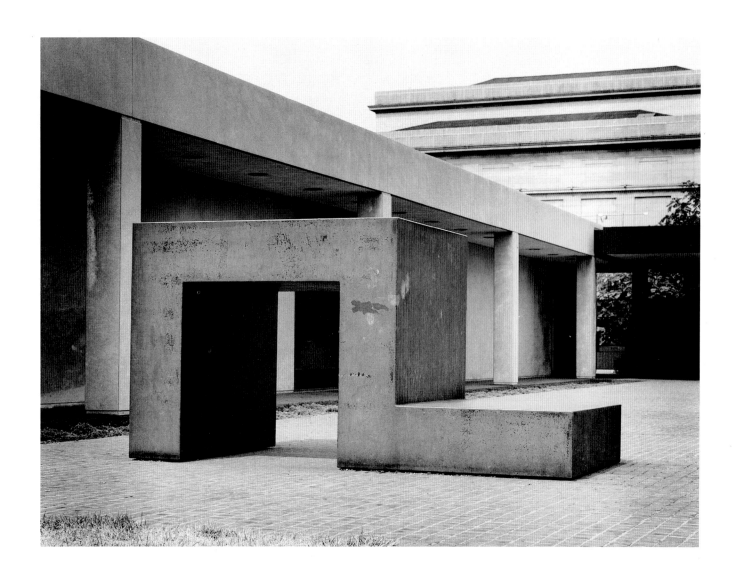

THIS PAGE AND OPPOSITE:

Playground. 1962. Painted steel, 64" x 10'8" x 64" (162.6 x 325.1 x 162.6 cm). Memorial Art Gallery of the University of Rochester. Gift of the Artist and Marion Stratton Gould Fund

Free Ride. 1962. Painted steel, 6'8" x 6'8" x 6'8" (203.2 x 203.2 x 203.2 cm). The Museum of Modern Art, New York. Gift of Agnes Gund and Purchase

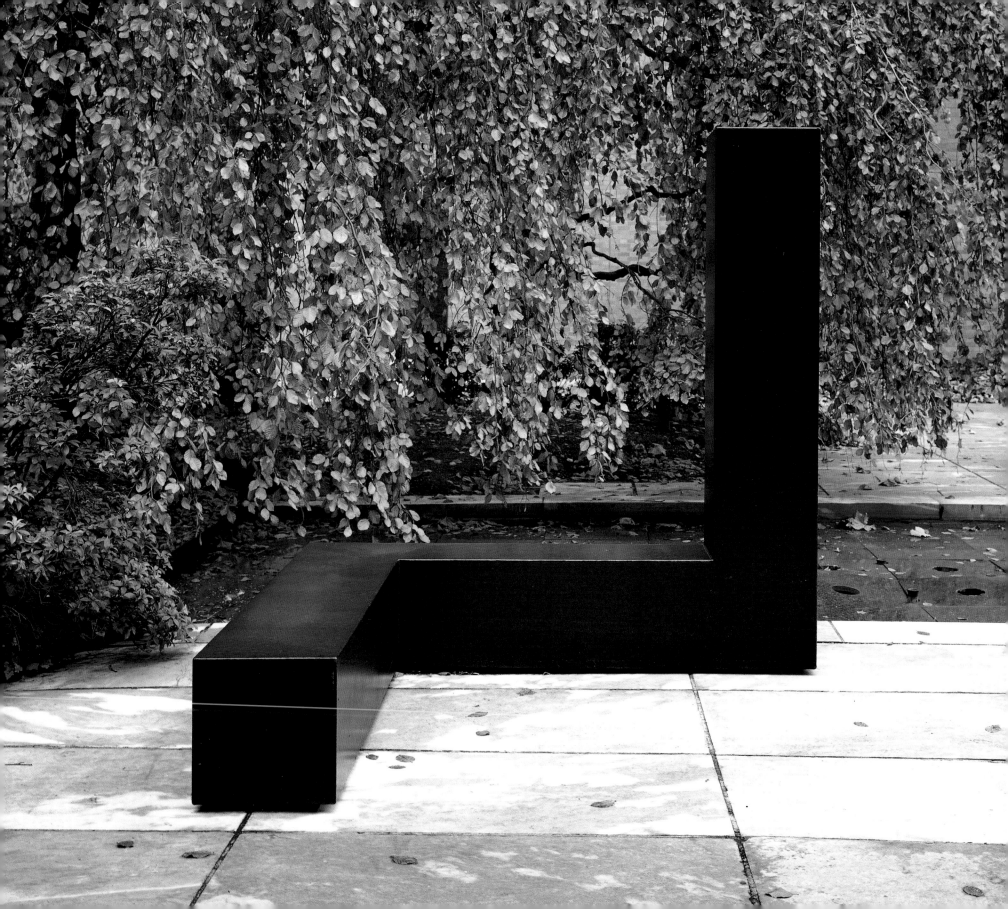

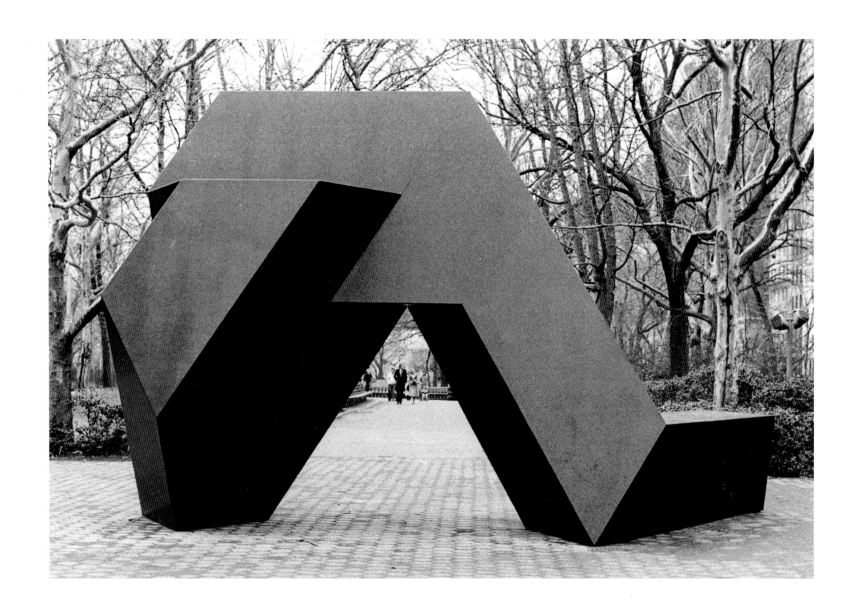

THIS PAGE AND OPPOSITE:

The Snake Is Out. 1962. Painted steel, 15'1 ½" x 23'2" x 18'10" (461 x 706.2 x 574 cm). The Patsy R. and Raymond Nasher Collection, Dallas, Texas. Shown installed on Doris Freedman Plaza, New York, 1982–83

We Lost. 1962. Painted steel, 10'8" x 10'8" x 10'8" (325.1 x 325.1 x 325.1 cm). Courtesy of the University of Pennsylvania Art Collection, Philadelphia

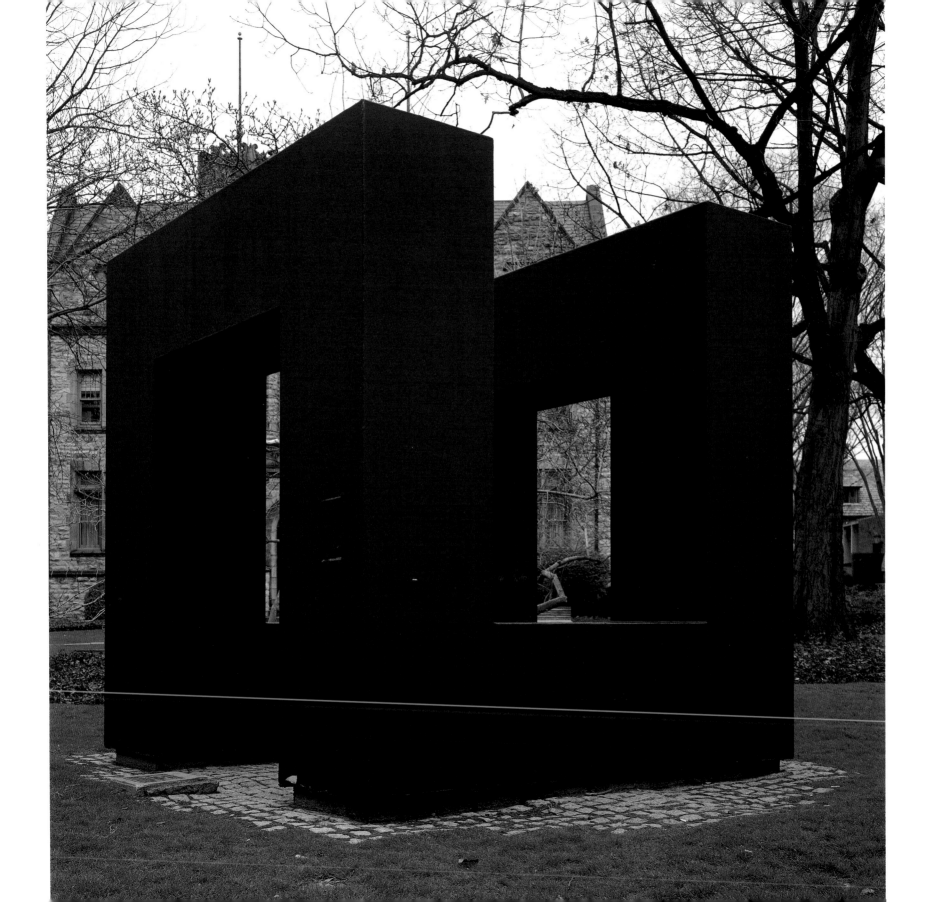

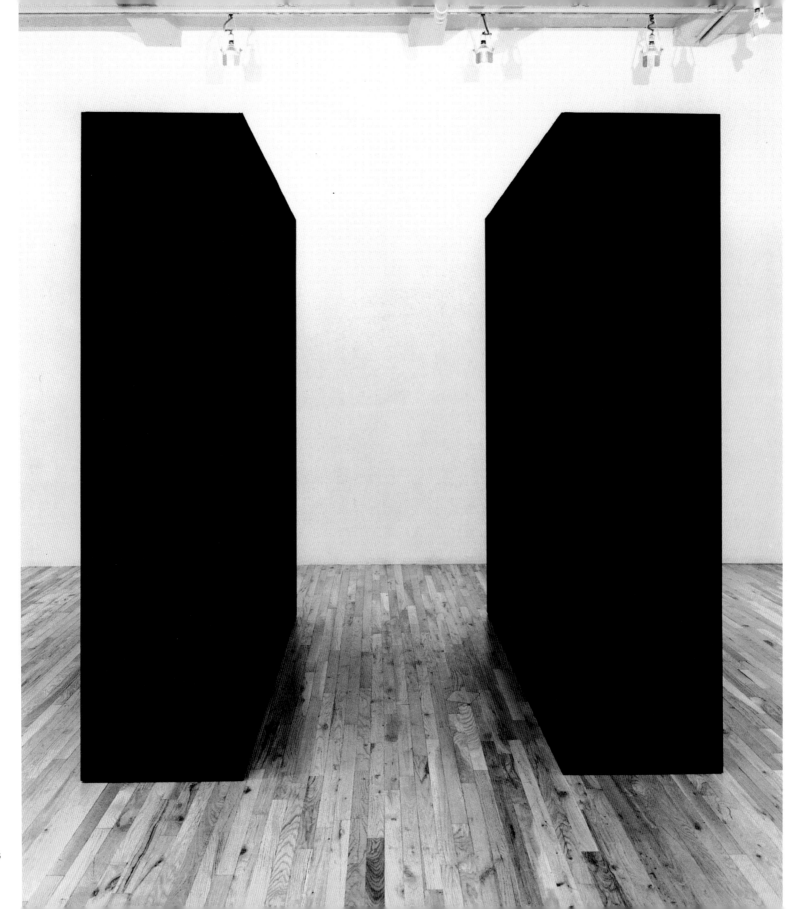

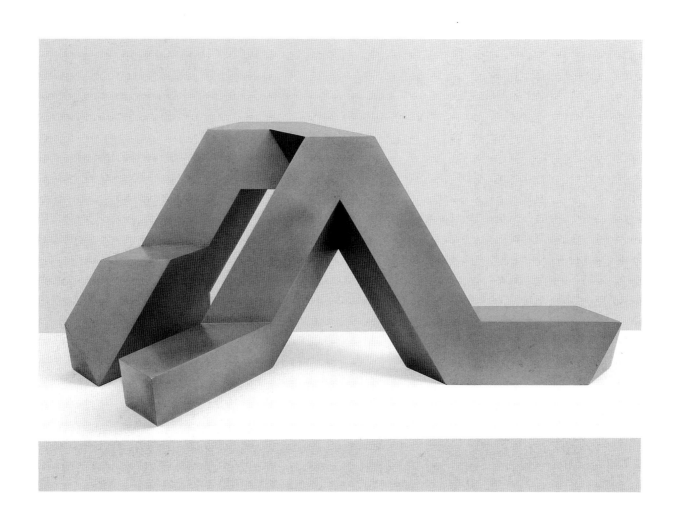

OPPOSITE AND THIS PAGE:

The Elevens Are Up. 1963. Painted plywood mock-up, 8 x 8 x 8' (243.8 x 243.8 x 243.8 cm) overall; 2 units, each 8 x 2 x 8' (243.8 x 61 x 243.8 cm). Installed at the Paula Cooper Gallery, New York, 1985. (subsequently destroyed)

Willy. 1962. Vapor blasted stainless steel, 13¾ x 22 x 22" (34.9 x 55.9 x 55.9 cm). New Jersey State Museum Collection, Museum Purchase

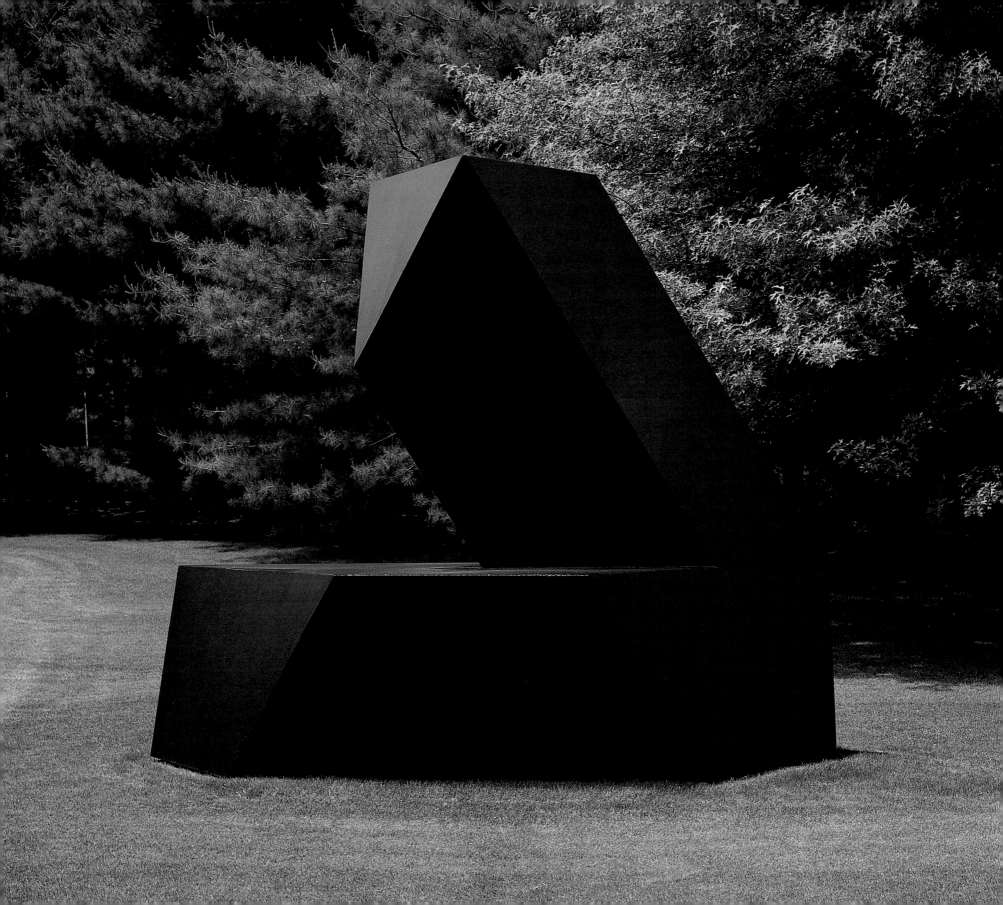

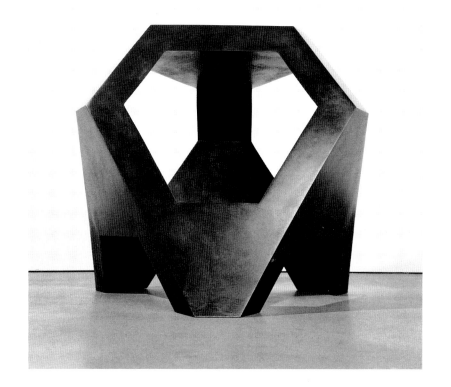

OPPOSITE AND THIS PAGE:

Duck. 1962. Painted steel, 11'4" x 13'10" x 9'3" (345.4 x 421.6 x 281.9 cm). The Donald M. Kendall Sculpture Gardens at PepsiCo, Inc., Purchase, New York. Courtesy PepsiCo, Inc.

Generation. 1965. Cast bronze, black patina, 30 x 35 1/2 x 35 1/2" (76.2 x 90.2 x 90.2 cm). Collection Seton Smith

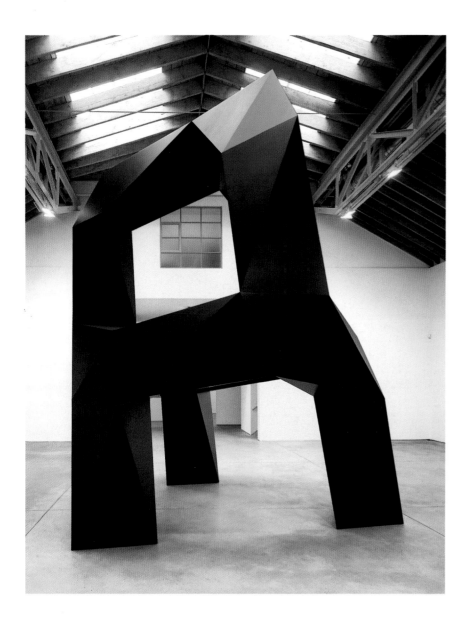

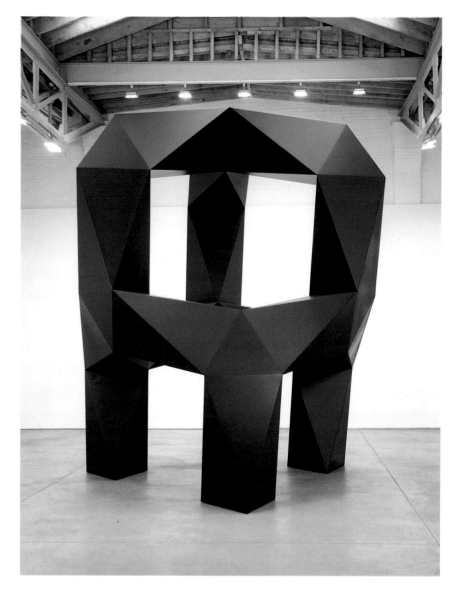

THIS PAGE AND OPPOSITE: *Moondog.* 1964. Painted aluminum, 17'1 ¼" x 13'7 ¼" x 15'8 ½" (521.3 x 414.7 x 478.8 cm). Collection Benesse Corporation, Tokyo, Japan

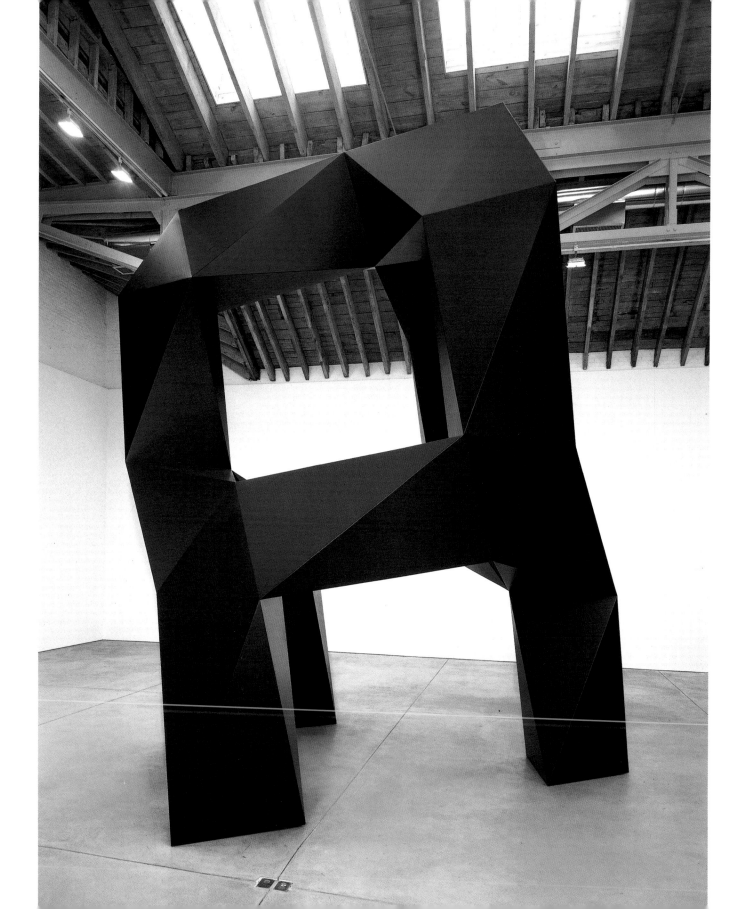

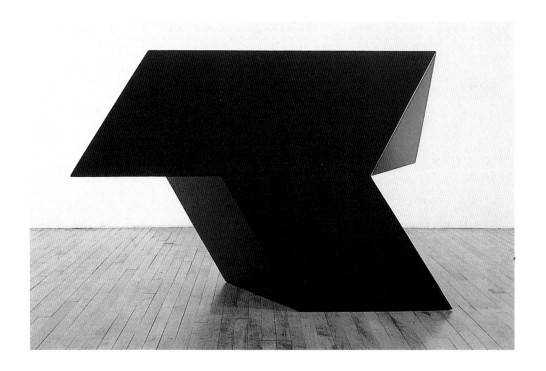

THIS PAGE AND OPPOSITE:

Tau. 1965. Cast bronze, black patina, 15 x 23 x 12½" (38.1 x 58.4 x 31.8 cm). Collection Robert and Lucy Reitzfeld, New York

Amaryllis. 1965. Painted steel, 11'6" x 7'6" x 11'6" (350.5 x 228.6 x 350.5 cm). The Metropolitan Museum of Art, New York

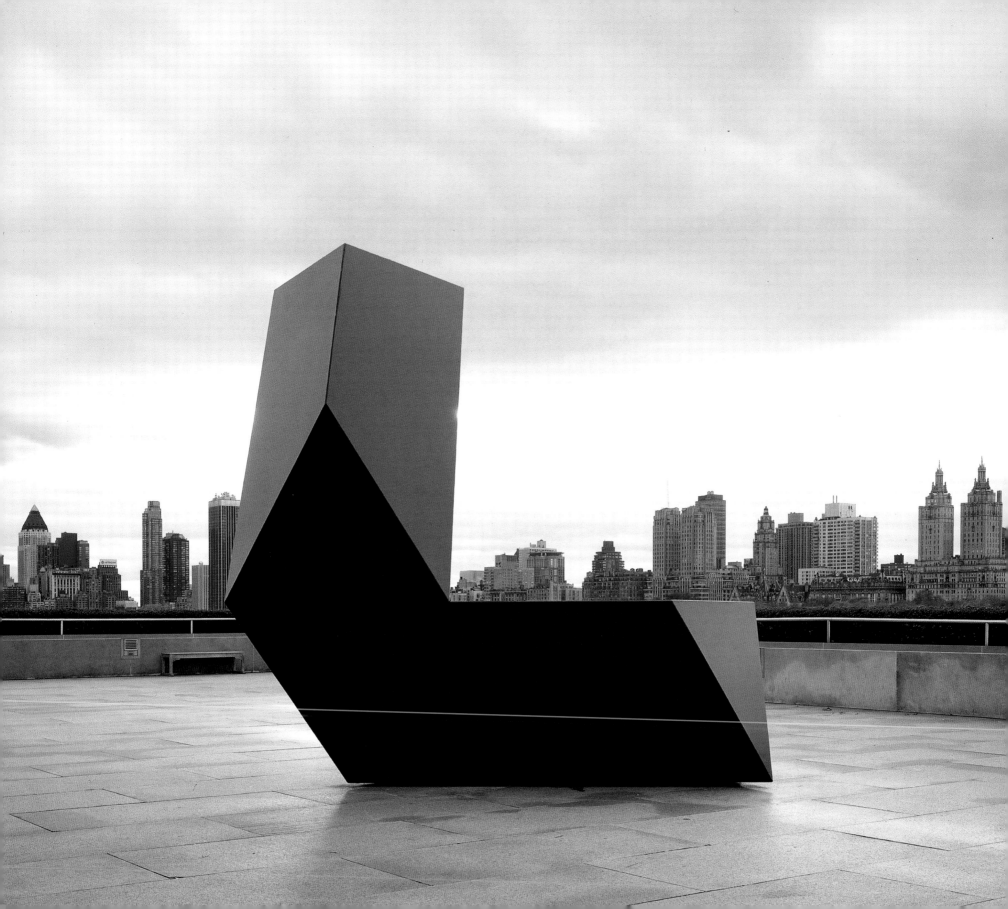

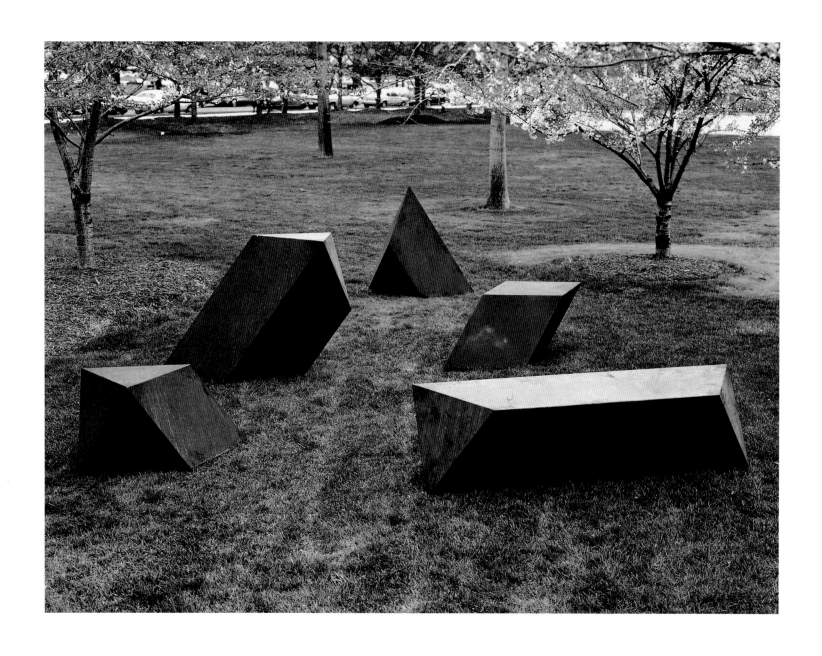

Wandering Rocks. 1967. Painted steel, 5 units, 23 to 45½" (58.4 to 115.6 cm) high. National Gallery of Art, Washington, D.C.
Gift of the Collectors' Committee, © 1998 Board of Trustees, National Gallery of Art

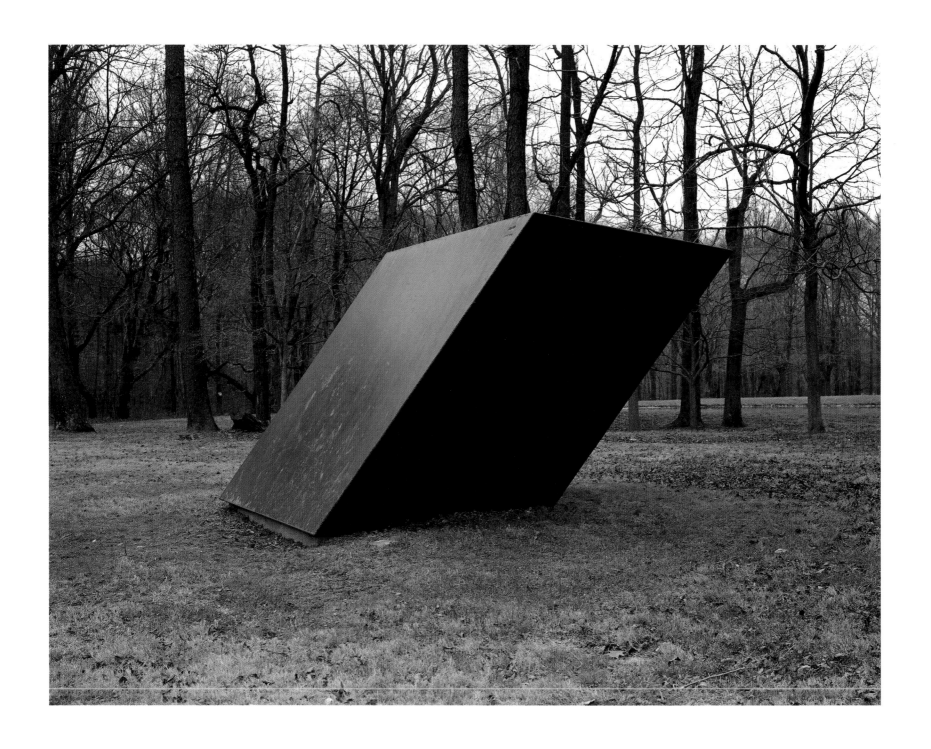

New Piece. 1966. Painted steel, 6'11" x 12' x 14'2" (210.8 x 365.8 x 426.7 cm). Institute for Advanced Study, Princeton, New Jersey

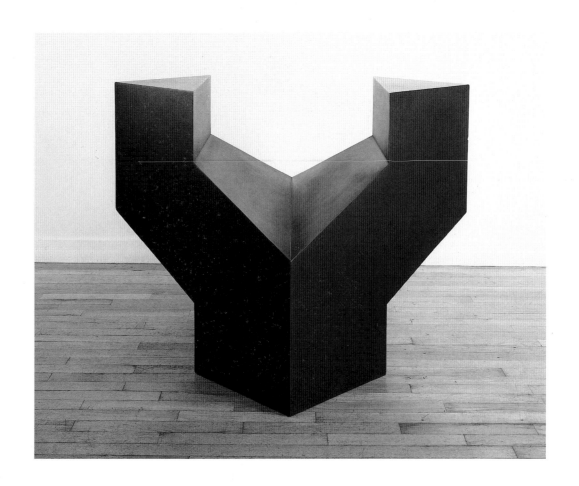

Equinox. 1968. Painted wood model, 30 x 42 ¼ x 42 ¼" (76.2 x 107.3 x 107.3 cm). Tony Smith Estate, New York

Smoke. 1967. Painted plywood mock-up, 24 x 48 x 34' (731.5 x 1463 x 1036.3 cm). Installed at The Corcoran Gallery of Art, Washington, D.C., October 1967–January 1968, in the exhibition *Scale as Content.* (subsequently destroyed)

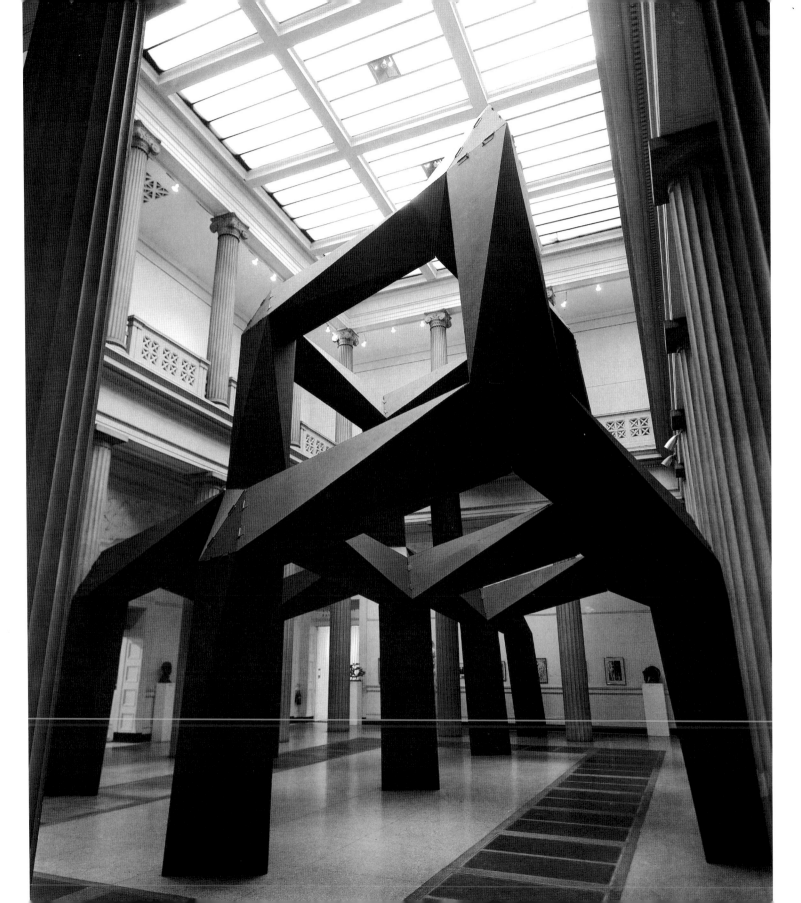

167

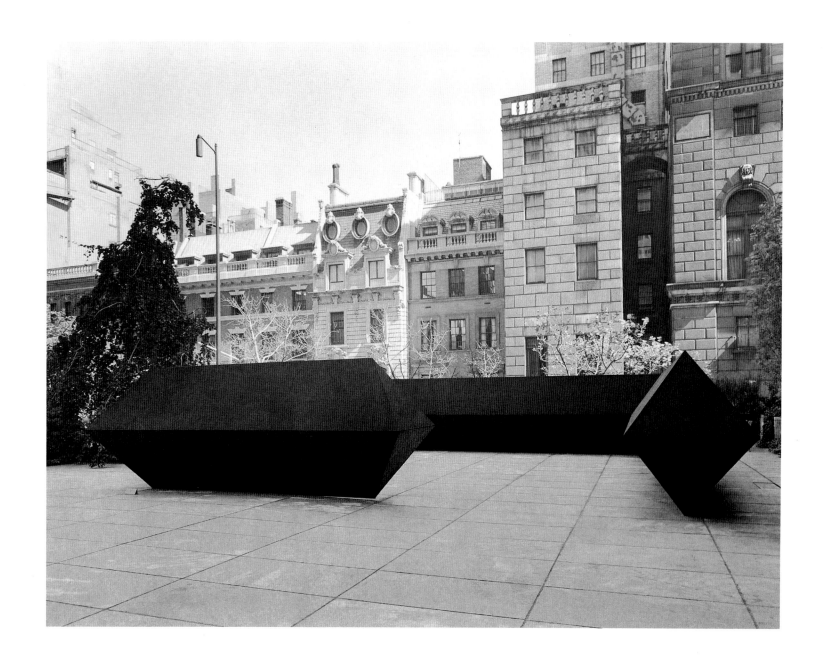

THIS PAGE AND OPPOSITE:

Stinger. 1967–68. Painted plywood mock-up, 6 x 32 x 32' (182.9 x 975.4 x 975.4 cm). Installed at The Museum of Modern Art, New York, 1968

Moses. 1968. Painted steel, 11'6" x 15' x 7'4" (350.5 x 457.2 x 223.5 cm). The John B. Putnam, Jr., Memorial Collection, Princeton University, Princeton, New Jersey

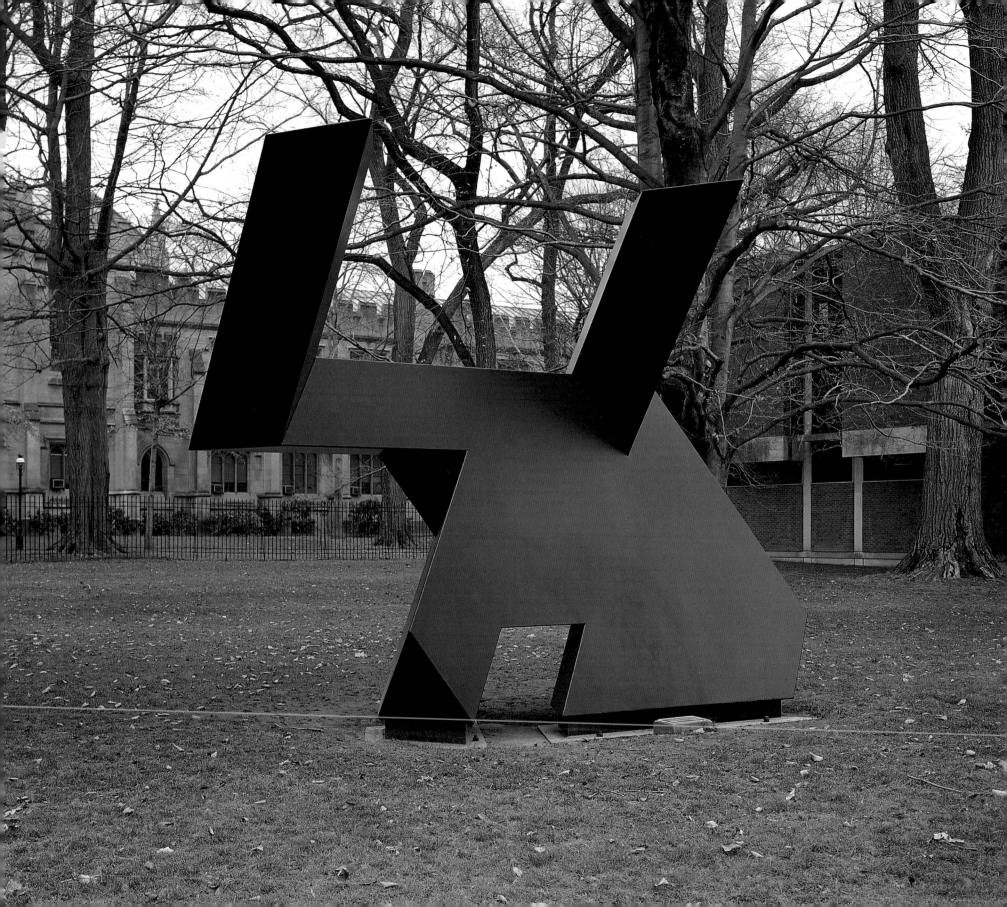

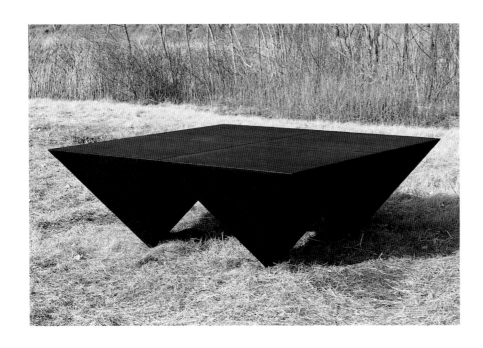

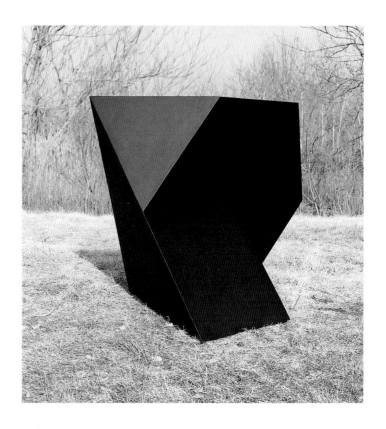

ABOVE: *For P.N.* 1969. Welded bronze, black patina, 28" x 6'8" x 6'8" (71.1 x 203.2 x 203.2 cm). Tony Smith Estate, New York

RIGHT: *For P.C.* 1969. Welded bronze, black patina, 64½" x 6'10" x 60" (163.8 x 208.3 x 152.4 cm). Private collection, Switzerland

OPPOSITE: *For D.C.* 1969. Welded bronze, black patina, 33" x 11'8" x 6'8" (83.8 x 355.6 x 203.2 cm). Private collection, Korea

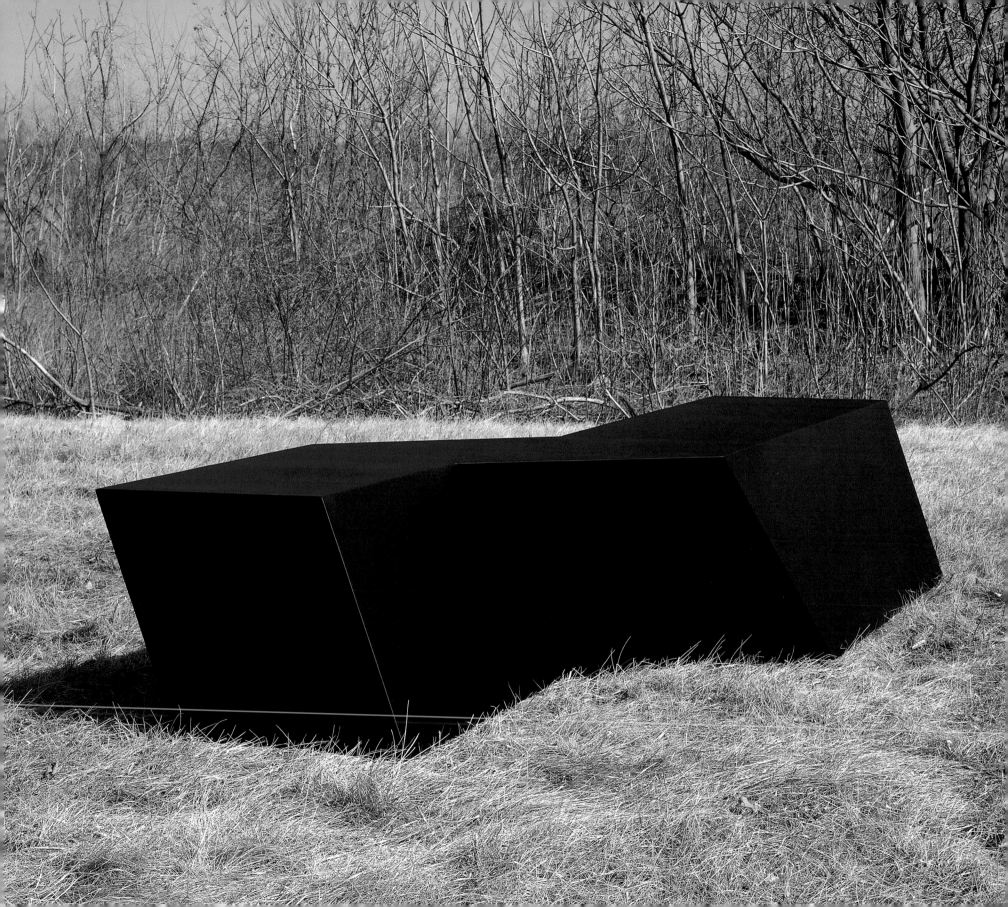

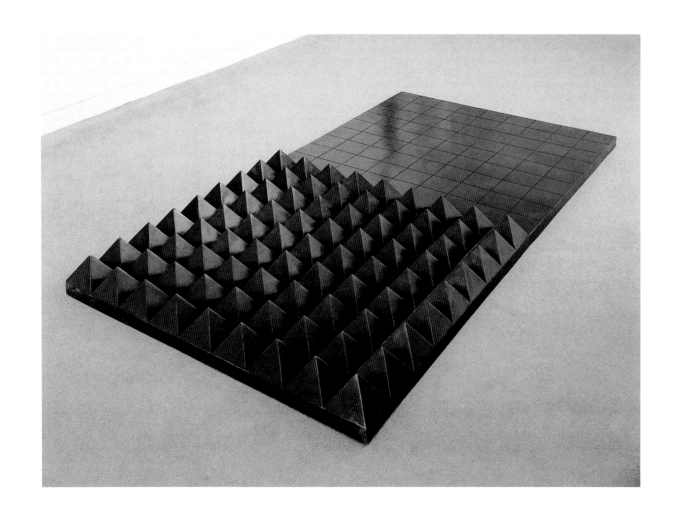

Hubris. 1969. Cast bronze, black patina, 5" x 6'10¼" x 41" (12.7 x 208.9 x 104.1 cm). Collection Clos Pegase Winery, Napa Valley, California

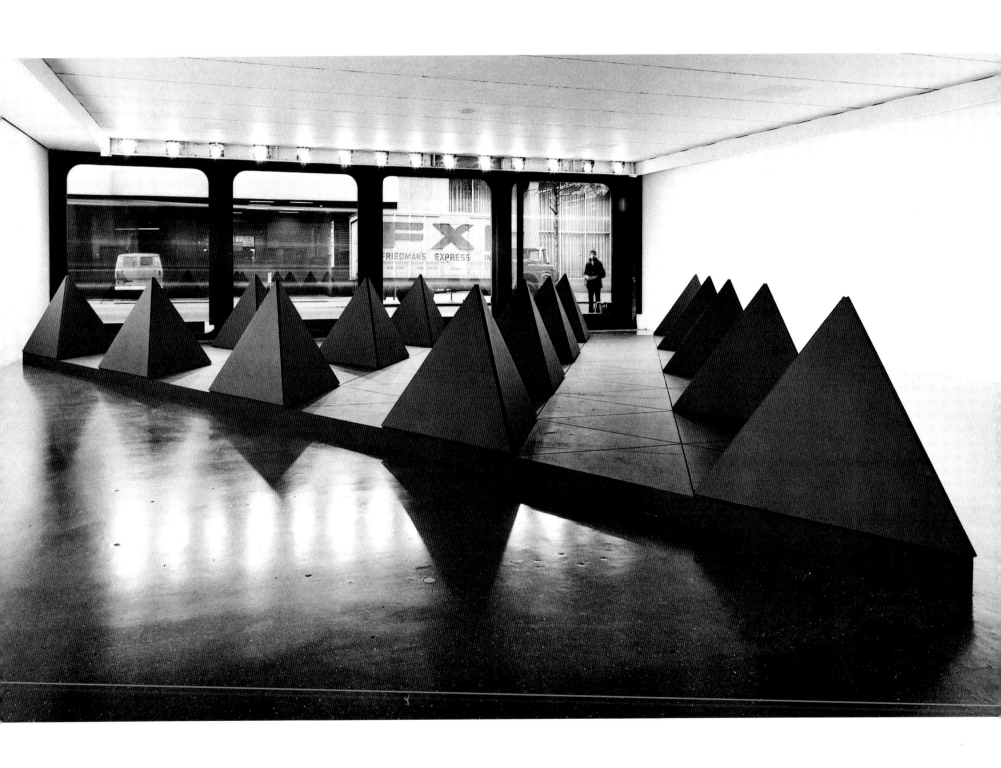

Eighty-One More. 1970. Painted plywood mock-up, 55⅜" x 41'6" x 36' (140.7 x 1264.9 x 1097.3 cm).
Installed at The Museum of Modern Art, New York, 1971. (subsequently destroyed)

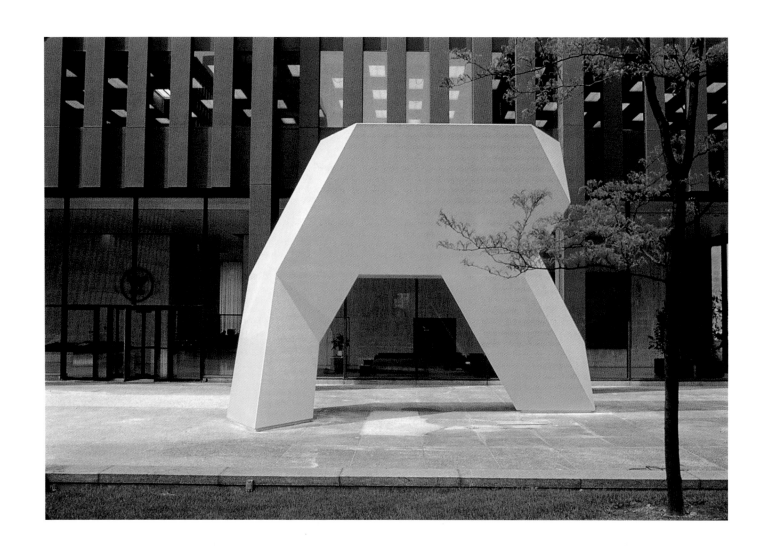

Light Up!. 1971. Steel, painted yellow, 20'9" x 16'6" x 28'7" (632.4 x 502.9 x 871.2 cm). University of Pittsburgh, Pittsburgh, Pennsylvania.
Shown installed at Westinghouse Corporate Headquarters, Pittsburgh, 1974–87

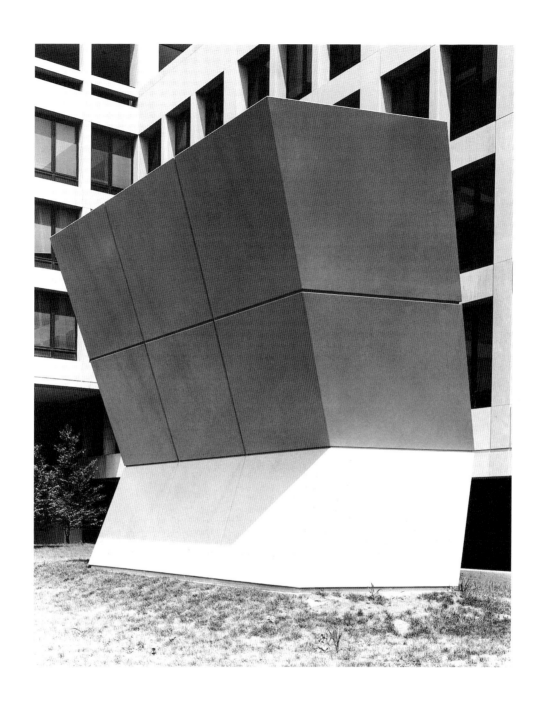

She Who Must Be Obeyed. 1971–72. Steel, painted blue, 20'9⅜" x 33'6" x 16' (633.4 x 1021.1 x 487.7 cm). General Services Administration Building, Washington, D.C.

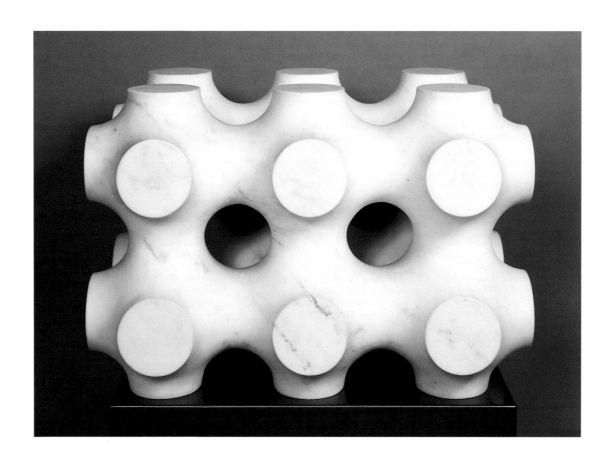

THIS PAGE AND OPPOSITE:

Fermi. 1973. Carrara marble, 28 x 42 x 28" (71.1 x 106.7 x 71.1 cm). Collection Henry and Renée Segerstrom

For Dolores (Flores para los muertos). 1973–74. Carrara marble, 44 1/4 x 44 3/4 x 45 1/4" (112.4 x 113.7 x 114.9 cm). The Patsy R. and Raymond Nasher Collection, Dallas, Texas

THE HENRY FV COLLEGE LIBRAH

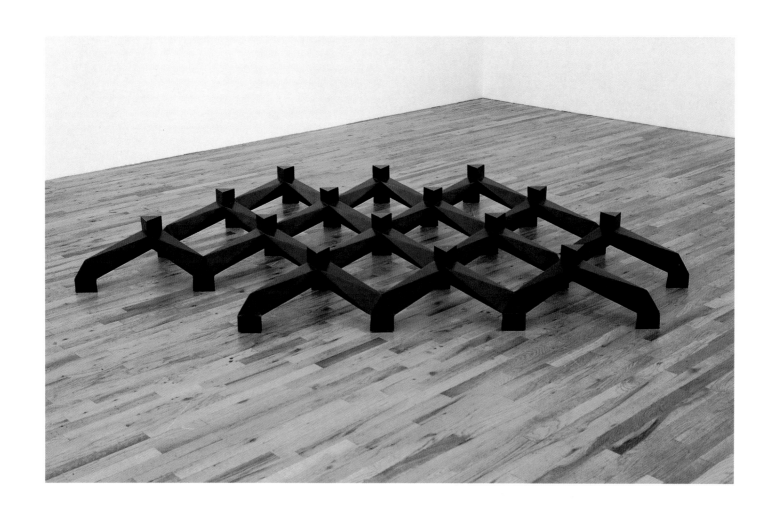

Smog. 1969–70. Cast bronze, black patina, 12" x 9'5" x 6'7" (30.5 x 287 x 200.7 cm). Collection Hans Noe, New York

Smug. 1973. Painted plywood mock-up, 11 x 78 x 64' (335.3 x 2377 x 1950.7 cm). Installed on St. John's Rotary, New York, 1988–93. (subsequently destroyed)

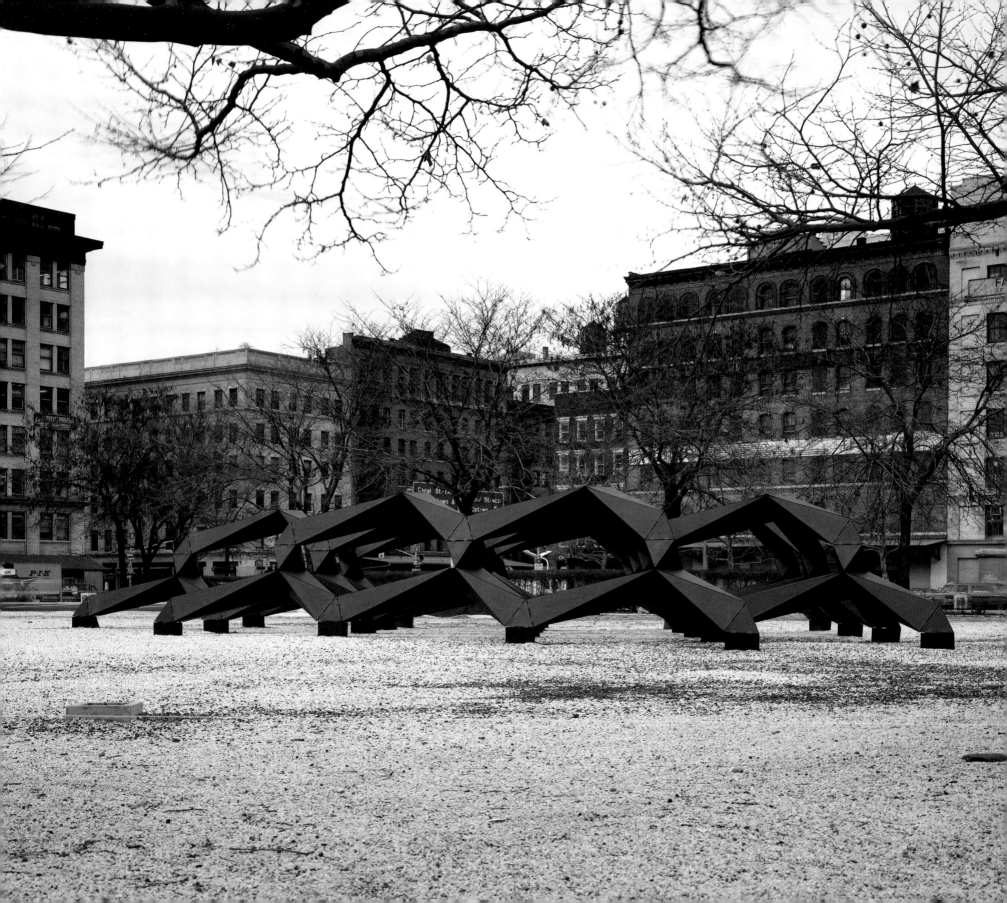

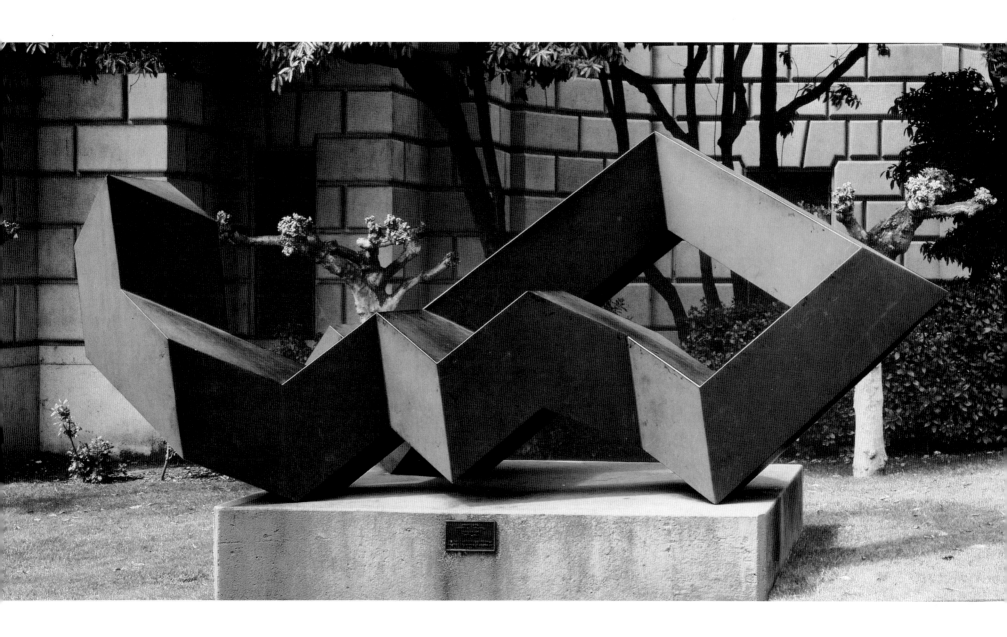

THIS PAGE AND OPPOSITE:

Throwback. 1976–77. Painted aluminum, 6'7⅝" x 16'2¼" x 8'9½" (202.2 x 493.3 x 267.9 cm). San Francisco Museum of Modern Art. William L. Gerstle Collection. William L. Gerstle Fund Purchase

Untitled (Atlanta). 1980. Cast bronze, black patina, 48 x 31 x 24" (121.9 x 78.7 x 61 cm). Private collection

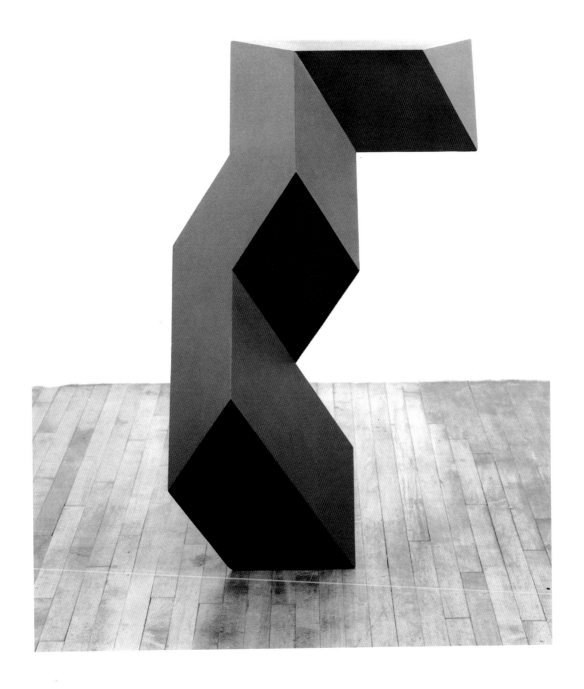

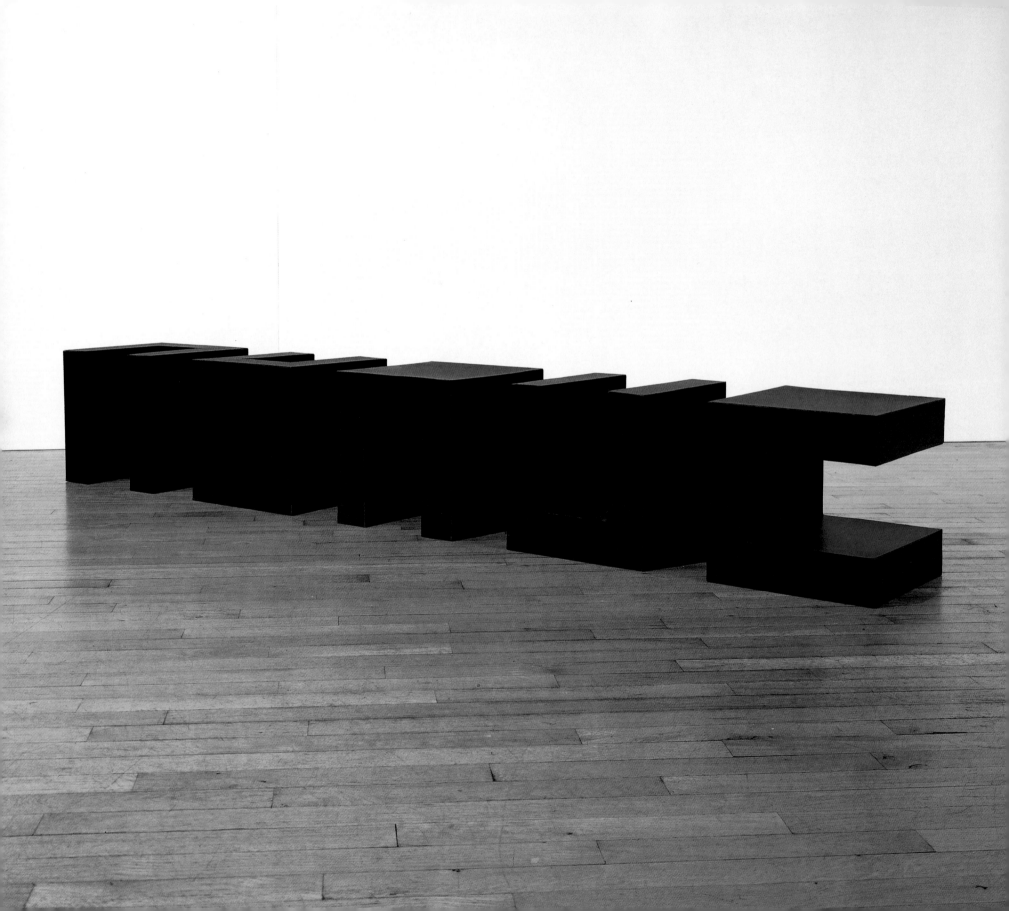

OPPOSITE: Untitled (Five Cs). 1980. Painted cardboard model, 5 elements, each 12 x 12 x 12" (30.5 x 30.5 x 30.5 cm). Tony Smith Estate, New York

Chronology · COMPILED BY JOAN PACHNER

1912

Born September 23 in South Orange, New Jersey, to Josephine (née McCabe; 1883–1941) and Peter Anthony (1882–1940). He is the second of seven children (Mary, born 1910; Joseph, 1914–1963; Eugene, 1918–1965; Peter, born 1920; Thomas, 1922–1991; William, 1925–1993) and third generation descendant of an Irish family. His father is a mechanical engineer and the primary stockholder in the A. P. Smith Manufacturing Company, a municipal waterworks factory, founded in the late 1800s by Anthony Peter Smith, Tony's grandfather. His mother is a homemaker whose family owned a boilerworks factory.

1915

Travels cross-country with his parents and older sister by railroad to see the Panama-Pacific International Exposition in San Francisco. In later years Smith would recall seeing the Palace of Fine Arts designed by Bernard Maybeck at the Exposition, as well as the Pueblo sites they visited in the Southwest on their return trip.

1916–26

Contracts tuberculosis around 1916. In order to speed his recovery, and to avoid the possibility of infecting his brothers and older sister, moves out of the main house into a small, prefabricated one on the family property; a nurse is hired to care for him. Is tutored at home and also attends Sacred Heart Elementary School sporadically.

1926–30

Commutes from South Orange to New York City to attend St. Francis Xavier, a Jesuit school, graduating in December 1930.

1931–33

Attends Fordham University, the Bronx, in spring and summer 1931, and Georgetown University, Washington, D.C., from 1931 to 1932. Returns to South Orange; operates a second-hand bookstore on Broad Street in Newark, New Jersey. Visits the "International Style" architecture exhibition at The Museum of Modern Art in New York in 1932 and is deeply impressed by it.

1934–36

Works for the family business, A. P. Smith Manufacturing Company, East Orange, as a toolmaker, draftsman, and purchasing agent. At night commutes to New York City to study drawing and painting at the Art Students League. Studies anatomy with George Bridgeman, drawing with George Grosz, and painting with Vaclav Vytlacil. Frequents the Gallatin Collection of Living Art at New York University, Curt Valentin's gallery, and The Museum of Modern Art, where in 1936 he visits the exhibitions *Cubism and Abstract Art* and *Fantastic Art, Dada, Surrealism.*

Tony Smith, Jane Smith, and Tennessee Williams in 1943

1937–38

Moves to Chicago to study architecture at the New Bauhaus headed by László Moholy-Nagy. Other teachers include György Kepes (drawing, lettering, layout, design), Alexander Archipenko (sculpture), and Henry Holmes Smith (photography). Particularly enjoys Hin Bredendieck's metal workshop and is appointed head of the workshop by Moholy-Nagy. Befriends artists Fritz Bultman, Gerald Kamrowski, and Theodore van Fossen. With van Fossen and others protests the curriculum's emphasis on industrial arts over the fine arts and opposes Moholy-Nagy's choice of George Fred Keck as architecture instructor.

1938–39

Visits friend John Feeley in Critchell, Colorado, and there builds his first structure, a chicken coop. In the spring of 1938 sees Frank Lloyd Wright's Ben Rebhuhn House in Great Neck, Long Island. In fall of that year begins work as a carpenter's assistant and bricklayer at Wright's Ardmore project outside Philadelphia; eventually becomes clerk of the works there. Also calculates construction costs for Wright's Usonian houses. After a short stay at Taliesin, in Wisconsin, helps build Wright's Armstrong House in Ogden Dunes, Indiana. In February 1939 returns to South Orange upon hearing that his mother is gravely ill.

1940–43

Builds first house with Theodore van Fossen (his partner until

1944) in 1940 for the Gunning family in Black Lick, Ohio. Father dies December 1, 1940, from a sudden, massive heart attack. Mother dies three months later on March 31, 1941. Moves to Greenwich Village in late 1941.

1943–45

In 1943 moves from New York to California with Jane Lawrence (née Brotherton); they marry that year on September 25 in Santa Monica, with Tennessee Williams as the only witness. They live in a storefront loft in Hollywood, at 1652 North Harvard Boulevard. Meets photographer Edmund Teske. Has various jobs, including work for a plant nursery and for Viennese furniture dealer Paul Frankl. In 1944 designs and builds a house for his father-in-law, L. L. Brotherton, in Mt. Vernon, Washington. Between 1943 and summer 1945 creates "The Pattern of Organic Life in America," in which he develops philosophical ideas and personal iconography central to future work.

1945

Returns to the East Coast. During the summer in Provincetown, Massachusetts, builds a painting studio for Fritz Bultman. Friends Hans Hofmann and Ann Ryan are there; meets Buffie Johnson, who introduces Smith to Barnett and Annalee Newman. In the fall moves to New York City and eventually settles at 51 West 16th Street.

1946–53

Begins teaching art to children at Hartley House, a Settlement House in the West 50s (1946–52); also teaches at New York University, School of Education (1946–50); at Cooper Union (1950–52); and at Pratt Institute of Art (1951–52). Becomes close friends with Abstract Expressionist artists, including Mark Rothko, Jackson Pollock, Clyfford Still, and Theodoros Stamos and builds a house for the latter on Long Island in 1951. Begins doing exhibition design for New York galleries and museums, especially at Betty Parsons Gallery (1949–53). Architectural work increases, and around 1951 hires two assistants.

1953–55

Leaves New York City to join wife, Jane, who is singing opera in Heidelberg, Germany. After a brief visit with friends in Stuttgart (late summer 1953), they tour Europe in the fall (Italy, France, and Spain). For Smith the highlight of the trip is seeing Le Corbusier's apartment complex in Marseilles, Unité d'Habitation. They resettle in Nuremberg before Christmas; daughter Chiara (Kiki) is born on January 18, 1954. Smith's work abroad includes

Tony Smith with Barnett Newman (left) and Jackson Pollock (middle) in 1951. Photograph by Hans Namuth

Tony Smith, c. 1946–47

numerous unrealized and visionary architectural designs ("Orient Express," "Glass Ranch House," and "Project for a Roman Catholic Church in an Ideal American Landscape"), architectural theories about city planning and Le Corbusier's Modular ("Metric Proportional Grid"), grid and circle paintings (including the *Louisenberg* group), as well as some wood-collage sculptures.

1955–61

Returns in May 1955 to family home on Stanley Road in South Orange. Twins Seton and Beatrice are born on July 24. In addition to work as a draftsman for the architectural firm of Edelbaum and Webster (1955–56), Smith accepts teaching positions at various institutions, including the Delahanty Institute (1956–57) and Pratt Institute of Art (1957–60), both in New York, and Bennington College, Vermont (1958–61). Frustrated with changes made to the Olsen Houses in Connecticut (1951), he begins to phase out architectural work. While teaching, makes his first titled sculpture, *Throne* (1956–57). In 1960 submits an entry to a competition to build a memorial to Franklin Delano Roosevelt.

1961

In spring 1961 is seriously injured in an automobile accident in Vermont; develops a blood condition, polycythemia (marked by an abnormally large number of red cells in the blood), as a result. During recuperation begins to make sculptural shapes by taping together small tetrahedral modules. Explores the formal possibilities of the cube in drawing, painting, and sculpture.

1962–65

Begins teaching at Hunter College, New York (1962–74). In 1962 makes *Black Box*, his first sculpture in steel. In November 1963, Samuel Wagstaff, Jr., curator at the Wadsworth Atheneum, Hartford, Connecticut, visits Smith in South Orange, having heard a lecture by artist Raymond Parker discussing some of Smith's new work. Wagstaff selects *The Elevens Are Up* (1963; The Menil Collection, Houston) for *Black, White, and Grey* (1964), a group show that includes mostly young artists (Ann Truitt, Agnes Martin, Robert Morris, and Frank Stella, among others). This is the first public exhibition to include Smith's work; he is fifty-one years old.

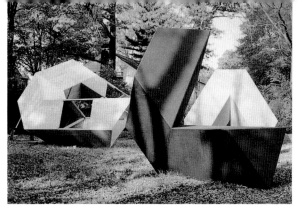

1966–67

In spring 1966, Smith's *Free Ride* (1962; The Museum of Modern Art) is included in his first New York group exhibition, *Primary Structures,* at the Jewish Museum, New York. In the fall of 1966, *Tony Smith: Two Exhibitions of Sculpture,* his first solo exhibition, is on view simultaneously at the Wadsworth Atheneum in Hartford and at the Institute of Contemporary Art in Philadelphia. Publications in *Artforum,* including "Talking with Tony Smith" (December 1966), and *Time* (cover article, "Master of the Monumentalists," October 13, 1967), dramatically increase his public profile, as does the outdoor exhibition of eight large-scale sculptures in Bryant Park early in 1967. Other important installations include *Maze,* in the exhibition *Schemata 7,* Finch College Museum of Art, New York, 1967, and *Smoke,* in *Scale as Content: Ronald Bladen. Barnett Newman. Tony Smith,* at the Corcoran Gallery of Art, Washington, D.C., 1967.

1968–73

In 1968 is included in *XXXIV Biennale* in Venice and *Documenta 4* in Kassel. In the late 1960s envisions various unrealized site-specific projects, including *Lunar Ammo Dump* (1968), for the University of Illinois at Chicago Circle; *Mountain Cut* (1968–69),

for Valencia, California; and *Haole Crater* for the University of Hawaii, Honolulu, where he was teaching during the summer of 1969. That same summer he designs *Bat Cave,* later exhibited at *Expo '70* in Osaka and in the *Experiments in Art and Technology* exhibition at the Los Angeles County Museum of Art, California, 1971. *Eighty-One More* (a plywood mock-up at one-fifth the intended size) is installed in the lobby of The Museum of Modern Art in 1971.

1973–80

In 1973 travels to Carrara, Italy, to work with carved marble, creating *For Dolores (Flores para los muertos)* (The Nasher Collection, Dallas) and other subsequent designs based on topological Klein surfaces. Teaches at Princeton University from 1975 to 1978 and again at Hunter College from 1979 to 1980. Late works include the blue *She Who Must Be Obeyed,* outside the General Services Administration Building, Washington, D.C.; the white *Lipizzaner,* installed outside the New Orleans Museum of Art in 1978; and the red-orange *Last,* inaugurated in 1979 in Cleveland, Ohio. In deteriorating health, Smith dies of a heart attack on December 26, 1980.

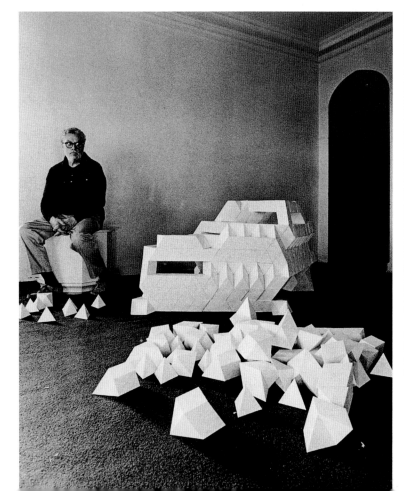

CLOCKWISE FROM TOP RIGHT:
Plywood mock-ups of *Amaryllis, Spitball,* and *Cigarette* in 1966; Tony Smith at work on *Louisenberg* in 1968 (Robert Swain at right); Tony Smith with daughters (left to right: Chiara, Seton, Beatrice) building tetrahedral modules in 1969; Tony Smith with *Bat Cave* model in 1969

Awards

1966
Longview Foundation Art Award
National Council on the Arts Award

1968
John Simon Guggenheim Foundation

1971
American Institute of Architects Fine Arts Medal

1974
College Art Association Distinguished Teaching of Art Award
Brandeis University Creative Art Award in Sculpture

1979
Member of American Institute of Arts and Letters

ABOVE: Tony Smith in 1970. Photograph by Hans Namuth

RIGHT: Installation of *Smoke* mock-up at The Corcoran Gallery of Art, Washington, D.C., 1967

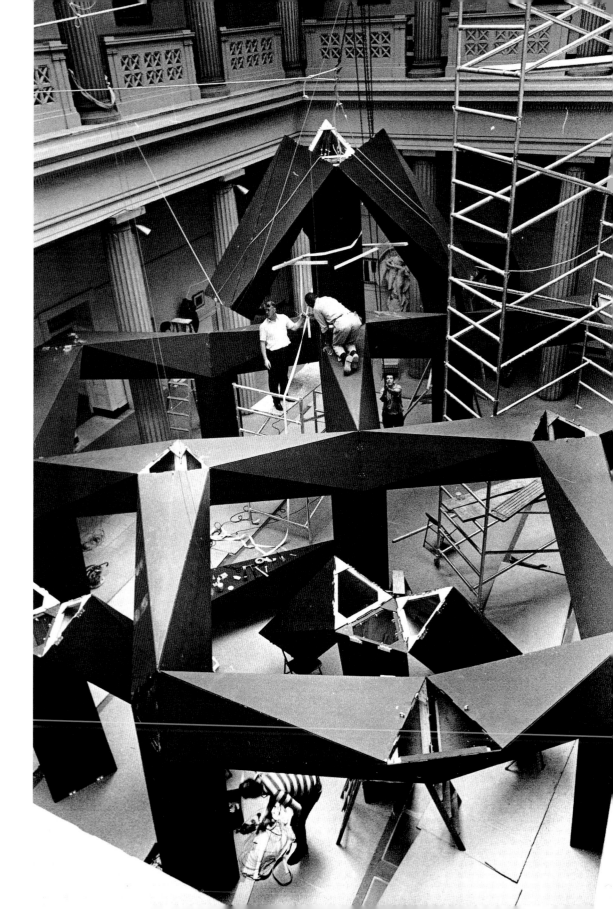

Writings, Interviews, and Letters · COMPILED BY JOAN PACHNER

I. RECOLLECTIONS AND STATEMENTS BY THE ARTIST

On Architecture

[For my first project, in Critchell, Colorado, 1938] I adapted U.S. Department of Agriculture Plans and Specifications for a chicken coop to local materials and site. I cut logs, barked, and formed them, and on a concrete foundation executed a log cabin hen house. The roof was made with boards and rolled roofing. The floor was cement. Windows were celoglass. I don't know if it was a good chicken coop. The family for whom I built it preferred it to their 50 year old miners cabin and moved in.[1]

. . .

As a firm we [Smith and Theodore van Fossen] designed and supervised the construction of residences which could be produced industrially but which would satisfy our standards of architecture. Therefore we spent more time on the design of an integrated utilities core and modular or otherwise standardized structural elements for a house than on executed work. In line with this project we designed two experimental houses for merchant builders, and made plans for neighborhood units, including shopping center, etc., and cultural facilities.[2]

. . .

A house is a formal establishment—a symbol and pretense of order. The hall is the soul of a house—the rest is a sweltering cave.

A building—as a classic expression—should be contained within a regular solid, as a picture is within its frame. It should have a plastic center around which it is organized, but also limits within which it is organized.[3]

. . .

All monumental architecture is an objectification of the death instinct.

Homes should be an attempt at the greatest intensification of the local in all its aspects.

The thing most lacking in the functional house is the quality of a dream; that quality of the environment so necessary to integration.[4]

. . .

Claud[e] Bragdon said that architecture must be functional, structural, schematic and dramatic. For me, the dramatic consists in the confrontation of an individual with the most intense expression of a specific time and place. What is monumental consists in giving this expression the clearest and most economical form.[5]

"The Pattern of Organic Life in America" (1943)

My "work in progress" is a pattern . . . The pattern of organic life in America.

There is an organic pattern of life here in America. There are deep rhythms and drives here but they are not clear. We have no great culture. Our energy is dissipated in our lack of any integrating and unifying element, any myth, any bible by which we can relate and interpret the complexity of our vast experience.

America—I am trying to clarify the pattern of organic life in America. I think that there is such a pattern here and it only needs uncovering. The poets have seen it, Thoreau, Whitman, Wright; but no one else has much idea of it.

The Western World is in every dimension bi-lateral symmetry, applied order, formal, arbitrary, static. They do an essentially material thing like putting four legs on a chair and then hang on some style. The style of organic life is intrinsic; it is built in, as it is in the airplane. Here in America, in the New World, style is conceived as built in, not hung on. Instead of the Cross we follow the law of growth, the spiral, dynamic equilibrium. . . . Only in our magic, our puritanism, in our freudian and colonial little boxes are we formal and false. Puritanism channelled in terms of growth as in Thoreau, as in Juan Gris gives an intense and vibrant life—but we just beat ourselves with it.

Method—taking a hint from the great author of Finnegans Wake Matter—from my great master F.LI.W. and my beloved mistress—America.

The spiral Cross
The way of the spirit
The revolution
Generation
The means of salvation

The square stands against chaos—it is absolute
it stands for unity, identity, being—it
stands for crystallization [?] and concretion—art
stands for the particular—the manifest

Start a series of notebooks based on recurrence—the typical experience—the universal nature—the cosmic order—and harmony and rhythm and spirit and intelligence.

Has America already her bible—in Walden?

Make it new.
Clothes
Manners
Music
Painting
Sculpture
Poetry
Architecture
Food
Automobiles

Make it new—John Cage is making music new—I like it.

If the individual is seen as a society of cells it can be seen that individual cells have given up their own independence to do the specialized work required for the organism as a while. Cells lose their identity before the demands of the whole body.

This country demands abstraction! the shadow of the underparts of the train—the poles and cross pieces, insulators and wires against the sky—the forms of the factories for crushing stones, etc. the corrals and fences and loading stations for cattle. This country demands a tremendous—abstract form.[6]

Science and Order

I had been familiar with the root rectangles of Jay Hambidge's *Dynamic Symmetry* since before I started high school. . . . I had been interested in the exposition of close-packing in D'Arcy Thompson's *On Growth and Form* . . . Thompson was writing about the effects of mathematical and physical laws upon living form.[7]

. . .

There are two forms of order: That of static, homogeneous elements so grouped as to form an order determined by certain limits. This is the basis of order in crystals, and in art, that used in the Japanese mat-module system of house planning. The other form is the organic in which heterogeneous, dynamic elements are subordinated to some closed, archetypal order, the limits of which are predetermined by the archetype itself and an enclosing format based on some form of symmetry. This is the type of all living organisms and the more conscious forms of art.[8]

. . .

I had always been impressed by systems of order. I always felt that instead [of] reducing a subject they lent to it an air of mystery—space became limpid and fluid when understood within the framework of an order which cut through the surfaces of things.[9]

. . .

For the last couple of thousand years most buildings have been based on symmetry of some kind, by far, most of them on bi-lateral symmetry. . . . At the beginning of the twentieth century, factory buildings, commercial buildings, etc., began to be regulated according to bays, according to column centers, without any organic symmetry or anything based on point, line, or plane . . . so that it would just be a repetition of units. It did not make any difference where a building ended. For instance, Mies Van der Rohe has said of the repetition in New England factories that they run out; that is, that the bay sides, the small windows between the wall sections, are so small and repeated so often

that it is impossible to comprehend the building as a complete unit. At the same time, architects began to take over this column-spacing as the basis on which buildings would be organized. . . . They were not reduced to introducing elements of false masks and all sorts of things just for the purposes of symmetry.[10]

Tetrahedrons and Cubes

I saw some kites, towers and other things made by Alexander Graham Bell . . . They were based on a lot of tetrahedrons, regular four-sided solids—all sides are equilateral triangles. It is very strong structurally . . . you can get a whole lot of them—all very solid. Now at one time I was fooling with hexagons . . . making a little alphabet of them . . . Well it occurred to me as a new line of approach to sculpture such a thing could be done by filling in some planes of a network of tetrahedrons . . . made of wires or dowels and leaving others open . . . when the underlying dynamic of the structure was realized, variations such as curved or other free or anthropomorphic elements could be introduced. At any rate this is quite a different world of form than the cube (not that I have anything against cubes).[11]

. . .

Corbusier . . . is quite right in starting with the cube (or some other solid) as a basis for a house but why must the house be a cube? A building—as a classic expression—should be a container within a regular solid—as a picture is within its frame—It should have a plastic center about which it is organized . . . A building should serve to divide the space within a solid—not just enclose it as does Le C.[12]

. . .

It is the clear realization of the cube in space which we cannot see, which informs and makes significant all that we do see . . . Without an awareness of the crystal structure of this continuum, our eyes are organs of sensation only.[13]

Advice to Students

To bring out of chaos, to give to the meaningless some meaning, to the formless some form, to the insignificant some significance is to create . . . [But] [c]reation . . . is not chance, although it may involve chance. Things do not create, nor do irrational animals. Instinct or other automatic process is not creative. Reflex is not creative.[14]

. . .

Painting is the inspiration and model for architecture; it is the painter who is the visionary.[15]

Tony Smith in New York to his wife in Germany 1950–51

Barney and Annalee [Newman] have been wonderful to me—without them I couldn't have done it. He has been like a father and a brother to me. Spiritually, intellectually, culturally (action).[16]

. . .

Somehow time goes by without any sense of life . . . There is just anxiety and blankness. At least I am away from the art scene. Everyone is better off in that direction. Jackson [Pollock] is more realistic. Barney [Newman] works. Mark [Rothko] teaches and looks after the baby. I feel as if I no longer have obligations on the score of admiration. I am moving more towards my own center of things and am concerned only about my and our affairs. . . . Aside for [sic] Barney, Mark, Cliff Still and Jackson, I don't much care.[17]

Europe 1953–55

Since during the period between leaving Los Angeles in about 1944 and coming to Europe in 1953 I had a degree of mental vigor which I shall probably not enjoy again . . . I read TIME all the time to keep in touch with what is going on generally. They never have a good word to say about our painters; their work is always described as confused, confusing, chaotic, still following European leads, etc. TIME is unable to see these pictures except in the light of European criticism which either cannot see the work or has no vocabulary with which to deal with it . . .

It is interesting to observe that the Europeans value most highly what in American art they are able to talk about most clearly, and that these are never what in our eyes are the best things. Europeans will not value what we do until we are able to tell them what we do. They recognize only what they have terms for . . . I am not condemning Europe for failing to see the American vision; I am condemning the American visionaries, naturally not the painters themselves, for not making a greater effort to explain themselves to civilization.[18]

. . .

There were some things, stained glass in a little partially cloistered chapel, and some other things in Palma which reminded me a lot of Baziotes; and I saw a lot of the work of . . . Antonio Gaudi which he liked. The things that I saw that I think you would like the most were the Greek temples at Paestum and Corbusier's building in Marseilles. I also saw his Swiss Pavilion in the University City, Paris, and the Siedlung which he and others did in Stuttgart . . . I think that the . . . Picasso which has moved me most of all his work is the man with the sheep or goat in Valouris.[19]

. . .

In Majorca I designed a city which is almost one building, a zigzag chain of buildings like the UN Secretariat, in plan resembling a train wreck. It makes me think of Lower Manhattan, the Grand Canyon, and Niagara Falls.[20]

Cities and Grids

I now have a theory about cities. I felt it when we were in Chicago, but couldn't quite put my finger on it. It is that all other cities exist on land but New York. In New York the land has ceased to exist and so has the sky. It is the first real city. The rest are all just big towns. OR if you like the other are cities on the land, and New York is a city in space.

The thing is that it is an altogether different kind of city in space than what has been visualized by Kiesler, Corbusier or whoever has talked about cities in space from this side of the ocean . . . New York is as different from other cities as cubism is from Cézanne.

I have read a lot of books on town planning lately and none of them seem to catch on to New York. They are all talking about maps, about the ground. [I understand New York] as a three-dimensional grid, a sort of jungle gym. Giacometti's *Palace [at 4 a.m.]* extended as a huge labyrinth. Mondrian's *Broadway Boogie Woogie* generating myriad tessaracts.

The entire space must be understood as a solid with the buildings and spaces between the buildings forming a "closepacked" order. Such a city would be a continuum of concrete spaces and clearly defined by top, sides and bottom. It would hover between earth and sky and be a purely human environment. For the New Yorker at least this could represent the absolute balance between open and closed spaces.

In New York we already have the grid plan . . . It is just that we cling to the conception of the buildings and blocks being masses and the space a void . . . We talk of the sky line as if the space of the sky comes down and becomes identified with that of the city. But that is the case of the space of Lower Broadway, our own triumphal arch and entry into the real city. But skylines are residues of an age . . . it is not a matter of making closed courts or squares; it is enough that spaces be defined and active.[21]

. . .

My conception of a city is that of something defined and limited in three-dimensions from the WILD which is without it, but which within is a continuum, a grid in plan and section, a close packed solid in which mass and volume are each geometric solids and not a lot of masses sticking up into a void. The void is in nature and it has no place in the city.[22]

. . .

The grid, the module, is still the basis of architectural order and freedom. It unifies what is similar and emphasizes what is dissimilar. This is the basis of human order because most things are similar and those things which are not similar are significant.[23]

. . .

The unit is simply a meter . . . and, by the simplest step in counting, two meters. So you can think of the system as a [metric proportional] grid, identical to the Japanese grid except that the unit is a whole meter . . . The unit is related proportionally to other elements simply by the traditional proportions of the GOLDEN SECTION, and related divisions.[24]

"Talking with Tony Smith" (1966)

Craftsmanship and art are much closer than artists seem to be willing to admit, but the question is, where does the distinction seem to take place?

I view art as something vast. I think highway systems fall down because they are not art. Art today is an art of postage stamps. I love the Secretariat Building of the U.N., placed like a salute. In terms of scale, we have less art per square mile, per capita, than any society ever had. We are puny. In an English village there was always the cathedral. There is nothing to look at between the Bennington Monument and the George Washington Bridge.

More and more I've become interested in pneumatic structures. In these, all of the material is in tension. But it is the character of the form which appeals to me. The biomorphic forms which result from the construction have a dream-like quality for me . . . a fairly common type of American dream.

I'm interested in the inscrutability and the mysteriousness of the thing. Something obvious on the face of it . . . is of no further interest. A Bennington earthenware jar, for instance, has subtlety of color, largeness of form, a general suggestion of substance, generosity, is calm and reassuring—qualities which take it beyond pure utility. It continues to nourish us time and time again. We can't see it in a second, we continue to read it. There is something absurd in the fact that you can go back to a cube in this same way. . . . When I start to design, it's almost always corny and then naturally moves toward economy.[25]

Minimalism

I don't believe that any of the people who have developed minimal art take . . . my work into account whatever. I think it is probably that by chance, I did a few pieces which were thought of as being minimal, whereas my intention may have been entirely personal. I certainly had no programmatic intentions in making such things as *Black Box* and *Die* whatever. I had some rather similar boxes which came to this country from Germany in 1955 which I liked and didn't throw out . . . I started to replace them with steel, although I certainly never thought of the boxes as sculpture. I just thought of them being there, which is how the word "presence" came into existence. I didn't think of them as "presences" in any melodramatic sense, but rather that I used that word simply in the context that they were there, that they were present.[26]

On Installations

The only thing I feel about the installation [of the *For* series] is that they should be placed not too far apart, so you can feel the space in between . . . there is one thing I insist on, and that is that they follow the same axial grid . . . I don't want them twisted around as objects...I always have the sculpture parallel and perpendicular to whatever architectural features exist. I don't like them spread around haphazard.[27]

* * *

The geometrical character of these earlier sculptures seemed most compatible in landscaped area, on lawns, against trees, in situations where their large, simple and clear planes were seen in contrast to the open spaces, or the smaller grain and irregular patterns, of nature. But in my hand the crystal lattices tended to produce linear forms which emphasized silhouettes and openings when they were placed in more urban environments. What was plastic in suburbia became graphic in the city.[28]

* * *

These figures [sculptures in Smith's 1966 exhibition at the Wadsworth Atheneum, Hartford, and the Institute of Contemporary Art, Philadelphia], whether based upon rectangular prisms, tetrahedra, or other solids, may be thought of as part of a continuous space grid. In the latter, voids are made up of the same components as the masses. In this light, they may be seen as interruptions in an otherwise unbroken flow of space. If you think of space as solid, they are voids in that space. While I hope they have form and presence, I don't think of them as objects among other objects; I think of them as being isolated in their own environments. I don't think of the pieces so much as examples of a type—such as the specimens that might fill out a stamp or coin collection. I think of them as seeds or germs that could spread growth or disease. The pieces seem inert or dormant in nature—and that is why I like them there, but they may appear aggressive, or in hostile territory, when seen among other artifacts. They are not easily accommodated to ordinary environments, and adjustments would have to be made were they to be accepted. If not strong enough, they will simply disappear; otherwise, they will destroy what is around them, or force it to conform to their needs. They are black and probably malignant. The social organism can assimilate them only in areas which it has abandoned, its waste areas, against its unfinished backs and sides, places oriented away from the focus of its well-being, unrecognized danger spots, excavations and unguarded roofs.[29]

Labyrinths and Mazes

Labyrinths and mazes are formal and symbolic analogues of a breakdown in intellect and will. They are of the underworld and they fascinate children. . . . My own earliest images or impressions of related manifestations were without any conceptual basis: the rotogravure pictures of trench warfare in the Sunday papers, the ben-day scenes from the Newark tong wars in the local dailies. The unifying abstraction became isolated and clarified through puzzles, and by going through an actual, if flimsy, structure in a boardwalk amusement concession at Asbury Park. Any search for the center, or for the "recipe" for getting out of the maze failed to interest me. My experience of such configurations is on an intuitive and emotional level, without a rationale, or even any analysis. . . . But the interest in subterranean complexes remained: fortifications, catacombs, mines, and quarries,

caves, archaeological excavations, subway junction points, and highway interchanges (with their high berns). . . . The corrugated cardboard caves weren't developed as conceived, but I hang on to the intent. *Smoke, Smog,* and *Smug* are mazelike still, as are the current pieces in marble which are based upon Klein and Fermi surfaces, and which are moving toward a topological "labyrinth of the ear."[30]

On Art

What is my intention? It is a new measure of man, in terms of free space, in terms of space that is defined but not enclosed, in terms of measurable space that flows so subtly into the infinite that it is impossible to say where the boundaries of art and nature lie.

I believe that all art is autobiographical. . . . All experience nature, men, their total experience is the autobiography of God.[31]

* * *

Almost everything in the man-made environment, and even in much of nature, is regulated by the axes of length, breadth, and height. The elements from which many of these pieces are made have more axes, and the forms developed from them move in unexpected ways. It is hard to visualize some of the pieces in their entirety, and it is difficult to draw them. It is for this reason that I work directly from maquettes rather than from sketches. . . . Of course, it is also a matter of temperament. If a piece is too predictable I find it boring and tend to tire of it quickly.[32]

* * *

I think my interest in painting remains that of dealing with the interchange of figure and ground. I don't think of certain shapes. I am mainly involved with trying to make an equilibrium over the surface based on fairly close values. The reason I tend to use those convex shapes is that I feel an area of color has its own center, and I resist shapes that radiate or suggest style and structure.[33]

* * *

There have been great people in the world, painters and poets on every level who've been able to express it as artists. I've all my life put down notes for working for something. I've never felt like an artist—it's a conduit for spiritual things—I've never felt in command of artistic media. I think that art is finally coming into a new realm: a realm of nobility and intellect and feeling that it hasn't had for a long time. It doesn't make any difference what you do it in, painting or poetry: just concentrate on making the most profound expression of your own life. There's such a thing as distilled expression, which is what you've got to do if you're going to be an artist. You can't send a message to one person. You have got to distill what you feel to such an extent that it becomes a universal message. You have to send a message to all the world. To all the people who ever lived.[34]

II. COMMENTS BY FAMILY, FRIENDS, AND CRITICS

Samuel Wagstaff, Jr., Curator [35]

Tony Smith is Irish, Celtic, mystic but rational. He puts geometry together by chance. Mathematical speculations produce an earthy concrete face. He hides his logic. . . . [His sculptures] are related to early cultures intentionally or through sympathy—menhirs, earth mounds, cairns and to this culture with equal sympathy—smokestacks, gas tanks, dump trucks, poured concrete ramps. No focus, no detail, no symmetry. They are plain but constantly changing. They are grave without being heavy, ordinary and mystical at the same time. If they were completely successful, they would merge in the general variety of nature.

Thomas Smith, Tony's brother [36]

[Tony] had one foot in elegance and one foot in bohemia. I remember him flying to Georgetown in a trimotor plane, one of those first transport planes. And he used to subscribe to a polo magazine because he used to love to imitate Paul Brown's drawings of polo players.

Tony [moved to the attic] and painted it all red lead. They use it for protecting metal. He painted the whole room, and he had a million books up there in orange crates. . . . There was a group who would come and go up in the attic and read the latest stuff of James Joyce and Yeats. . . . They were up-to-date on everything—Eliot, Thoreau, Yeats.

Peter Smith, Tony's brother [37]

I recall when [Tony] got out of Georgetown . . . he was very much interested in first editions of books. There was a bookstore down on Broad Street in Newark called The Philosopher's Bookstore, which was a used bookstore and it had hundreds of thousands of books there and had big back rooms. So he talked my father into buying a bookstore for him.

Theodore van Fossen met Tony Smith at the New Bauhaus; they were architectural partners from 1939 to 1944 [38]

[In Chicago] Tony Smith, Fritz Bultman, George Mercer, Alex Giampietro, Bob Scheuss, and I had a whole floor, the third floor, of one of these grand old Gold Coast mansions that we turned into an apartment and working place. We made a kind of Miesian apartment in which all the walls were painted white. It was an interesting building of its period. All the floors were straw mats, and when anybody came in they took off their shoes. We made the furniture all low. It was very nice. We each designed our own space and had a common room in the back which served as a place to get together next to the kitchen.

Gerald Kamrowski met Tony Smith when they were students at the New Bauhaus in Chicago in 1937–38 [39]

[After moving back to New York City] Tony lived on Carmine Street with [Quentin] Fiore, and I lived on Carmine Street, too. It was an apartment in the back of a building . . . a cold water flat with a fireplace. . . .

He was very concerned with structure . . . and the idea of using geometry. He was a great one for believing in the bible by D'Arcy Thompson [*On Growth and Form*].

Jeanne Bultman met Tony Smith through her husband, Fritz Bultman, who had been a classmate at the New Bauhaus in 1937 [40]

[Tony and Fritz] had enormous background in reading everything—I mean off-beat poets, plus established poets, all the philosophers. They both evidently had spent their whole life reading background material and retaining it. . . . [Tony] would go into long readings of James Joyce, in brogue. He had an Irish setter, and she would sit and look at him, and he would read to her! And the dog would howl! . . . [Tony was] a lot of fun and also informative. [Tony and Fritz] would come to a passage in Joyce, and they would stop and discuss it. . . . Tony would also recite comedy routines. . . . He remembered all the light stuff, too, word for word.

Jane Smith, Tony Smith's wife [41]

I met Tony on New Year's Day, 1943, at Fritz Bultman's. Tony wore a beard, which people did not do at that time. I looked at him and thought, "Oh, my god—he looks like a Moor!" At that time I was working on Desdemona in Verdi's *Othello*. I was wearing a hexagon-shaped hat, which I had cantilevered. He went home and designed a house after that hat. Five days later we were walking up Fifth Avenue and he asked me to marry him. We were married in September 1943 in Santa Monica with Tennessee [Williams] as best man.

George Segal and Anthony Louvis were both Tony Smith's students in 1949 at New York University's School of Education

George Segal [42]

Tony was an architect who was madly in love with the new painting [Abstract Expressionism]. He would walk down the halls with a Rothko under his arms to show us what the new painting looked like. He would go on and on about how beautifully Rothko was able to use color to project an inside mood. He would tell us about Gauguin and Sérusier dealing with that idea. . . . He started showing us pictures of Abstract Expressionist paintings. "Have you ever seen photographs of the Rockies and the Far West and what the Western landscape looks like? Imagine yourself hovering in a helicopter and looking straight down on it." I still remember that after all these years. I thought that was a fabulous insight.

Then he would start rambling about walking through an Italian town. Every twenty steps you would come across a public sculpture. You could drive 3,000 miles across America and never see an outdoor work, never. But still you could encounter some vivid, energetic buildings, modern factories, which he considered high-level sculpture.

Then he started talking about James Joyce. He made us read Joyce. . . . He would have some prints of Picasso and Braque, and he would say, "Do you see any connections between Joyce's writings and these paintings?" What a connection—a connection between literature and this radical, subversive painting that was being argued about! And Joyce was in the papers because he was forever being sued for obscenity. Tony was trying to provoke you to do your own thinking, to act and react.

Anthony Louvis [43]

Tony was really a strange character to me at the time because of his personal demeanor. When I first knew him he used to wear the same thing all the time, a blue chambray workshirt, a black tie, khaki pants, and a jacket. It never varied. That was it.

He would always be making diagrams. The one thing I remember is that they were always fluid and moving in and of themselves . . . and his thinking was very original. . . . He wasn't teaching out of some book, he was teaching from what came right out of his head. It was very exciting. . . .

He talked about liking New England farmhouse structures, where you would have a house and several barns that would be separate. He liked that notion—possibly it goes back to his childhood, when he lived in that little house that was separate.

He was always interested in Corbusier and working with numbers. For a while he was interested in the radical five: two squares plus the golden triangle—the square root of five. Jay Hambidge did some work on the radical-five triangles—slightly larger than two squares—long and narrow.

He knew so many of the artists. He was always encouraging, trying to buy their works, encouraging other people to buy their work—always generous and giving in that sense, the way that he was able to think creatively and spontaneously about something. . . . He had that quality of really original thought about history, theology, education. It just seemed so right and logical. . . . He had the capability of leading you into an understanding of things.

Arthur File met Tony Smith when he was his student at Pratt Institute in Brooklyn [44]

I was at Pratt Institute night school, and Tony was teaching a weekly three-dimensional design course. It turns out that I was living three or four blocks away from him in South Orange! After class I would often drive him home. Each week we had an assignment. We'd bring in something we had made, symmetrical stuff, and then asymmetrical stuff, and then something based on the spiral. And then he'd come around and discuss them one by one. . . .

He wanted bigger and bigger [sculptures]. We finally used plywood. The size of a sculpture was determined by the size of a sheet of plywood, which came four feet wide. . . . It was very simple. They were all equilateral triangles. There really wasn't any big puzzle. Then we began making the biggest ones. . . .

When he wanted to make them full-size, we were wondering what structure they would need to stand up. I said that I thought that they would work using just the skin as the structural component, that they really wouldn't need anything inside . . . The skin would be the structure, and the whole thing would stand up, which it did. I don't know whether he had arrived at that idea, too, or whether we had arrived at it simultaneously. Of course, we really didn't know if it would work until we did one. And it seemed to work, so that made it very simple. So then all you had to do was to nail the skin together. My idea was to do them as cheaply as possible.

For finishing them I had suggested putting on black automobile undercoating that they use on automobiles as a finish. I was surprised that he went for that. I just jokingly said, "Well, we could just spread them with this black undercoating." A lot of them were done that way. It was a way of getting a big thing filled and cheaply. And, of course, when they ended up in steel they started costing money, but that was years later.

Doug Ohlson met Tony Smith when he was a student of his at Hunter College [45]

Part of the genius of Tony was that he had theories, but he messed them up. The paintings were eighteen-by-twenty-four inches. He would do a plan or a root rectangle and then the end of the canvas would be left alone. It threw everything out of kilter. You didn't know what was going on. There was a real plan there, but the last six inches or so would be blank canvas.

Jim Shepperd was Tony Smith's student at Hunter College and a friend [46]

If you tried to bring up one aspect of Tony's work, he would deflect your comment. If you tried to talk about a great visual aspect of the piece, he would start talking about how he came up with the title, or some story from his childhood. If you talked about the mathematics, he would talk about the aesthetics. If you talked about expressionism in relation to it, he talked about math. I think it was partly that he didn't want the pieces to be reduced to some visual trick or some exercise in geometry or to be seen as purely expressionist. I don't know if it was consciously, but I think it was an attempt not to reduce his sculptures to a description. So sometimes it was hard to discuss them.

Often ideas came to him in dreams, but when pieces were being made, he was interested in practical solutions. He especially liked the fact that Art File figured out how to make the mock-ups like stage sets, where there was no substructure. Tony was used to architecture that had studs and joists as a substructure for a building. Art came up with a method where you basically nailed the sheets together like stage flats, and there was no skeletal structure underneath. Tony was amazed by things like that. In that sense, he was systematic and curious about how to resolve technical problems in the most practical way.

Robert Swain assisted Tony Smith with his sculptures [47]

The first time I met Tony was in 1967 with Chris Wilmarth, who was a sculptor. We went to disassemble the Bryant Park show. [The sculptures] were put together with box nails, and we had crowbars and you just pried them apart. Art File, who had worked for Tony earlier, built all these pieces . . . that were absolutely ingenious. He used three-eighths-inch plywood on a two-by-four-inch skeleton, which meant that he could build massive volumes that were self-supporting for the least amount of money. Then we would coat them with car undercoat. . . .

At the end of the day [after disassembling the pieces], we had a couple of drinks. It was kind of bizarre because Tony said, "Do you guys want to come over for dinner?" We walked to Port Authority and got on the Penn Central Railroad and went to Orange. There was Jane with Anne, Bebe, and Kiki, the dinner table set with the dinner. . . . You arrived at this brick Georgian house [that was] totally empty. Tony had about eight chairs in this house. Over the years people gave him different things, but the house was very sparely furnished. There was a Pollock in the dining room, upstairs an Agnes Martin, a Barnett Newman, and one painting that Tony had done . . .

The way [Tony's sculptures] were done was off-the-cuff. Tony would simply say, "Could you go out to Minneapolis and put these pieces together?" When I arrived at the Walker, I ran into Martin Friedman, the director, who said, "This is crazy. The stuff arrived but it's just beat up plywood." I said, "Yeah, that's it." And he said, "What am I going to do? This isn't art! What am I going to do?" So I said, "Let's go down and look at it." The truckers had just thrown the sheets of plywood off the truck . . . [and they] weren't really labeled at all! So you had *Cigarette* mixed up with *Amaryllis*, *Amaryllis* mixed up with *Marriage*—all this junk . . . and there were big holes in the sides where the sheets had been damaged. But what [Friedman] didn't realize, and what other people didn't realize, is that these were based on tensile structures that when you put in the last panel, the last tetrahedron, the whole thing tightened up and it was strong and self-supporting. And then it was coated with tar.

[I went to Washington to supervise the construction of *Smoke* but] I didn't have the model. [It was] one of the [most] ironic things of all the pieces I ever built for Tony. He always did the drawings afterward, which I found both humorous and kind of alarming, because he would call me up and say, "I did the drawing." And I would say, "What?" He would say, "I did the drawing for *Stinger*." "Well, we already built that, so what?" was my response. But he would do the drawing afterward.

At one point when I put in the whole bottom [of *Smoke*], it was out of alignment in the atrium. I called up Tony and said, "Tony the bottom is not aligned. I can't get it aligned." He said, "Look Bob, the most important thing is to get the bottom aligned so you can put on the top." I said, "Look, that's why I'm calling Tony. That's why I'm calling." And he would say over and over,

"You have to get the bottom aligned." He flew in from New Jersey, and we looked at it, and he said, "We have to align it now, today." So I said, "Tony, there's me and there's you." And Tony's health was up and down. He said, "Go down into the basement and cut a lot of two-by-fours," which I did. On the bases of all these things we put a two-by-four and a wedge up against the base of every one of them . . . It took us most of the afternoon to get it lined up, and at the end of the day they were all lined up. . . . Tony stood at the very end, which he would do, and he scowled, and then he went down and stomped alongside each one and the thing shifted over just enough. And then he put on his hat and coat and went back to New Jersey. And I started the second level. . . .

Stinger was very complicated because again Tony had not done any drawings or anything. We built a section of it in his backyard so he could look at it. He would sort of describe part of it. It was very peculiar. He would say, "On this front you have these two tetrahedrons together and it comes around the back" and you got to the back and that's how it would be.

He put *Black Box* on the site of the little house where he had spent so much time. The neighborhood kids would cut through the yard in such a way that they would have to walk by it. When he put it out there the first day, they were terrified by it; they had no idea what it was. So they started throwing rocks at it and they would chant. It became almost like a kind of primitive situation where they were terrified of this thing, and he got upset by it because he thought they would damage it. He couldn't figure out, as he told me, in his own mind, what to do about it. So finally one day they really assaulted it with a lot of rocks and were screaming. . . . He got in the car and chased these kids around the block and got them cornered. He said, "You kids don't know what you are doing when you throw stones at that black box because your parents could get in a lot of trouble!" And he rolled up the window and left. And there was no more problem with *Black Box*.

Chiara (Kiki) Smith, Tony's eldest daughter [48]

At the moment we became teenagers, my father became famous. All of a sudden we became popular—it was cool. Before that we were considered weird. Our backyard was filled with large, abstract, black sculptures—it looked strange to the neighbors. Our dark shingle house was the largest on the block, with practically no furniture, and a gravestone in the front yard with the name Smith on it. He had a beard and he drove a Porsche, both of which I was very embarrassed by.

Certainly we worked on *Bat Cave* [1969]. All our neighborhood friends came after school every day because there were thousands of elements to it, so we had a little factory to fold them.

Although my father did not have an overt spiritual practice, his deep spiritual concerns were apparent in him and in his work.

In my work I have used images of small structures like cells or crystals to build a large whole, like the sperm piece that

The Museum of Modern Art has. Using individual parts to make a whole probably comes from my father's work and also using paper as a sculptural medium. I don't have a studio. I work in my living room as he did. He was my model of being an artist in his devotion, perseverance, and commitment to his vision, and how that defines one's daily life.

Patricia Johanson was a student of Tony Smith's at both Bennington College and Hunter College[49]

He would come in [to the classroom] with some specific idea in mind, and then he would go around and look at our work. We were to do projects. He would throw out a large subject and then because we were artists, we would go off and do what we were doing anyway. And then it would be incumbent upon us to relate it to whatever the design problem had been.

There was no question about his ambition or where he placed himself in terms of what was being done. All he ever talked about was greatness. Clearly he wanted to be the only sculptor of that time, and in many ways he was. This is a constant theme.

A lot was talked about chance, where you just throw papers up into the air and let them fall and that was going to be the work of art. That, in a sense, is what he did with his life.

At this point he was making little cardboard models every day and just taping them together. You could see the tape. Sometimes he would paint them black. Eventually he got a cadre of students who would actually do the work for him, and he would give them to people. It was a way of disseminating it, of getting it out into the world, of getting people to talk about it.

Tony would stand up there like he was God speaking from the top of the mountain. He would make pronouncements. It was actually a very wonderful message. It was never a message of doubt. It was always delivered from on high that this is the great tradition and you students are in the position of carrying on the great tradition. And it was always uplifting, and there was always that element of spirituality. Nobody else was doing that. Everybody else was just making work. You know the 1960s were filled with self-doubt. But not Tony. The people he talked about repeatedly—Michelangelo, again and again and again, and [Le] Corbusier, Jackson Pollock, and all the Abstract Expressionists. They were all heroes, certainly to us. You had this chance. It was the artist as grand creator. And he placed himself in that tradition, and he inspired us to think about ourselves in the same way. So art was really a calling. Tony came out of the tradition of this heroic individual struggling but conquering all. This is the way he saw the artist.

We went down to the Corcoran to see the installation [Smoke]. The fact that it expanded beyond the walls, it filled the entire atrium, it surrounded you, it encompassed you, it was there—it was overwhelming. That was his image of art.

Samford Wurmfeld was a student of Tony Smith's at Hunter College[50]

Tony was doing something very basic in his work and that had to do with the whole notion of figure-ground relationships. Of course, he did abstract paintings in the 1950s and 1960s that played with two-color figure-ground relationships in paint very much in tune with this idea. Although the Abstract Expressionists like Motherwell, Newman, and Kline played with this idea, it was in a kind of painterly way. Tony had a conception of the totality before he even started.

Smith started with Die, [which] is a pure volume, but then he got to the whole series of pieces shown in Bryant Park in which they are all sections of the cube. What are those pieces about? On the one hand, they are about volume—a black figure on a white field. On the other hand, they are about the spaces that they make, like white on a black field. And third they are about the totality of the two together as they make a cube—you have The Elevens Are Up, Free Ride—a whole series of pieces play with the interaction of mass, volume, and the totality of the two together.

Smoke is when he really blew it all apart, changing your perception of space. The totality of the two together is the entire space-lattice that you are in. [The fact that] it expanded to fill the space of this white neoclassical atrium is really what made it work. It's about the interrelationship between the mass, the volume, and the interaction of the two together. He was the one who did this in sculpture.

Pat Lipski was a student of Tony Smith's at Hunter College[51]

As a teacher he treated everyone alike. I remember sitting and watching him give attention to the kid I thought was the least talented. And sometimes I was wrong—through Tony's care the person would blossom, and gifts that no one knew about would surface. He was completely there for the time he was talking to you.

One of Tony's most fervent theories was about the border of a painting. He said that Pollock's best paintings had a border, that is, they did not go out to the edge. Tony also had a theory which came down as a rule—that three colors should never touch at one point.

Richard Tuttle met Tony Smith in November 1966[52]

Tony had the idea that if it wasn't easy, he couldn't do it. . . . You could buy materials right from the store—four- or eight-foot plywood sheets—no cutting, no fuss, no thinking about it. . . .

In 1966 I was in Hartford painting Cigarette black. It was cold, the wind was blowing, and Tony wandered by and looked up. Was he concerned about whether it would be done on time, or did he like the way the piece looked? He asked: "Do you know who made the link between art and the fashion world?" His answer was Franz Kline.

Tony didn't just say things off the top of his head, but there was

always a structure. He was doing something, he was putting something together, and as wild as it might seem, it was not irrational.

Steingim Laursen, former director of the Louisiana Museum in Denmark, met Tony Smith in 1971[53]

Two things I remember very well. [One was] that he was very taken with the paintings of Hubert Robert. I was a little bewildered but then when I went to the Louvre . . . I totally understood. They were two ruins [in a Robert painting] which have a monolithic form. And I can clearly see then why that shape, which is heavy, . . . has this body that his sculptures have. And the other thing was that when he stayed in Cologne he was very taken with the Romanesque churches there.

Abby Zito met Tony Smith at Bennington College in 1958[54]

The day I met Tony he talked about the Forbidden City in Peking. What he loved about it was that it was closed. Center of the city, center of the Empire, axis mundi, cosmic center, where both temporal and spiritual power had their source. . . . Tony is like the Forbidden City. There's no way through him. There is a mystery at the center. . . .

Two finite images very different from one another occur to me when I think of Tony's mind and his life as an artist: the seed and the iceberg.

The seed is the generative principle, the visible germ of all creation . . . the basic unit of life in the cosmos: the module reduced as far as it will go but implying everything. The seed is in the five platonic solids, the same on every side, which close pack and will fill space forever without interstices: the cube, the tetrahedron, the octahedron, the dodecahedron, and the icosahedron—the basic stuff of Tony's sculpture. . . .

The iceberg, on the other hand . . . I think of Tony's actual work as the tip of an iceberg whose total physical substance, from which it never separates, is immense . . . The iceberg is the work and the mystery behind the work. The seed is the work and the rational structure behind the work. . . .

Tony loved the juxtaposition of sacred space and sacred time in primitive architecture: the impossibly large stones, perfectly set, of Stonehenge, its central pillar illuminated on the day of the summer solstice, and New Grange in Ireland, a long tunnel incised with spirals whose central core saw the sun only on that same Midsummer's Day. . . . He must have bought every book on archaeology that dealt with early man's sense of organization and his expression of it architecturally . . .

It was structure in all its aspects that possessed Tony: from earliest childhood. . . . He studied the structure of . . . human system building in the realm of number and language; measurement and political organization . . . the structure of nature, from the shape of the atom to the forms of beehives and anthills and termite mounds . . . the structure of heaven depicted by Aquinas as the beatific vision. . . .

Tony rejoiced in the accomplishments of humankind. The hand, image of our distinction, thrilled him. His was a thoroughly Western sensibility. His ideals were those of the Renaissance: Greek humanism tempered by the Christian idea of Grace. . . . The Jesuits taught him logic, mathematics, philosophy, and Greek. He was a natural mystic, although he professed to have no interest in the occult. . . . He was, in the tragic Western tradition, haunted by the idea of the crucifixion and expected to suffer and sacrifice himself; the "we die daily" of St. Paul.

His humility explains his deliberate passivity about his career and answers the question of why he didn't show until he had passed fifty. Tony had a deep distrust of the applications of the will and deliberately chose not to push for recognition. Although he enjoyed the trappings of success late in life, as a rich man's son, he was casual about money and would never make what he would consider a moral compromise to get it. He was generous to the point of eccentricity; even when he had very little money he would give away what he had to help a struggling artist, student or friend . . . This is not to say that for one moment Tony had any doubts about his own greatness as an artist and thinker. He didn't. . . .

For Tony all space was alive, a continuum energized by whatever penetrated it . . . the energy generated would multiply forever in that pattern and empty space could be said to be filled with these forms, which would contribute to the sense of cosmic harmony. . . .

Tony saw the particular as generating the universal in a world of its own design, sometimes anthropomorphic, like *Amaryllis* and *Willy*, grounded in a Jungian confidence in the familiarity of the forms that matter to the unconscious mind. There is no work of Tony's that does not lead the viewer into a relationship with a larger cosmos outside the work that is generated by the work.

Tony identified with Michelangelo to such an extent that the announcement of his first show bore a quote from him in Tony's handwriting across the modular, undulating cutout form: "Always make a figure Pyramidall, serpentlike, and multiplied by one, two and three."

Tennessee Williams, a close friend of Tony Smith's, delivered this eulogy after his death [55]
Magnitude and mystery, a sense of the unknown and probably unknowable. It is never attained in coherent language, meaning the instrument of writers who can be read. It was for Tony Smith his natural and seemingly effortless *materiel* as a plastic artist, a sculptor. When I look at his work in its ultimately intended dimension, I always say to myself: "This is the work of a man who saw beyond death." Visionaries and mystics are not comfortable people. That which is incomprehensible to our frightened, comfort-seeking sensibilities or perceptions has about it a kind of eminence before which we inwardly shudder a bit, and for that very reason it is most needful to us in this time. Tony Smith's work speaks to us more powerfully of God than that of any artist whose work I have known, and its inaccessibility to an easy comprehension, or perhaps to any comprehension at all, is the heart of that power.

Notes

All archival material in the Tony Smith Estate
© 1998 Tony Smith Estate.

Part I

1. Tony Smith, writing on architecture, Germany, c. 1954, Archives, Tony Smith Estate, New York. Hereafter cited as ATSE.
2. Tony Smith, draft of a job application, March 1953, ATSE.
3. Tony Smith, unpublished writings, c. 1945, ATSE.
4. Tony Smith, "The Pattern of Organic Life in America," unpublished manuscript, 1943, ATSE.
5. Tony Smith, "Project for a Parking Lot, " *Design Quarterly*, no. 78/79 (1970): 64.
6. Smith, "Pattern of Organic Life."
7. Samuel J. Wagstaff, Jr., "Talking with Tony Smith," *Artforum* 5 (December 1966): 15.
8. Tony Smith, writing dated June 28, 1946, from New Canaan, Connecticut, ATSE.
9. Tony Smith, writing titled "Skowhegan, 1971," ATSE.
10. Elayne H. Varian, *Schemata 7,* exh. cat., Finch College Museum of Art, New York, 1967, n.p.
11. Letter from Tony Smith to Fritz Bultman, c. 1947, ATSE.
12. Tony Smith, unpublished writing, c. 1945, ATSE.
13. Tony Smith, "Notes made after Visual Arts Class, Fe. 16, '49," ATSE.
14. Tony Smith, sketchbook, c. 1947–48, ATSE.
15. Elizabeth A. Trumbower, class notes from a class entitled "Visual Arts and Contemporary Culture," taught by Tony Smith at New York University, School of Education, spring 1949, ATSE.
16. Letter from Tony Smith to Jane Smith, October 11, 1950, ATSE.
17. Letter from Tony Smith to Jane Smith, October 19, 1951, ATSE.
18. Letter from Tony Smith to Hans Noe and Dick Schust, April 23, 1955, ATSE.
19. Letter from Tony Smith to Fritz Bultman, March 25, 1954, ATSE.
20. Tony Smith, "The City," c. May 1954, ATSE.
21. Letter from Tony Smith to Fritz Bultman, July 2, 1954, ATSE.
22. Tony Smith, "On the Way to a City," dated June 19, 1954, ATSE.
23. Tony Smith, statement in a sketchbook titled "Europe," May 12, 1953, ATSE.
24. Letter from Tony Smith to Hans Noe, November 15, 1954, ATSE.
25. Wagstaff, "Talking with Tony Smith," 17, 18.
26. Draft of an interview with Tony Smith conducted by Renée Sabatello Neu for The Museum of Modern Art, New York, July 25, 1968, ATSE.
27. Lucy R. Lippard, "The New Work: More Points on the Lattice," typescript of an interview, 1971, ATSE.
28. "Statements by Sculptors: Tony Smith," *Art Journal* 35 (winter 1975–76): 129.
29. Samuel J. Wagstaff, Jr., *Tony Smith: Two Exhibitions of Sculpture*, exh. cat., Wadsworth Atheneum, Hartford, Connecticut, and The Institute of Contemporary Art, Philadelphia, 1966, n. p.
30. Janet Kardon, ed., "Janet Kardon Interviews Some Modern Maze-Makers" (includes "A Letter from Tony Smith October 1975"), *Art International* 20 (April–May 1976): 65
31. Smith, "Pattern of Organic Life."
32. *Tony Smith,* exh. brochure, The Museum of Modern Art, New York, 1968, n.p.
33. Lucy R. Lippard, "Tony Smith: Talk about Sculpture," *Artnews* 7 (April 1971): 49, 68.
34. Abby Zito, "The Mind of Tony Smith," unpublished manuscript, 1992 © Abby Zito.

Part II

Except where otherwise noted, all interviews were conducted by Joan Pachner, who would like to extend her appreciation to the family members, friends, and colleagues of Tony Smith, who generously gave of their time to share their recollections and insights.

Special thanks are due to Jim Shepperd for his unstinting efforts to ensure the factual accuracy about Smith's work in her two essays in this book.

35. Wagstaff, *Tony Smith: Two Exhibitions of Sculpture*, n.p.
36. Interview of October 1, 1989.
37. Interview of April 14, 1991.
38. Interview of August 29, 1991.
39. Interviews of January 11, 1989, and August 12, 1997.
40. Interview of May 3, 1987.
41. Interview of November 22, 1988.
42. Interview of August 12, 1997.
43. Interview of September 22, 1997.
44. Interview of March 18, 1992.
45. Interview of October 23, 1997.
46. Interview of February 15, 1998.
47. Interview of January 20, 1992.
48. Interviews of September 29 and December 19, 1997.
49. Interview of December 21, 1997.
50. Interview of September 26, 1997.
51. Pat Lipski, "What Tony and Lee and Clem Told Me: A Reminiscence," 1995.
52. Interview of November 3, 1997.
53. Interview of October 1, 1997.
54. Zito, "The Mind of Tony Smith."
55. ATSE.

Selected Bibliography · COMPILED BY LESLIE JONES

Interviews and Personal Statements

1966

Wagstaff, Samuel J., Jr. "Talking with Tony Smith." *Artforum* 5 (December 1966): 14–19. Reprinted in Gregory Battcock, ed., *Minimal Art: A Critical Anthology*. New York: E. P. Dutton, 1968, pp. 381–86, and in *Tony Smith*, exh. cat., Louisiana Museum for Moderne Kunst, Humlebaek, Denmark, 1995.

1967

Lippard, Lucy, R. "Homage to the Square." *Art in America* 55 (July–August 1967): 50–57. Personal statement by Smith, p. 53.

Smith, Tony. "The Maze/Tony Smith." *Aspen,* nos. 5 and 6 (fall and winter 1967): sec. 22.

Varian, Elayne H. Interview with Tony Smith in *Schemata 7,* exh. cat., Finch College Museum of Art, New York. Reprinted in Battcock, ed., *Minimal Art: A Critical Anthology*, pp. 378–80.

1968

Neu, Renée Sabatello. Interview with Smith in *Tony Smith*, exh. brochure, The Museum of Modern Art, New York.

1970

Smith, Tony. "Project for a Parking Lot." *Design Quarterly* (special issue entitled *Conceptual Architecture*), no. 78/79 (1970): 64–66.

1971

Lippard, Lucy R. "Tony Smith: Talk about Sculpture." *Artnews* 7 (April 1971): 48–49, 68, 71–72.

1975

"Statements by Sculptors: Tony Smith." *Art Journal* 35 (winter 1975–76): 128–29.

1976

Kardon, Janet, ed. "Janet Kardon Interviews Some Modern Maze-Makers" (includes "A Letter from Tony Smith October 1975"). *Art International* 20 (April–May 1976): 64–68.

1978

Cummings, Paul. Interview with Tony Smith for the Archives of American Art, August 22 and August 30, 1978.

Green, Roger. "*Lipizzaner:* An Interview with Tony Smith and Mrs. P. Roussel Norman." *Arts Quarterly* (The New Orleans Museum of Art) 1 (July–September 1978): 8–9.

Articles and Reviews

1949

"The Core of This House Is Its Kitchen: A New Design Trend Puts the Kitchen (Once Housed in a Service Wing) in the Center of the House." *House and Garden* 95 (January 1949): 58–59.

1964

Judd, Donald. "Black, White and Gray." *Arts* 38 (March 1964): 36–38. Reprinted in *Donald Judd: Complete Writings 1959–1975*. Halifax: The Press of the Nova Scotia College of Art and Design, and New York: New York University Press, 1976, pp. 117–19.

Wagstaff, Samuel J., Jr. "Paintings to Think About." *Artnews* 62 (January 1964): 38, 62.

1966

Burton, Scott. "Old Master at the New Frontier." *Artnews* 65 (December 1966): 52–55, 68–70.

Glueck, Grace. "No Place to Hide." *New York Times*, November 27, 1966, sec. 2, p. 19.

Morris, Robert. "Notes on Sculpture, Part 2." *Artforum* 5 (October 1966): 20–23. Reprinted in Battcock, ed., *Minimal Art: A Critical Anthology*, pp. 228–35.

1967

Baro, Gene. "Tony Smith: Toward Speculation in Pure Form." *Art International* 11 (summer 1967): 27–30.

B[attcock], G[regory]. "*Schemata 7* at Finch College." *Arts* 41 (summer 1967): 53.

Benedikt, Michael. "New York: Tony Smith." *Art International* 11 (April 1967): 63–64. Revised version entitled "Sculpture as Architecture: New York Letter, 1966–67," in Battcock, ed., *Minimal Art: A Critical Anthology*, pp. 89–90.

Fried, Michael. "Art and Objecthood." *Artforum* 5 (June 1967): 12–23. Revised version in Battcock, ed., *Minimal Art: A Critical Anthology*, pp. 116–47.

Graham, Dan. "Models and Monuments: The Plague of Architecture." *Arts* 41 (March 1967): 32–35.

Gray, Cleve, and Francine du Plessix Gray, eds. "Who Was Jackson Pollock?" *Art in America* 55 (May–June 1967): 48–59; "Anthony Smith," 52–54.

[Herrera, Hayden]. "Master of the Monumentalists." *Time* 90 (October 13, 1967): 80–86.

Lippard, Lucy R. "The Ineluctable Modality of the Visible." *Art International* 11 (summer 1967): 24–26.

_____. "Homage to the Square." *Art in America* 55 (July–August 1967): 50–57.

Rosenberg, Harold. "Eight Monumental Presences in Bryant Park." *The New Yorker* (February 25, 1967): 108–09. Reprinted in Battcock, ed., *Minimal Art: A Critical Anthology*, pp. 306–07.

"Sculpture: Presences in the Park." *Time* (February 10, 1967): 74.

1968

Chandler, John N. "Tony Smith and Sol LeWitt: Mutations and Permutations." *Art International* 12 (September 1968): 16–19. Reprinted in *Sol Lewitt*, exh. cat., Gemeentemuseum, The Hague, 1970, pp. 18–20.

Lippard, Lucy R. "Escalation in Washington." *Art International* 12 (January 1968): 42–46. Reprinted in Lucy R. Lippard, *Changing: Essays in Art Criticism*. New York: E. P. Dutton, 1971, pp. 237–54.

1969

Reise, Barbara. "Untitled 1969: A Footnote on Art and Minimal Stylehood." *Studio International* 177 (April 1969): 166–72.

1970

"Sculpture by Order." *Time* (September 14, 1970): 72.

1972

Baker, Kenneth. "Tony Smith, Museum of Modern Art." *Artforum* 10 (February 1972): 78–79.

1979

Tallmer, Jerry. "Tony Smith: Just Multiply It by Five." *New York Post,* May 26, 1979, 16.

1980

Glueck, Grace. "Tony Smith, 68, Sculptor of Minimalist Structures." *New York Times,* December 27, 1980, sec. D, p. 26

Tuchman, Phyllis. "Tony Smith, Master Sculptor." *Portfolio* 2 (summer 1980): 52–55.

1981

Goossen, E. C. "Tony Smith, 1912–1980." *Art in America* 69 (April 1981): 11.

Tuchman, Phyllis. "Tony Smith: A Modern Master." *New Jersey Monthly* 5 (January 1981): 120–26.

1982

Carmean, E. A., Jr. "The Church Project: Pollock's Passion Themes." *Art in America* 70 (summer 1982): 110–22. Originally published as "Les peintures noires de Jackson Pollock et le projet d'église de Tony Smith," in *Jackson Pollock*, exh. cat., Centre Georges Pompidou, Musée national d'art moderne, Paris, 1982, pp. 54–77.

1984

Armstrong, Richard. "Tony Smith." *Artforum* 22 (April 1984): 80.

1987

Criqui, Jean-Pierre. "Trictrac pour Tony Smith." *Artstudio* (Paris) no. 6 (fall 1987): 38–51.

1990

Chave, Anna C. "Minimalism and the Rhetoric of Power." *Arts* 64 (January 1990): 44–63.

1991

Cotter, Holland. "Tony Smith at Paula Cooper." *Art in America* 79 (September 1991): 136.

1993

Criqui, Jean-Pierre. "Dédale, Architecte et Sculpteur." *L'Architecture d'aujourd'hui* (April 1993): 42–47.

Pachner, Joan. "Tony Smith at Paula Cooper." *Art in America* 81 (February 1993): 109–10.

1995

Brignone, Patricia. "Tony Smith." *Artpress* (July / August 1995): 63.

1997

Corn, Alfred. "Tony Smith at Paula Cooper." *Art in America* 85 (September 1997): 63.

Drathen, Doris von. "Away from Categories: An Alternative View of Tony Smith and Carl Andre." *Artpress* (May 1997): 38–47.

Exhibition Catalogues

1966

Primary Structures. New York: The Jewish Museum. Text by Kynaston McShine.

Tony Smith: Two Exhibitions of Sculpture. Hartford, Conn.: Wadsworth Atheneum, and Philadelphia: The Institute of Contemporary Art. Text by Samuel Wagstaff, Jr., with an introductory statement and entries by Smith.

1967

American Sculpture of the Sixties. Los Angeles: Los Angeles County Museum of Art. Text by Maurice Tuchman, with an essay by Irving Sandler.

Scale as Content: Ronald Bladen. Barnett Newman. Tony Smith. Washington, D.C.: The Corcoran Gallery of Art. Text by Eleanor Green.

1968

The Art of the Real USA 1948–1968. New York: The Museum of Modern Art. Text by Eugene C. Goossen.

Minimal Art. The Hague: Gemeentemuseum. Text by Enno Develing, with an essay by Lucy R. Lippard (reprinted in Richard Kostelanetz, ed., *Esthetics Contemporary*. Buffalo: Prometheus Books, 1978).

1970

9 Sculptures by Tony Smith. Newark: Newark Museum and the New Jersey State Council on the Arts. Text by Eugene C. Goossen.

Unitary Forms: Minimal Sculpture by Carl Andre, Donald Judd, John McCracken, Tony Smith. San Francisco: San Francisco Museum of Modern Art. Text by Suzanne Foley.

1971

A Report on the Art and Technology Program of the Los Angeles County Museum of Art 1967–1971. Los Angeles: Los Angeles County Museum of Art. Text by Maurice Tuchman, with an essay by Jane Livingston.

Tony Smith: Recent Sculpture. New York: M. Knoedler & Co. Text by Martin Friedman and an interview with Smith by Lucy R. Lippard.

1974

Tony Smith: Painting and Sculpture. College Park: University of Maryland Art Gallery. Text by Eleanor Green.

1977

Project: New Urban Monuments. Akron: Akron Art Institute. Introduction by Robert Doty and a statement by Smith.

1979

Tony Smith: Ten Elements and Throwback. New York: The Pace Gallery. Text by Sam Hunter.

1981

Tony Smith, "81 More," and the Sculptural Process. Union, New Jersey: Kean College. Text by Virginia Stotz.

1983

Tony Smith: Paintings and Sculpture. New York: The Pace Gallery. Text by Robert Hobbs.

1985

Tony Smith Selected Sculptures: 1961–1973, Part I. New York: Xavier Fourcade, Inc., in cooperation with Paula Cooper Gallery, New York, and Margo Leavin Gallery, Los Angeles.

1986

Beyond Formalism: Three Sculptors of the 1960s: Tony Smith, George Sugarman, Anne Truitt. New York: Hunter College Art Gallery. Text by Maurice Berger.

1987

A Century of Modern Sculpture: The Patsy and Raymond Nasher Collection. Dallas: Dallas Museum of Art. Edited by Stephen A. Nash.

1988

Tony Smith: Skulpturen und Zeichnungen / Sculptures and Drawings 1961–1969. Münster: Westfälisches Landesmuseum. Texts by Friedrich Meschede and Joan H. Pachner.

1992

Tony Smith. New York: Paula Cooper Gallery; Madrid: Galeria Theo; and Geneva: Galerie Pierre Huber. Texts by Jean-Pierre Criqui and Kosme María de Barañano.

1995

Tony Smith. Humlebaek, Denmark: Louisiana Museum for Moderne Kunst. Text by Jean-Pierre Criqui and reprint of Samuel Wagstaff, Jr.'s 1966 *Artforum* article.

Tony Smith: A Drawing Retrospective. New York: Matthew Marks Gallery. Texts by Klaus Kertess and Joan Pachner.

1997

Alfred Jensen, Tony Smith: Personal Geometry. New York: PaceWildenstein.

Tony Smith: Moondog. New York: Paula Cooper Gallery. Text by Michael Brenson.

Monographs and General Books

Ashton, Dore. *Sculpture on the Edge of Dreams*. Princeton: The Institute for Advanced Study, 1982. Reprinted in Ashton, *Out of the Whirlwind: Three Decades of Art Commentary*. Ann Arbor: UMI Research Press, 1987.

Battock, Gregory, ed. *Minimal Art: A Critical Anthology*. New York: E. P. Dutton, 1968. Reprinted, with an introduction by Anne M. Wagner. Berkeley and Los Angeles: University of California Press, 1995.

Lippard, Lucy R. *Tony Smith*. New York: Harry N. Abrams, and Stuttgart: Verlag Gerard Hatje, 1972.

Potter, Jeffrey. *To A Violent Grave: An Oral Biography of Jackson Pollock*. New York: G. P. Putnam's Sons, 1985.

Unpublished Theses

Pachner, Joan Helen. "Tony Smith: Architect, Painter, Sculptor." Ph.D. diss., New York University, Institute of Fine Arts, 1993. Ann Arbor, Michigan: UMI Dissertation Information Service, 1993.

Rorimer, Ann. "Tony Smith." M.A. Qualifying Paper. New York University, Institute of Fine Arts, 1970.

Exhibition History · COMPILED BY LESLIE JONES

Solo Exhibitions

1966

Wadsworth Atheneum, Hartford, Conn., and The Institute of Contemporary Art, Philadelphia. *Tony Smith: Two Exhibitions of Sculpture*. Hartford, November 8–December 31; Philadelphia, November 22, 1966–January 6, 1967.

1967

Bryant Park, New York. *Tony Smith*. January 28–March 12.

Walker Art Center, Minneapolis. *Large Scale Sculpture by Tony Smith*. September 9–October 15.

Galerie Müller, Stuttgart. *Tony Smith: The Wandering Rocks*. October 28–December 8; traveled to Galerie Renée Ziegler, Zurich, December 15, 1967–January 28, 1968; Fischbach Gallery, New York, January 27–February 22, 1968; Galerie Yvon Lambert, Paris, March 1–31, 1968; Donald Morris Gallery, Detroit, May 10–31, 1969.

1968

The Museum of Modern Art, New York. *Tony Smith*. A circulating exhibition, not on view at The Museum of Modern Art; traveled to White Museum of Art, Cornell University, Ithaca, N. Y., September 9–October 6; Art Gallery of Ontario, Toronto, October 25–November 24; Georgia Museum of Art, University of Georgia, Athens, January 3–31, 1969; Tennessee Fine Arts Center, Nashville, March 3–31, 1969; University of St. Thomas, Houston, April 28–May 26, 1969; Henry Gallery, University of Washington, Seattle, June 23–July 21, 1969; Santa Barbara Museum of Art, Santa Barbara, August 18–September 29, 1969.

1969

Honolulu Academy of Arts, Honolulu. *Sculpture by Tony Smith*. October.

1970

Newark Museum and the New Jersey State Council on the Arts, Newark. *9 Sculptures by Tony Smith*. October 6–November 15; traveled to Montclair State Art Museum, November 22, 1970–January 3, 1971; The Art Museum of Princeton University, January 17–February 22, 1971; The New Jersey State Museum, Trenton, February 27–April 11, 1971; and Cumberland County College, Vineland; Garden State Arts Center, Holmdel; and Morris Museum, Morristown, all in New Jersey.

1971

M. Knoedler & Co., New York. *Tony Smith: Recent Sculpture*. March 23–April 24.

The Museum of Modern Art, New York. *81 More*. November 30, 1971–January 31, 1972.

1974

University of Maryland Art Gallery, College Park. *Tony Smith: Painting and Sculpture*. February 8–March 8.

1976

Fourcade, Droll Inc., New York. *Tony Smith: Casting of Models and Small Pieces*. March 16–April 17.

1979

The Pace Gallery, New York. *Tony Smith: Ten Elements and Throwback*. April 27–June 9.

1980

Ace Gallery, Venice, Calif. *Ten Elements*. July 22–August.

1981

Kean College, Union, N. J. *Tony Smith, "81 More," and the Sculptural Process*. September 14–18.

1983

The Pace Gallery, New York. *Tony Smith: Paintings and Sculpture*. September 23–October 22.

1984

Hunter College Art Gallery, New York. *Tony Smith Drawings*. January 20–February 10.

1985

Xavier Fourcade, Inc., New York, in cooperation with Paula Cooper Gallery, New York, and Margo Leavin Gallery, Los Angeles. *Tony Smith Selected Sculptures: 1961–1973, Part I*. New York, October 19–November 16; Los Angeles, October 25–December 7.

1986

Xavier Fourcade, Inc., New York. *Tony Smith: Paintings 1953–1963, Small Sculpture 1961–1969*. May 17–June 21.

Galerie Daniel Templon, Paris. *Tony Smith Sculptures 1961–63*. September 13–October 15.

1987

Bakalar Sculpture Gallery, List Visual Arts Center, Massachusetts Institute of Technology, Cambridge, Mass. *Tony Smith: The Shape of Space*. January 17–April 5.

Paula Cooper Gallery, New York. *Tony Smith 'Maze.'* November 7–26.

1988

Westfälisches Landesmuseum, Münster. *Tony Smith: Skulpturen und Zeichnungen / Sculptures and Drawings 1961–1969*. February 21–April 24.

St. John's Rotary, New York. *Smug*. October 1988–October 1993.

1989

Jones Hall Gallery, University of St. Thomas, Houston. *The Tony Smith Retrospective*. November 4–December 8.

1990

Galerie Ressle, Stockholm. *Tony Smith: Sculptures from the 60's*. September 22–October 27.

1991

Paula Cooper Gallery, New York. *Tony Smith: Ten Elements*. March 2–30.

1992

Paula Cooper Gallery, New York; Galeria Theo, Madrid; and Galerie Pierre Huber, Geneva. *Tony Smith*; traveled to Fundación Torre Picasso, Madrid, June 17–July 17; Sala Rekalde, Bilbao, December 17, 1992–January 31, 1993; Villa Arson, Nice, January 21, 1993–March 20, 1994; Musée d'Art Moderne et Contemporain, Geneva, September 1994–January 1995; Musée d'Art Moderne, St. Etienne, France, May 5–July 19, 1995; Louisiana Museum for Moderne Kunst, Humlebaek, Denmark, September 22, 1995–January 7, 1996. (Exhibition title varies at some locations.)

Paula Cooper Gallery, New York. *Tony Smith: Paintings and Sculpture 1956–1962*. November 3–28.

1993

Paula Cooper Gallery, New York. *Willy*. April 30–May 29.

1995

Matthew Marks Gallery, New York. *Tony Smith: A Drawing Retrospective*. November 1–January 13, 1996.

1997

Paula Cooper Gallery, New York. *Tony Smith: Moondog*. April 19–June 7.

Group Exhibitions

1964

Wadsworth Atheneum, Hartford, Conn. *Black, White, and Grey*. January 6–February 9.

1966

The Jewish Museum, New York. *Primary Structures*. April 27–June 12.

Whitney Museum of American Art, New York. *Annual Exhibition 1966: Sculpture and Prints*. December 16, 1966–February 5, 1967.

1967

Los Angeles County Museum of Art, Los Angeles. *American Sculpture of the Sixties*. April 28–June 25; traveled to Philadelphia Museum of Art, September 15–October 29.

Finch College Museum of Art, New York. *Schemata 7*. May 12–June 18.

The Corcoran Gallery of Art, Washington, D.C. *Scale as Content: Ronald Bladen. Barnett Newman. Tony Smith*. October 7, 1967–January 7, 1968.

The Solomon R. Guggenheim Museum, New York. *Sculpture from Twenty Nations: 5th Guggenheim International Exhibition*. October 20, 1967–February 4, 1968; traveled to Gallery of Ontario, Toronto, February–March 1968; National Gallery of Canada, Ottawa, April–May 1968; Montreal Museum of Fine Arts, Montreal, June–August 1968.

Museum of Art, Carnegie Institute, Pittsburgh. *1967 Pittsburgh International Exhibition of Contemporary Painting and Sculpture*. October 27, 1967–January 7, 1968.

1968
Albright-Knox Art Gallery, Buffalo, N.Y. *Plus by Minus: Today's Half Century*. March 3–April 14.

Gemeentemuseum, The Hague, The Netherlands. *Minimal Art*. March 23–May 26.

Venice, Italy. *XXXIV Biennale, Linea della Ricerca: dall'informale alla nuova strutture* (central pavilion). June 22–October 20.

Kassel, Germany. *Documenta 4*. June 27–October 6.

The Museum of Modern Art, New York. *The Art of the Real USA 1948–1968*. July 3–September 8; traveled to Centre National d'Art Contemporain, Paris, November 14–December 23; Kunsthaus Zurich, January 18–February 16, 1969; Tate Gallery, London, April 24–June 1, 1969.

The Museum of Modern Art, New York. *In Honor of Dr. Martin Luther King*. October 30–November 2.

1969
Akademie der Kunst, Berlin. *Minimal Art*. March 23–April 27.

The Metropolitan Museum of Art, New York. *New York Painting and Sculpture 1940–1970*. October 15, 1969–February 1, 1970.

1970
Osaka, Japan. *Expo '70*. New Arts Section. March–September.

Fondation Maeght, Vence, France. *L'Art vivant aux Etats-Unis*. July 16–September 30.

San Francisco Museum of Modern Art, San Francisco. *Unitary Forms: Minimal Sculpture by Carl Andre, Donald Judd, John McCracken, Tony Smith*. September 16–November 1.

Whitney Museum of American Art, New York. *1970 Annual Exhibition: Contemporary American Sculpture*. December 12, 1970–February 7, 1971.

1971
Los Angeles County Museum of Art, Los Angeles. *A Report on the Art and Technology Program of the Los Angeles County Museum of Art 1967–1971*. May 10–August 29.

Sonsbeek, Arnhem, The Netherlands. *Sonsbeek 71: Sonsbeek buiten de perken*. June 19–August 15.

1972
Whitney Museum of American Art, New York. *Whitney Museum of American Art Annual*. January 25–March 19.

1973
Whitney Museum of American Art, New York. *1973 Biennial Exhibition: Contemporary American Art*. January 10–March 18.

1974
Monumenta Newport Inc., Newport. *Monumenta*. August 17–October 13.

1975
National Collection of Fine Arts, Smithsonian Institution, Washington, D.C. *Sculpture: American Directions, 1945–75*. October 3–November 30.

Philadelphia College of Art, Philadelphia. *Labyrinths: Symbol and Meaning in Contemporary Art*. October 16–November 21.

1976
Whitney Museum of American Art, New York. *200 Years of American Sculpture*. March 16–September 26.

Bennington College Art Center, Bennington, Vt. *Artists at Bennington–The Visual Arts Faculty 1932–1976*. May 20–June 2.

Indianapolis Museum of Art, Indianapolis. *Painting and Sculpture Today, 1976*. June 9–July 18.

1977
Akron Art Institute, Akron, Ohio. *Project: New Urban Monuments*. May 1–June 19; traveled to Columbus Gallery of Fine Arts, July 15–September 25; Contemporary Arts Center, Cincinnati, October 8–November 27; Tennessee Botanical Gardens and Fine Arts Center, Nashville, January 7, 1977–February 25, 1978; Cranbrook Academy of Art, Bloomfield Hills, Mich., May 12–September 10, 1978; Edwin A. Ulrich Museum of Art, Wichita State University, Kan., December 1, 1978–January 3, 1979.

The University of Michigan Museum of Art, Ann Arbor. *Works from the Collection of Dorothy and Herbert Vogel*. November 11, 1971–January 1, 1978.

1979
American Academy and Institute of Arts and Letters, New York. *Exhibition of Newly Elected Members and Recipients of Honors and Awards*. May 23–June 17.

1980
San Francisco Museum of Modern Art, San Francisco. *Twenty American Artists*. July 24–September 7.

1982
American Academy and Institute of Arts and Letters, New York. *Memorial Exhibition: Marcel Breuer, Wallace K. Harrison, Joseph Hirsch, Julian Levi, Tony Smith*. November 15–December 19.

1983
P.S. 1 (Project Studios One), The Institute for Art and Urban Resources, Long Island City, New York. *Abstract Painting 1960–69*. January 16–March 13.

1984
Paula Cooper Gallery, New York. *Carl Andre, Donald Judd, Tony Smith*. May 24–June 22.

Whitney Museum of American Art, New York. *BLAM! The Explosion of Pop, Minimalism, and Performance, 1958–1964*. September 20–December 2.

1985
Paula Cooper Gallery, New York. *Sculptors' Drawings*. March 7–30.

The Art Museum, Princeton University, Princeton, N.J. *A Decade of Visual Arts at Princeton: 1975–1985*. November 17, 1985–January 12, 1986.

New York Studio School, New York. *On Ontogeny: Sculpture and Painting by 20th Century American Sculptors*. November 20–December 19.

1986
Centre Georges Pompidou, Musée National d'Art Moderne, Paris. *Qu'est-ce que la sculpture moderne?* July 3–October 13.

Hunter College Art Gallery, New York. *Beyond Formalism: Three Sculptors of the 1960s: Tony Smith, George Sugarman, Anne Truitt*. September 18–October 24.

Los Angeles County Museum of Art, Los Angeles. *The Spiritual in Art: Abstract Painting 1890–1985*. November 23, 1986–March 8, 1987; traveled to Museum of Contemporary Art, Chicago, April 17–July 19, 1987; Haags Gemeentemuseum, The Hague, September 1–November 22, 1987.

1987
Bakalar Sculpture Gallery, List Visual Arts Center, Massachusetts Institute of Technology, Cambridge, Mass. *Tony Smith: The Shape of Space*. January 17–April 5.

Dallas Museum of Art, Dallas. *A Century of Modern Sculpture: The Patsy and Raymond Nasher Collection*. April 5–May 31; traveled to National Gallery of Art, Washington, D.C., June 28, 1987–February 15, 1988; Centro de Arte Reina Sofía, Madrid, April 6–June 5, 1991; Forte di Belvedere, Florence, July 8–November 1, 1991; Tel Aviv Museum of Art, Tel Aviv, January 1–April 26, 1992.

Guild Hall, East Hampton, N.Y. *Long Island Modern: The First Generation of Modernist Architecture on Long Island*. August 16–September 20.

The Solomon R. Guggenheim Museum, New York. *Fifty Years of Collecting: An Anniversary Selection (Sculpture of the Modern Era)*. November 13, 1987–March 13, 1988.

1988
Socrates Sculpture Park, Long Island City, N. Y. *Sculptors Working*. May 22, 1988–March 15, 1989.

1991
Galerie Pierre Huber, Geneva. *Sol Lewitt, David Rabinowitch, Joel Shapiro, Tony Smith*. June 14–July 27.

Galerie Gmurzynska, Cologne, Germany. *Vision by Room, Art and Architecture from 1910 to 1990*. November 15, 1991–January 31, 1992.

1993
Centre d'Art Contemporain du Domaine de Kerguéhennec, France. *De la main à la tête, l'objet théorique*. May 1–September 19.

1994
Musée d'Art Moderne et Contemporain, Geneva. *Inaugural Exhibition*. September 22, 1994–January 29, 1995.

1996
The Solomon R. Guggenheim Museum, New York. *Total Risk, Freedom, Discipline: Abstraction in the 20th Century*. February 8–June 2.

The Museum of Modern Art, New York. *Abstraction: Pure and Impure from the Permanent Collection*. February 16–May 21.

Karsten Shubert Gallery, London. *From Figure to Object: A Century of Sculptors' Drawings*. September 13–November 2.

1997
The Solomon R. Guggenheim Museum, New York. *A Century of Sculpture: The Nasher Collection*. February 7–June 1.

PaceWildenstein, New York. *Alfred Jensen, Tony Smith: Personal Geometry*. May 2–June 20.

Hirschl & Adler Modern, New York. *Tony Smith/Christopher Wilmarth*. December 6, 1997–January 24, 1998.

Photograph Credits

Jörg P. Anders: p. 133; Christopher Bliss: p. 176; Rudy Burckhardt, courtesy Tony Smith Estate: p. 186 upper right; Andrew Bush: pp. 52 right, 53 bottom, 55 bottom left and right, 57 top, 58 top left and right, 64 top right; Geoffrey Clements, courtesy Paula Cooper Gallery and Tony Smith Estate: pp. 74, 119, 156, 178, 181; Courtesy Paula Cooper Gallery and Tony Smith Estate: p. 175; George Cserna: p. 173; Bruce Cunningham, courtesy Tony Smith Estate: pp. 67 bottom, 69 top left and bottom left; John Dean, Baltimore: p. 147; D. James Dee, courtesy Paula Cooper Gallery and Tony Smith Estate: pp. 158, 179; Detroit Institute of Arts, photo © 1998: p. 144; T. Charles Erickson, courtesy Paula Cooper Gallery and Tony Smith Estate: pp. 170, 171; Lee Ewing: p. 125; Zindman Fremont, courtesy Hirschl & Adler Modern: p. 172; David Gahr, courtesy Tony Smith Estate: p. 26; Ed Glendinning: p. 93 bottom; Thomas Griesel: pp. 51 bottom, 64 top left, 70, 97–99, 100 top left and right, 101, 102, 104, 120; David Heald: p. 177; Hickey-Robertson, Houston: p. 146; Kate Keller: p. 24; Eric Landsberg: p. 63 top; Malcolm Lubliner, courtesy Tony Smith Estate: p. 186 bottom left; Richard Margolis: p. 152; James Matthews: p. 168; The Metropolitan Museum of Art, New York, photo © MMA: p. 163; Andrew Moore, courtesy Paula Cooper Gallery and Tony Smith Estate: p. 162; The Museum of Modern Art, New York: p. 127; Jon Naar, courtesy Tony Smith Estate: pp. 43, 60; © 1991 Hans Namuth Estate, courtesy Center for Creative Photography, The University of Arizona: endpapers, pp. 9, 185 top, 187 left; frontispiece and p. 37 (courtesy Tony Smith Estate); Thomas Powel: pp. 12, 18, 20, 22, 23, 25, 33, 38, 54 bottom, 56, 58 bottom, 59, 64 bottom, 66 top, 68, 69 right, 71, 78, 79, 83 top right, 86 left, 88 left, 89, 90, 93 top, 94, 96, 100 bottom right, 103, 105–118, 121–24, 125 top left and bottom right, 126, 136–43, 145, 148–50, 153, 159–61, 165, 166, 169, 182; Thomas Powel, courtesy Matthew Marks Gallery, New York: pp. 11, 27, 29, 42, 73, 80, 81, 82, 83 top left and center and bottom left, 84, 85, 86 center and right, 87, 88 right, 91, 92, 128, 131; Thomas Powel, courtesy Paula Cooper Gallery and Tony Smith Estate, New York: pp. 159-61; Courtesy Tony Smith Estate: pp. 31, 36, 40, 41, 44, 50, 57 bottom, 66 bottom, 72, 154, 184, 185 bottom, 186 center right; Ingeborg Tallarek, courtesy Tony Smith Estate: p. 19; Ivan Dalla Tana, courtesy Paula Cooper Gallery and Tony Smith Estate: p. 151; Courtesy University of Pittsburgh: p. 174; © 1967 *The Washington Post,* reprinted with permission, courtesy Corcoran Gallery: p. 187 right; Whitney Museum of American Art, New York: photo © 1998: p. 83 bottom right; Ellen Page Wilson, courtesy Tony Smith Estate: pp. 39, 51 top, 52 left, 53 top, 54 top, 55 top, 61, 62, 63 bottom left, 65, 67 top; Graydon Wood: p. 155; John Wronn: p. 63 bottom right, p. 130.

Lenders to the Exhibition

The Detroit Institute of Arts
Institute for Advanced Study, Princeton, New Jersey
Memorial Art Gallery of the University of Rochester
The Menil Collection, Houston, Texas
The Metropolitan Museum of Art, New York
The Museum of Modern Art, New York
New Jersey State Museum, Trenton, New Jersey
Tony Smith Estate, New York
The Toledo Museum of Art
University of Pittsburgh, Pittsburgh, Pennsylvania

Collection Clos Pegase Winery, Napa Valley, California

Paula Cooper Gallery, New York

Jeanne Bultman
Robert M. Cochran
Jean Taylor Federico
Hans Frei
Daniela Frua De Angeli Rivetti
Tony and Gail Ganz
Arne and Milly Glimcher
Robert Gober
Agnes Gund
Sarah-Ann and Werner H. Kramarsky
Hans Noe
Ellen Phelan and Joel Shapiro
Robert and Lucy Reitzfeld
Marjorie L. and Stephen S. Schwartz
Henry and Renée Segerstrom
Mr. and Mrs. Robert Shapiro
Chiara Smith
Jane Smith
Seton Smith
Richard Tuttle
Donald Windham

Anonymous Lenders

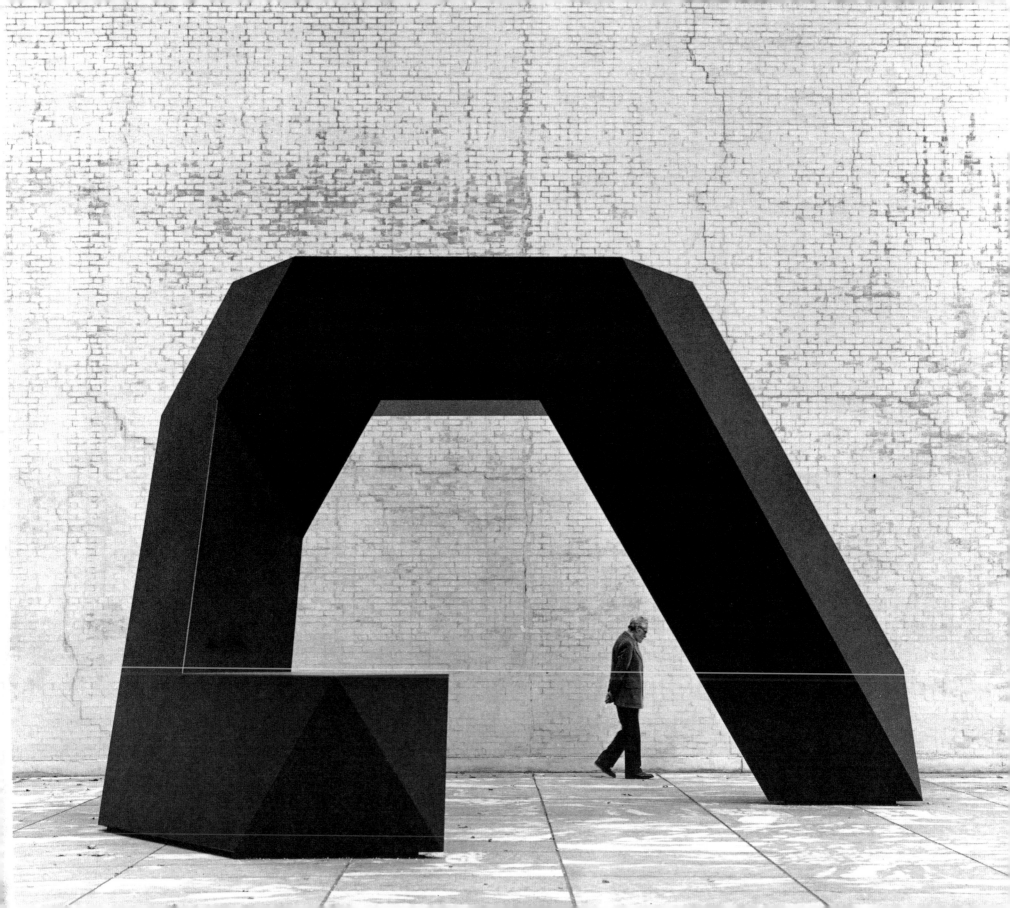